The Stones of Venice

The Stones of Venice

Lionello Puppi

Photographs by Mark E. Smith

with 157 colour illustrations

 Thames & Hudson

Picture research and captions by Massimo Favilla and Ruggero Rugolo

Translated from the Italian by Alexis Gregory

This edition first published in the United Kingdom in 2002 by
Thames & Hudson Ltd, 181A High Holborn, London WC1V 7QX

www.thamesandhudson.com

British Library Cataloguing-in-Publication Data
A catalogue record for this book is available from the British Library

ISBN 0-500-34189-3

Printed and bound in Italy

CONTENTS

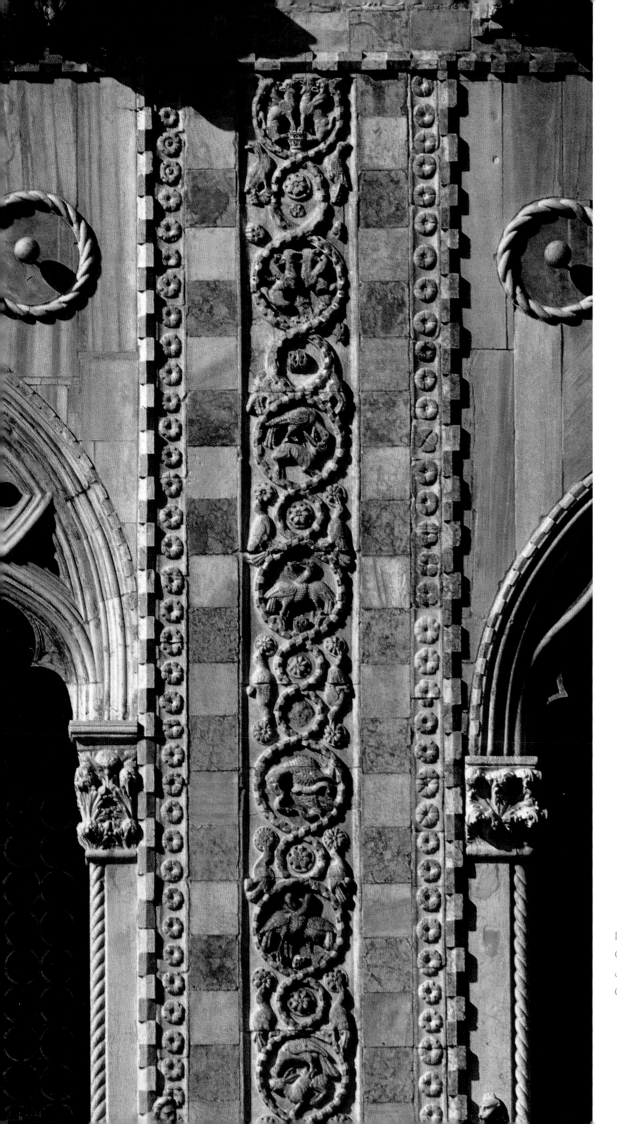

Detail of the facade of the
Ca d'Oro, in whose naturalistic
decoration the Byzantine and
Gothic worlds are combined.

*For Massimiliano
and Luisa,
who made me
a gift of Venice
so that they could
rediscover the city
themselves through
the memory of its
ancient columns.*

... a city of graceful arcades and gleaming walls, veined with azure and warm with gold, and fretted with white sculpture like frost upon forest branches turned to marble. JOHN RUSKIN, *The Stones of Venice*

In the Beginning Were the Waters

In the beginning were the waters, meeting and mingling here in the lazy currents of the vast, brackish lagoon, suspended between land and open sea. Moving according to the whims of the moon or the caprices of the wind, the waters caused a cluster of small islands to rise or sink, to grow or disappear – ephemeral islands of muddy earth with outlines as shifting as those of the clouds. These fertile fragments, on which rich farms as well as beautiful villas would in time appear, were protected from the unpredictable and devastating natural calamities that the weather or the sea might threaten. As a result, thanks to the unique way in which they were formed, these patches of land became, during the 4th and 5th centuries A.D., a refuge for the nearby population – people from Latino, Oderzo and Padua and various other places in the Euganean hills.

Civitas Venetiarum mirabilis est ac velut mundi miraculum quoniam in aquis fundata est. (The city of Venice is a marvel, almost a wonder of the world, as it is built on water.)

SAN LORENZO DA BRINDISI
De fundatione mysticae civitatis Dei Mariae

These victims of barbarian invasions turned very quickly towards the survival economy that this aquatic environment offered. Thus, in the 6th century A.D., Cassiodorus wrote from Ravenna, 'Only fish are found in abundance by the inhabitants [of the islands of the lagoon]; here poverty lies in proximity to wealth, and members of both groups share the same food and live in identical houses, so that nobody envies the home and hearth of his neighbour and, living under the same conditions, all are sheltered from the vices that dominate the rest of the world. Their entire activity, and any possible competition between them, is linked to the salt marshes. Instead of scythes and ploughs, they use nets, and these are the bases of everybody's livelihood.'

In a much later painting, one of Domenico Tintoretto's greatest masterpieces – now in the Scuola Grande di San Giovanni Evangelista – representing *St Mark Blessing the Islands of the Lagoon*, the majestic standing figure of the patron saint is set off against a background of straw cabins built on stilts, standing on narrow strips of land enclosed by wooden palisades, or on rudimentary piers also made of wood. Cassiodorus also mentions 'the great number of boats' used by the people of the lagoon that pass swiftly and silently through the waters and which the inhabitants 'tether to their houses like animals'. According to a document written at the end of the 12th century, these vessels were always kept ready to go to mass on feast days, when they would be taken right up to the place of worship 'through the canals, as these people had no other way to get around'.

Each city conceives, and then builds up over time, the myth of its origins, its identity and its destiny. The beginnings of Venice could only come about through a supernatural act of faith involving the combination of people fleeing the barbarian scourges in the north, obliging them to give up the opulence and comfort of their ancestral domains, and this unusual landscape of scraps of land surrounded by brackish water, where they could provide for themselves. Here they rediscovered their original innocence and here they founded, on the island of the Rialto, a city quite unlike any other that had ever existed or was reputed to have existed. According to legend, where the Basilica of San Marco, named after the patron saint of the future city, now stands, an angel appeared before St Mark, whom Christ had bidden to wander through these marshy lands, predicting that in this silty and humid setting he would one day find peace, eternal glory and the serenity of a dignified tomb. '*Pax tibi, Marce*' ('Peace to you, Mark') were the angel's words of greeting, prophesying this 'holy construction of a city never before seen'. 'Almost all agree', the legend continues, that the work began in A.D. 421 and, to be exact, on 25 March, the day 'of excellent works made' and a date closely linked with the fate of humanity itself; for 'on that same day', almighty God created Adam, our first ancestor, and the Son of God was conceived in the womb of the Virgin Mary, to come among us to fulfil the role of the Messiah and to undergo the torments of the Passion and death on the Cross. 25 March is also the *zorno di Venere*, or 'day of Venus', the goddess who rose from the sea foam fertilized by Uranus and who was carried by a smiling Zephyr to the island of Cythera, standing on a large sea shell and dispensing grace and beauty as she went. Every shore that she passed was suddenly adorned with the most beautiful flowers. And from this coincidence of dates arose a deep conviction in the mythical imagination of Venice that the city had a very special mission to fulfil, one that was recited in the prayers of the ruling Doge. The city was subject to the will of the gods who were to preside, for all eternity, over the superior task that they had assigned to her – that is to say, the *pulchritudo urbis*, or beauty of the city, which here reached the height of perfection.

Venezia-Venusia or 'Venus of the Venetians', according to a learned humanist treatise, meant either that Venus took her name from the city, or that the Venetians took on her myth. In addition, this incomparable city set itself up as the earthly mirror of celestial Jerusalem fulfilling a biblical prophecy of the Psalms in being 'beautiful for situation, the joy of the whole earth... the city of the Great King', a place of perfect beauty, a

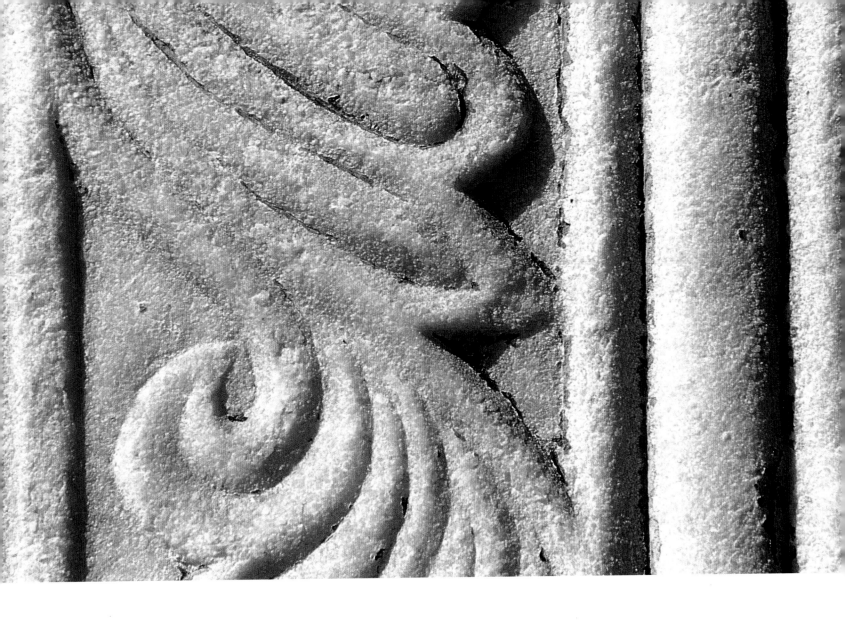

new world and a great spectacle that would not be appropriate 'for the eyes of those who either do not see or, seeing, are little amazed'. In the wake of Titian, Veronese and Tintoretto, of Sansovino, Sanmicheli, Palladio and Alessandro Vittoria, all of whom reflected the city's splendour in the 16th century, the poet Luigi Groto, who was blind from birth, invoked a 'Venice born free and burning with charity before God, as well as generosity towards both its citizens and strangers, a new Venus, a divine work notwithstanding its human features, which, like Venus, had arisen naked in the midst of the waves, a city without ramparts and yet invincible, since its impregnable walls are under the incessant watchfulness of Nereids and Neptune.' At a later date, Venice celebrated the millennium of its history; the sumptuous city 'founded not on earth but on the sea; not by tyrants, like Nineveh or Babylon, but by those who detested tyrants; not by thieves, predators, peasants and shepherds, like Rome, but by the most noble and most virtuous people of Venetian lineage; not built by pagans or worshippers

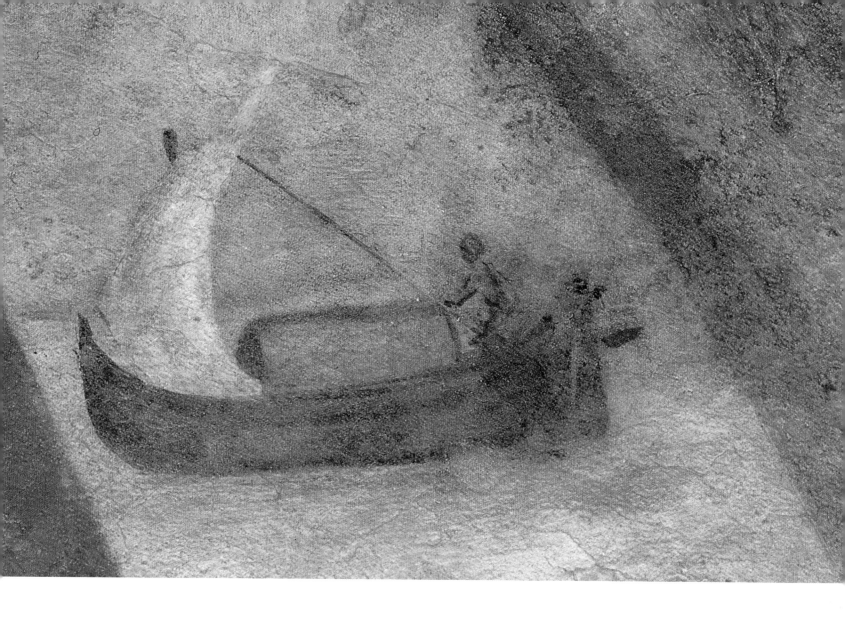

of idols, like Troy or Athens, but by Christians who loved their crucified Lord and expressed their adoration through precious materials, or even through wood and ordinary stones, as was the case in Ulm, Augsburg and Constance'. Later in time, there was an all-enveloping wave of profound resignation as well as a proud assertion of the incomparable legend of the city in a perennial evocation of lost dreams and ambitions, often expressed in popular songs: 'To you, most beautiful Venice, we will give Ancona as a husband, as jewelry you will have the keys to Rome, and the waves of the sea will be your wedding ring.'

If it is true that every city likes to be seen as it sees itself, Venice is wound up in the tangle of its myth and in the myriad reflections that this myth gives rise to. The water, present from the beginning of

Left This leaf of Istrian stone, waving and rustling in the breeze on one of the porches of the Basilica of San Marco, has an almost ethereal quality.

Above A small boat, whose sail is filled by the wind in this delightful fresco, can be seen in the covered passage of the Pasina in San Silvestro and reminds us how Venice was once awash with colour. Over time, the elements, lack of upkeep and pollution have worn away the frescoes and washed away the vivid colours which covered the facades of Venice's buildings until the middle of the 19th century.

13

time, remains — purified by ingenious means that cleanse the foul deposits of mud and putrid vegetation caused by rotting roots and reeds. The lagoon became streaked with skilfully dug canals, and dykes were built to prevent the erosion of the fragile islands. A few huts, initially scattered at random, suddenly came together to form a first urban nucleus that was soon controlled politically and militarily by an administration governed by a *dux*, or leader, chosen from those official landowning families who devoted themselves, among other matters, to maritime affairs. This duchy, subject to the Eastern Roman Empire, was protected by the Carolingian Franks who had defeated the Lombards in many areas of the Italian peninsula.

In the year 774, the first bishopric was established on the island of San Pietro di Castello, and some fifty years later, in 829 to be precise, the Dux (Doge) Giustiniano Partecipazio ordered a basilica to be erected and dedicated to the Evangelist Mark, who had been chosen as patron saint of the city. Then, as the century waned, Pietro Tribuno decided to build, in the same area near the Rialto, a fortified citadel in emulation of his predecessor, Orso Partecipazio, who had built a great number of houses there. In this way, a centripetal movement developed around these earliest crucial urban axes. The wisdom of these fortifications was to be confirmed by two great attacks from the sea, the first during the 9th and 10th centuries and the second during the 11th and 12th centuries. These attacks radically altered the territory of the lagoon and did much to further the creation of the great *Civitas Venetiarum*, or city of the Venetians, and to bring about the radical transformation of different population groups into a unique Venetian people. This, in turn, created an intensification of building activity.

Families who possessed superior financial, social or political status took charge, and the simple straw and mud huts gave way to true houses built of stone. Alongside these developments there was a great increase in buildings intended for manufacturing and commerce, including the first shipyards at the Arsenal, dating from 1104, all

Right Thick leather-bound volumes and parchments are a few of the objects that talented sculptors created for the monument to Niccolò Tommaseo, erected in Campo Santo Stefano. The names of Homer and Dante are engraved on the spines of these books, making us think of a journey or simply the journey of life, connecting the here and now with far-off civilizations. But where is this journey leading? Towards paradise? Towards memories of what has been lost? Towards the past? Is it a Venetian odyssey?

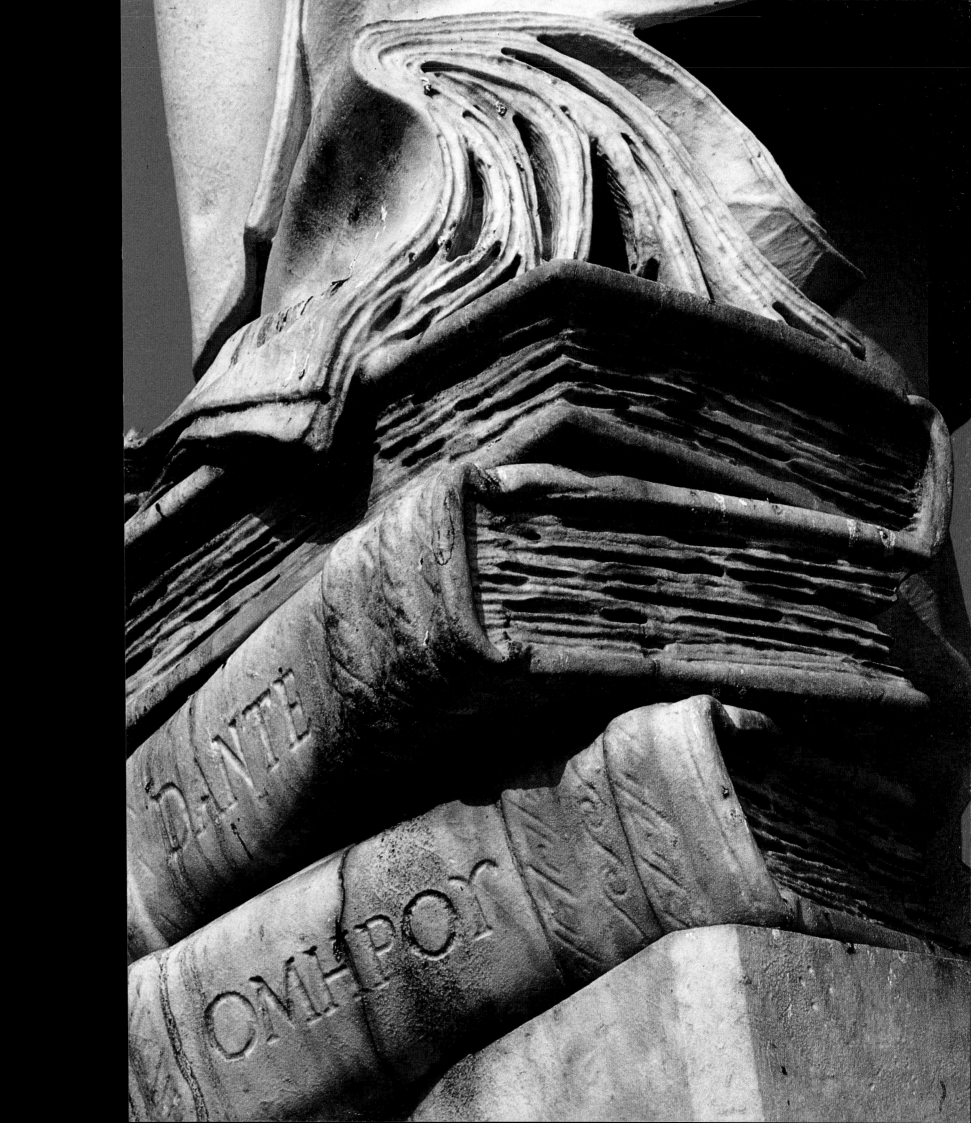

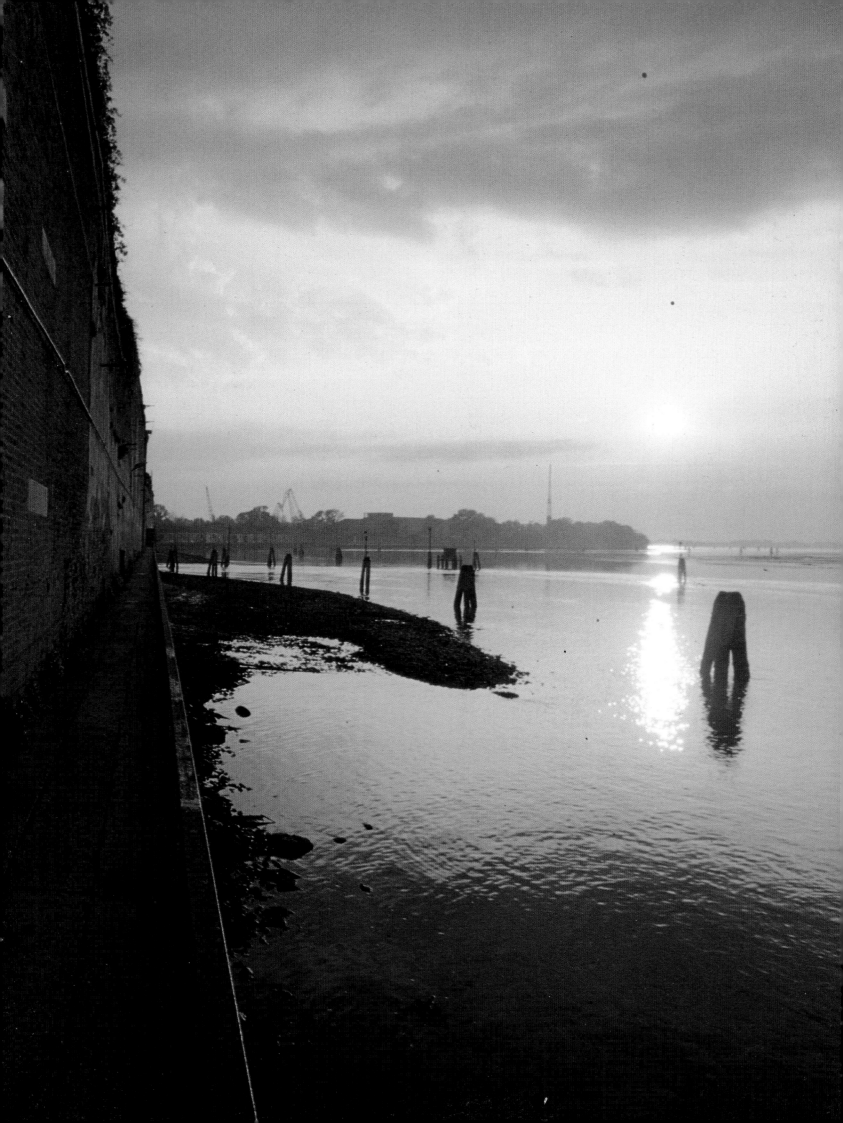

bearing witness to the dynamic flourishing of an emerging civilization. Parallel to this economic boom, the Venetian ducal authority gradually began to free itself from the yoke of Byzantium and eventually affirmed its complete political autonomy by striking coins that purposely ignored the name of the Byzantine emperor, bearing instead the proud motto *Christus imperat Venecia* ('Christ rules over Venice'). A Golden Bull dated 992 sanctioned this new independence and granted the Venetians, formerly vassals of the Eastern Empire, the gratifying status of being auxiliary to Byzantium. While affirming the originality of their own culture, the Venetian people would nonetheless continue to reflect the indelible stamp of their Byzantine heritage which, due to its implacable opposition to geometry, linearity and perspective, and its great sensitivity to fine materials and to a particular treatment of form, inspired the splendour of light, the elegance of line and the magical colouring of Venetian painting.

The process of centralization of urban life soon united the smaller islands, which started to gravitate around the larger ones (Rialto and Castello), adding to them a number of island groups in outlying parts of the lagoon: Murano, Burano, Torcello. Then a truly labyrinthine series of walkways was created, faithfully following the winding courses of the canals themselves. Soon a network of small streets came into being, as well as the *fondamenta*, those stone quays or embankments that stretch along the maze of twisting *rii* (narrow thoroughfares); the *calli*, tortuous alleys (some also paved) that snake their way through a forest of brick and marble formed by buildings; the *rughe*, straighter and broader streets, but still eluding any attempt at rectilinear geometry; and finally the well-heads that dominate the centres of the *campi* (formerly grassy squares) and the smaller *campielli*.

In 1346, the young Tuscan friar Nicolò da Poggibonsi wrote in his *Libro d'Oltremare*, 'Look at this land attentively; I am speaking of Vinegia.' He was astonished by an urban ensemble that was 'so different from cities built in other lands, for it has but a few pedestrian ways, the other routes being small or large canals. Thus we travel everywhere by water, in a boat, since, although certain streets are out of the water, nearly all of them have no pavement at the side of the road and thus it is more

Preceding pages The warm tones of the red brick wall surrounding the Arsenal dissolve into the foggy atmosphere of the lagoon.

Right The abstract design on the floor of a Murano church dedicated to Santa Maria and San Donato may represent a early Christian basilica.

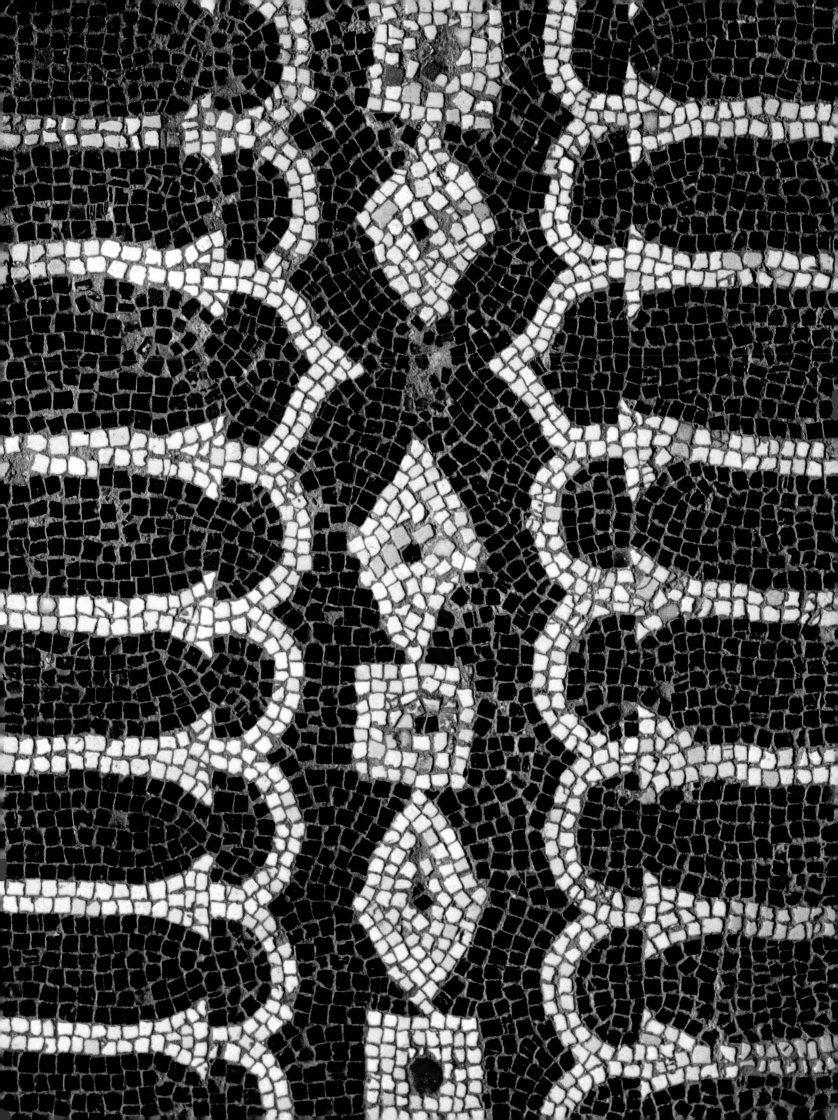

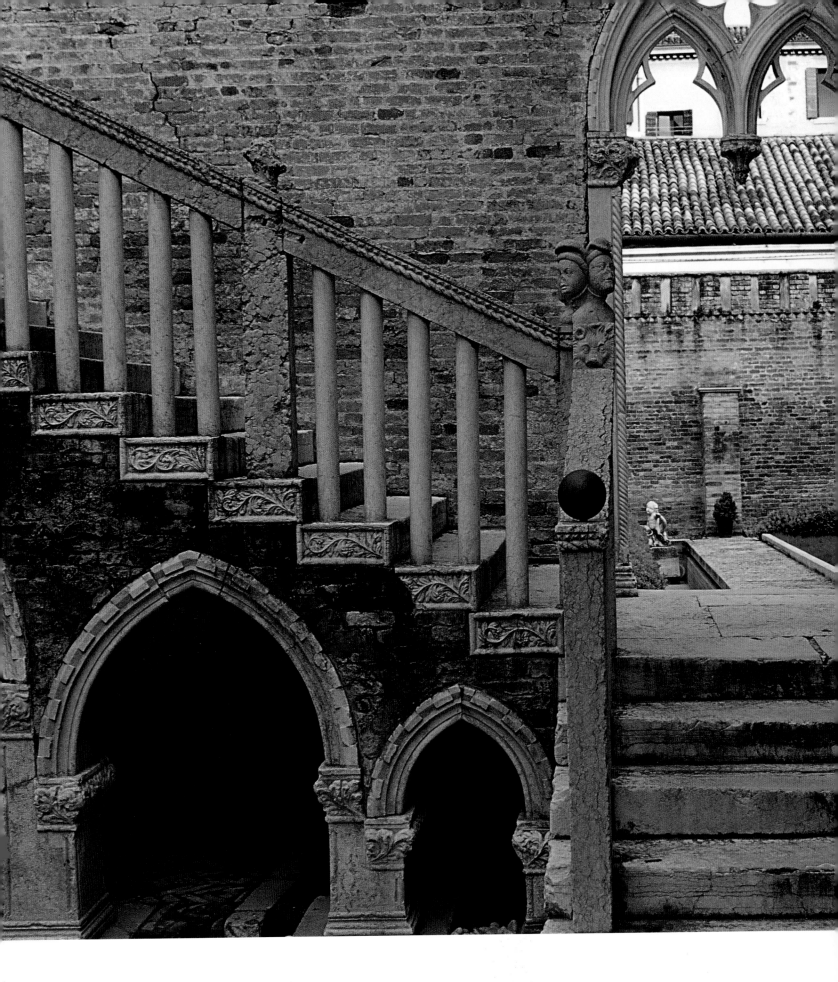

convenient to use the waterways.' He continues his description, recalling a great number of very beautiful houses and a multitude of belfries. Two years later, the city's population of 100,000 was decimated by the Black Death, and the plague struck again in 1563 when the population had risen to 160,000. The very special nature of the site prevented any form of physical expansion, and the urban nucleus was therefore subjected to a huge increase, within its restricted space, in the number of *calli*, *campi* and bridges, giving rise to a prodigious development of public, private and religious architecture and ornament (which was constantly in flux according to the demands of style), as well as twisting alleyways that were used by the inhabitants of the long ribbon-like stretches of buildings.

The development process was essentially based on political, mercantile and manufacturing activities. The largest and most important political centre was the Piazza San Marco, whose original and definitive layout was established in the 12th century by the Doge Sebastiano Zani. Here the magistrates of the Republic occupied their seats of honour in the Doge's (or Ducal) Palace, whose chapel/mausoleum sheltered the mortal remains of the patron saint, Mark the Evangelist, which the Doge had the responsibility of preserving and guarding. Here were the offices of the procurators, the mint, the public library and archives, and the prisons. This district, where the wisdom of the State was enshrined, was dedicated to the goddess Minerva, and was of such profound symbolic significance and so close to the centre of the universe — as reflected in miniatures that embellished a number of medieval nautical charts — that it was the site of rich public ceremonies celebrated from the 15th to the end of the 18th centuries. The mercantile world developed around the Rialto, at the mid-point of the Grand Canal, an urban agglomeration that grouped around its port the most important *fondaci*, or warehouses, and markets of the city. This commercial centre was dedicated to Mercury. Finally came the third nucleus, the domain of Vulcan, once a secretive hideout where iron was delicately wrought, situated at the Arsenal on the eastern side of this very compact island. It was in these immense workshops that the ships were produced that assured Venice of its undisputed hegemony over the

The lion of St Mark the Evangelist is Venice's most important symbol and can be found throughout the city, on well-heads, and adorning the newel post of this Gothic staircase in the courtyard of the Palazzo Contarini della Porta di Ferro in Santa Giustina. Its watchful and well-meaning eye follows us wherever we go.

neighbouring Adriatic as well as the Levantine coast of the Mediterranean throughout a good part of its history.

While the original layout of the area presided over by the Doge saw little change over time and still retains its aspect of a Roman forum, it is generally recognized that the most important architectural impact on Venice dates to the third decade of the 16th century, when Jacopo Sansovino, later followed by Vincenzo Scamozzi and Baldassare Longhena, greatly enriched the Piazza San Marco so as to better exalt the power of *La Serenissima*, as the Republic came to be known. The markets and warehouses of the Rialto, along the Grand Canal, were united by the famous stone Rialto Bridge, which replaced its wooden predecessor and which served the important purpose of linking the trading areas on both sides of the Canal. Access to the Arsenal by land and sea was also improved. As for the islands of San Giorgio and the Giudecca (which were originally places of profound spirituality where monks pursued their vocation away from secular life, as well as places where the nobility could enjoy, in their residences there, the delights of leisure and rest away from urban bustle), these were actively integrated into the historic nucleus, as well as into the architectural ensemble, as a result of the work of Andrea Palladio between 1560 and 1577, in particular his church of the Redentore. This place of worship, which he conceived following the terrible plague of 1576, was connected to the city of Venice by a pontoon bridge, which was reconstructed every year on the occasion of a solemn memorial procession led by the Doge, the Patriarch and the leading political, civic and religious dignitaries of the city. This created not only a visual spectacle, but also a physical link between the historic nucleus and the island of the Giudecca. The church of Santa Maria della Salute, built by Longhena and dedicated to the Virgin of Health (or Salvation) immediately after another great plague in 1630, stands near the tip of the island of Dorsoduro and was linked to the other side of the Grand Canal by a different kind of temporary bridge that was suspended over the water during another annual ceremony of thanksgiving. The precarious character of this type of construction bears witness to a very definite desire to preserve the island status of the Giudecca, and to have just one permanent bridge (not by chance at the level of the commercial port) linking the two banks of the Grand Canal. The sinuous Canal gives breathing space to the dense urban fabric, its broad and powerful course seeming almost to repudiate the innumerable twists and intersections of the smaller waterways.

The 15th-century staircase of the Palazzo Contarini del Bovolo is reminiscent of a snail shell or the tendrils of a climbing plant.

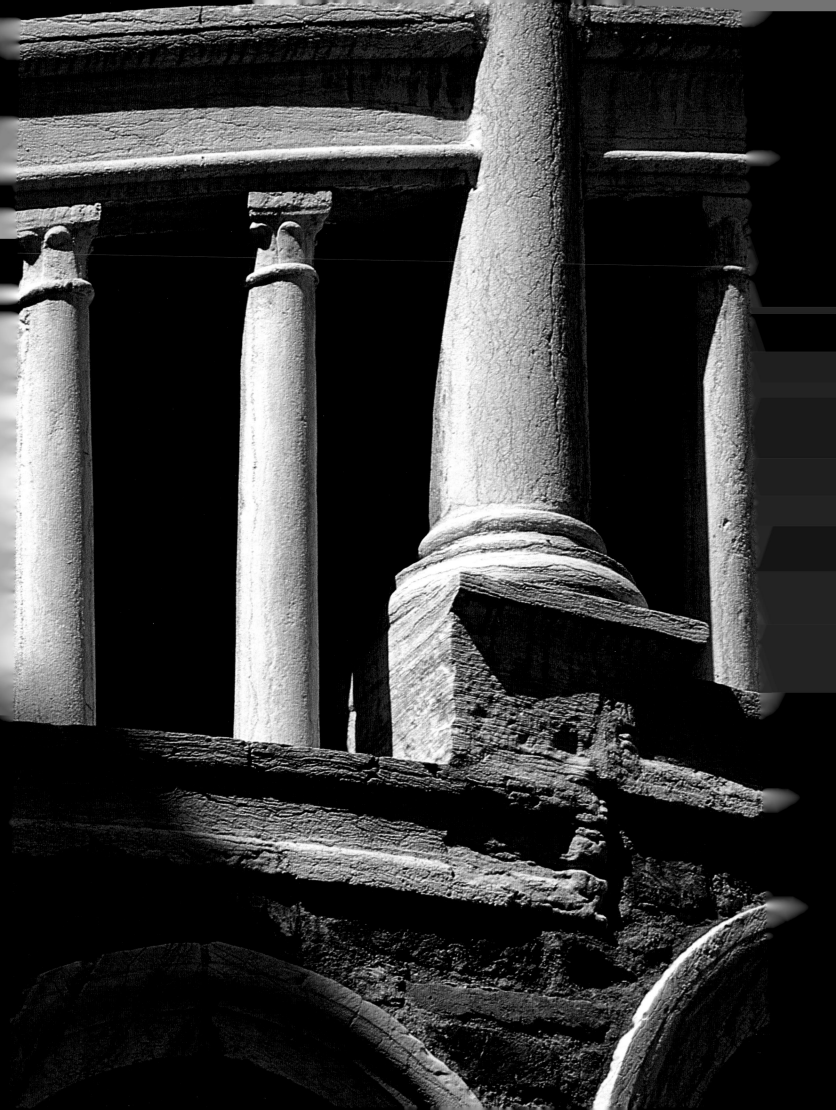

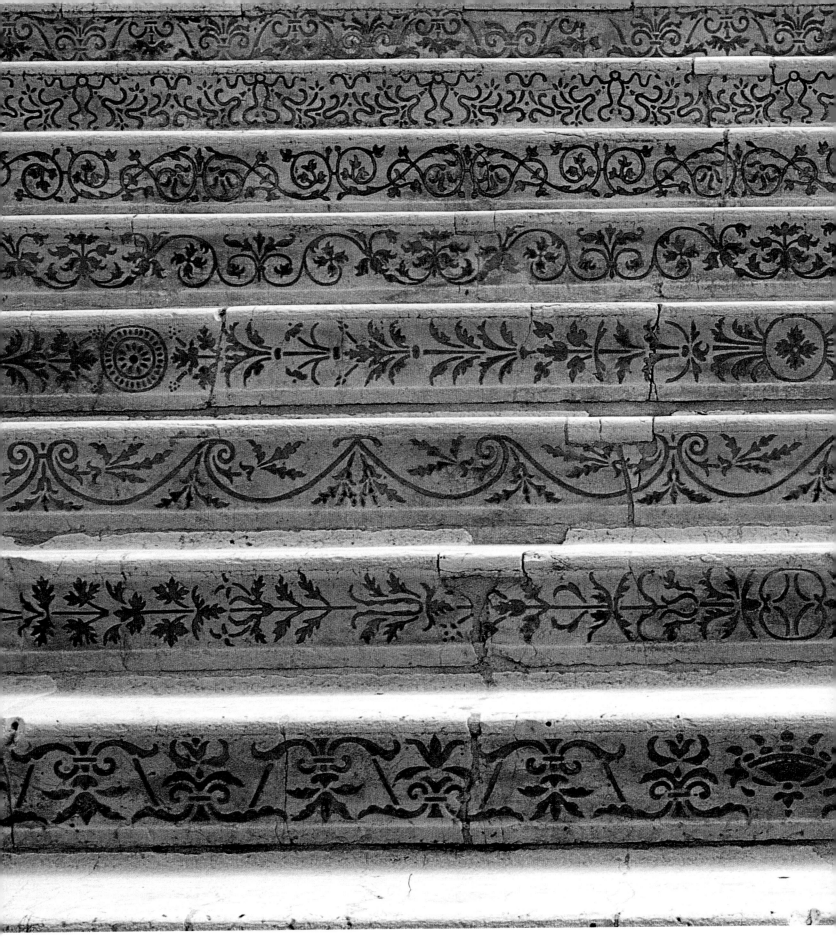

The affectionate observation of the grace and outward character of vegetation is the sure sign of a more tranquil and gentle existence, sustained by the gifts, and gladdened by the splendour, of the earth.

RUSKIN, *The Stones of Venice*

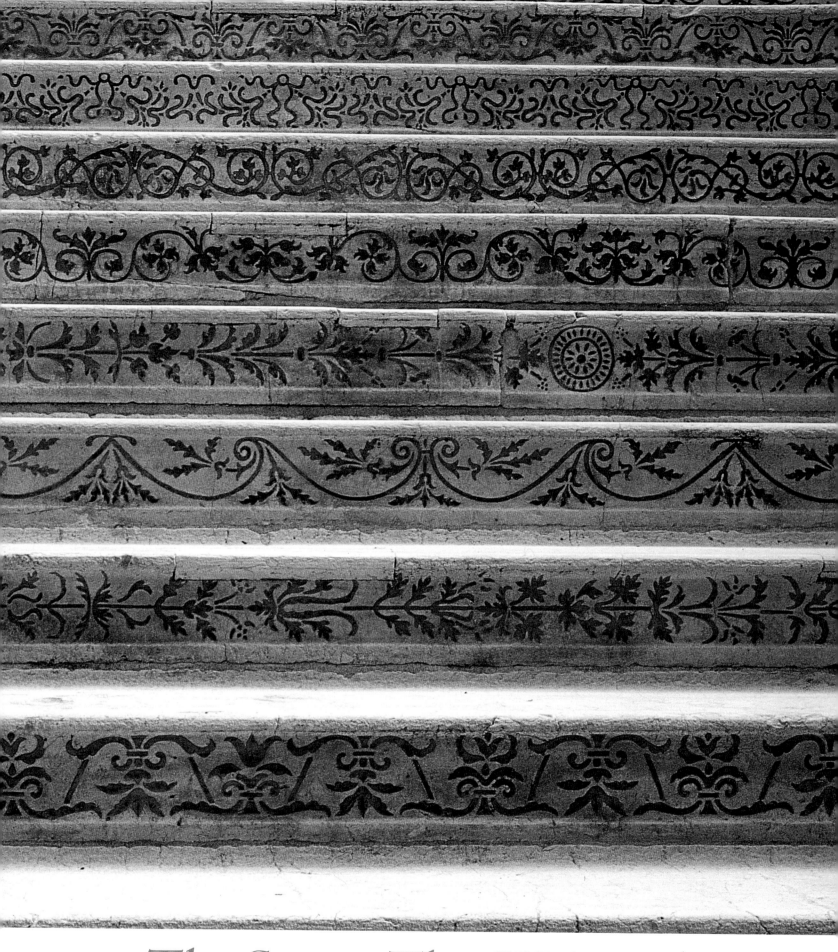

The Stones That We Tread

The only way to care for Venice as she deserves it, is to give her a chance to touch you often — to linger and remain and return.
HENRY JAMES, *Italian Hours*

Venice is not built for hasty travellers who are happy with a fleeting visit to the obligatory tourist sites, seeing little and determined simply to find the shortest and least tortuous route between two points. On the contrary, the city offers an invitation to explore the mysterious twilight of its *sotoporteghi*, or archways under buildings; to step around the sudden curve of a tufa wall and come across a deserted *calle* leading abruptly to a skewed bridge; to turn one's glance towards doorways opening on to the monastic silence of gardens and hidden orchards; to slow one's pace cautiously over *fondamenta* scattered with gravel or paved with loose flagstones as sharp and dangerous as a mountain ridge; and to savour all those unforeseeable moments that only the reflections of a topsy-turvy, fragile Venice can offer, like the crystal dawn that caresses this incomparable garden of stone and brick. The more enterprising of the

Venice resembles a garden of stone in which, over the centuries, the remarkable expertise of skilled craftsmen have created a true *ars topiaria*. Bricks have been used since antiquity to pave the main public and private spaces of the city, and were laid *a cortello* or *in piano* (vertically or horizonally). Their warm red tones gave character to Venice's squares, courtyards, cloisters, quays and streets until the end of the 16th century, when they began to be replaced with the grey trachyte *masegni* from the nearby Euganean hills.

Right The herringbone brick floor in the medieval cloister of Sant'Apollonia can still be seen today.

Preceding pages The Renaissance *Scala dei Giganti* (Giants' Staircase) in the courtyard of the Doge's Palace has richly ornamented steps.

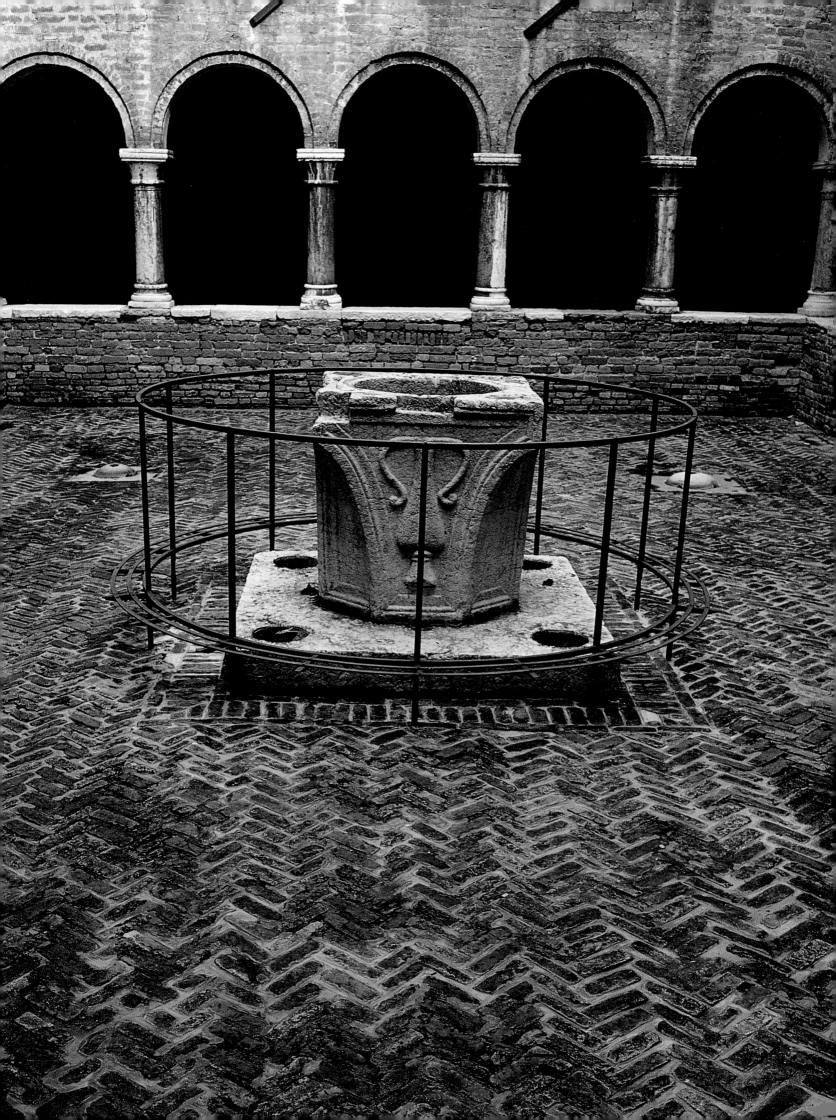

The wild grass grows well and strongly, one year with another; but the wheat is, according to the greater nobleness of its nature, liable to the bitterer blight. RUSKIN, *The Stones of Venice*

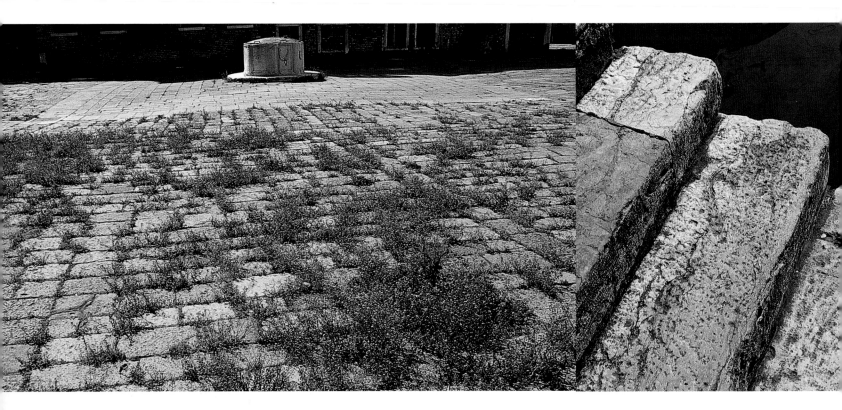

city's visitors – those who venture from the well-trodden paths – are rewarded with the sudden discovery of places where the monotonous grey of the street is broken. The lead-coloured paving stones which cover the majority of the public spaces, such as the State-protected parvis of basilicas, are often enlivened by imaginative lines and multiple geometric designs made with white marble cut from the quarries of Istria (in particular from Pola, Rovigno and Brioni), or by almond-shaped, red-stained, pock-marked stones that come from the rocky bowels of Verona's hills. And we must not forget the even merrier games that are played with medallions or squares of green serpentine, nor the great paving stones that have been carefully pierced to swallow the rainwater and channel it into nearby cisterns. Visitors may also be carried away by the

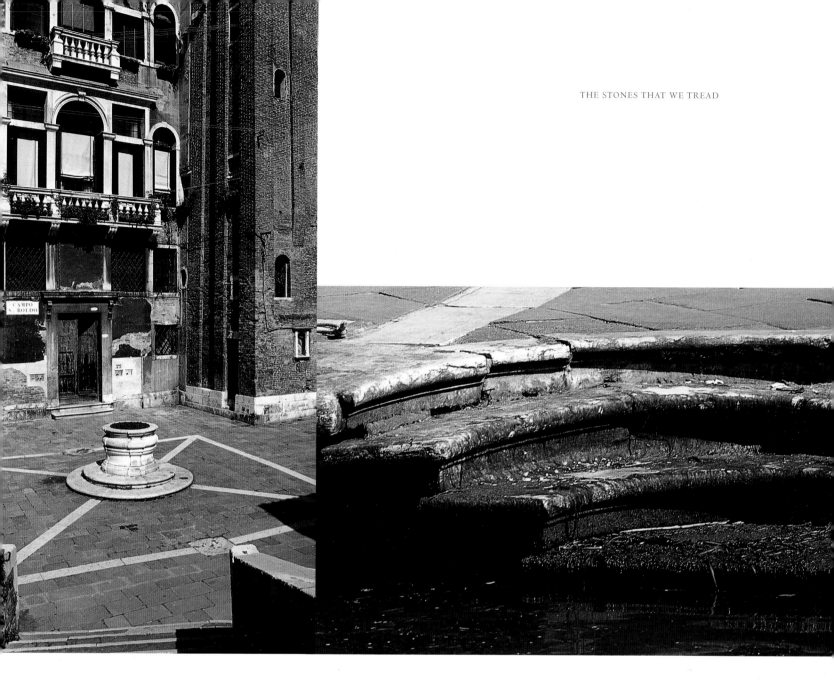

confusion of bricks baked in the kilns around Padua, Polesine and Treviso (these last being the most prized), or from the Giudecca; their warm brownish tones sometimes enhanced by gleaming white motifs made from limestone powder or from mortar mixed with pebbles. Or they may be captivated by the grass and moss that attract multicoloured butterflies, by the hopping of a quarrelsome seagull or a peaceful but mischievous pigeon, or by the padded steps of a lazy cat looking for a place to curl up and rest.

This topsy-turvy Venice, where the tangible sensation of people gone by wraps us in restlessness,

After the fall of the Republic in 1797, brick pavements were limited to courtyards, side streets and the *sotoporteghi*, while the greater part of the city was paved in *masegni*. This more resistant stone was often combined with Istrian white stone to create geometric designs which enlivened the uniform colour of the ground. These stones were laid dry on a base of clay, allowing blades of grass to continue to grow between the cracks. Nature, in the form of weeds, grass, moss or water is therefore not completely excluded and is allowed to engage in fruitful dialogue with its companion, stone.

31

... necessities consequent upon the employment of a rougher material, compelling the workman to seek for vigour of effect... RUSKIN, *The Stones of Venice*

is strewn with invisible imprints of its past and resonates with footsteps which trod the connecting paths of this garden of stone long before our own. Stately footsteps of proud patricians, senators and procurators of state, dressed in cloaks of velvet or embroidered violet satin; steps of beggars or good-for-nothings; the hurried steps of sellers of spiced drinks or honeyed sweetmeats; steps of those absorbed in their prayers; steps of the well-established rich or of nameless beggars in rags — all gathered together in a procession of standards, banners, torches and candles — giving thanks for the miracles they have enjoyed through the intervention of their benevolent protectors, or rendering homage to the Republic, born of divine wisdom; steps of rich and poor brethren, all members of the company of death, their faces covered in black silk, their

In 1723, the old herringbone brick floor of Piazza San Marco (**overleaf**), first laid in 1267, was replaced with more hard-wearing trachyte stone. Enhanced by introducing pieces of Istrian stone, the sophisticated design created by Andrea Tirali was replaced with an identical pattern in 1890 due to wear and tear. The white Istrian stone enlivens the monochromatic trachyte by forming delicate contrasts and highly elaborate motifs, which can be seen in public and prestigious places such as the church of Santa Maria della Salute (**left**). This grandiose State church, begun by Longhena in 1631, was built as a votive temple by the citizens of Venice, in the wake of a terrible plague outbreak.

33

arms raised as they hold a small image representing the suffering of the Saviour, gathered in a sombre parade to accompany convicted criminals to the scaffold set up on the Piazzetta between the columns of St Theodore and St Mark.

Then there are the steps of poets and literary figures, painters, architects, sculptors, carvers and illuminators of manuscripts who together created the art of this 'impossible city'; and the steps of thousands upon thousands of travellers who have always been dazzled by Venice, considering the city to be the most fascinating and admirable place to be seen anywhere in the world. And, of course, there are the steps of John Ruskin and Thomas Mann, the latter wandering in the guise of Gustav von Aschenbach, who already saw in the worn stones of Venice the sand and dust to which they would inevitably be reduced. There are invisible imprints of past footsteps and the unmistakeable tracks of long-gone carts drawn by small, long-suffering donkeys, and of the hooves of horses that once galloped in the *calli* and lingered in the *campi* to take advantage of the refreshing water generously provided by the cisterns and wells.

...and the traveller, dazzled by the brilliancy of the great square [Piazza San Marco], ought not to leave it without endeavouring to imagine its aspect in that early time, when it was a green field, cloister-like and quiet, divided by a small canal, with a line of trees on each side.

RUSKIN, *The Stones of Venice*

Looking up from the pavement, visitors cannot fail to notice the great variety in the forms of the well-heads, which the unrestrained imagination of the Venetians have adorned with an astonishing variety of elements; sometimes a sculpted lion, the companion of St Mark, the beast overflowing with arrogance; or perhaps heraldic insignia of noble families, the heroic deeds of certain corporations and political factions, or unlikely hybrid monsters from the pages of a fantastic bestiary, as well as a host of cryptic signs and indecipherable insignia. A tour by land and water through this unique and surprising city is sometimes abruptly interrupted by a receding flights of steps, their varying degrees of steepness making for an easy or an arduous ascent. The steps may be of a

... these wells furnish some of the most superb examples of Venetian sculpture.

RUSKIN, *The Stones of Venice*

uniform colour or polychrome, and may lead to the bare entrance of a *fondaco*, or may link a rounded or ogival doorway to the shady atrium of a palazzo where a silky light bathes the plants of its secret garden. Sometimes they may invite visitors to enter the dark and narrow nave of a small church, scented with aromas that combine the sweetish fragrance of exotic incense with the last drips of a dying candle at the end of its short lifespan. Or they may lead to one of those vast places of worship, with a nave punctuated by the solemn geometry of columns and capitals, rough hewn in the quarries of Istria and Verona, then worked by skilled stonecutters according to plans drawn up by the architect — unless they had been purloined during a Crusade or military expedition from the forums and imperial palaces of Byzantium, or perhaps

from the ruins of proud pagan antiquity scattered throughout Dalmatia, Anatolia and the islands of the Levant.

Our eyes are drawn back to the ground, away from the walls of passageways which, bathed in a pallid light, resemble shadowy curtains, or from the straight lines of the naves and aisles of churches, and we become all the more amazed by the magical appearance of the inverted firmament that spreads out and expands beneath our very feet. Marcel Proust remembered the days when he had first crossed the threshold of the Basilica of San Marco with his mother, and he

Far left On one of the *masegni* laid in Campo Santo Stefano, opposite the chemist of the same name, there used to be a great bronze mortar in which *teriaca* was made; this was an almost alchemical panacea made largely from adders captured in the Euganean hills.

Above The *piere sbuse* or *gatoli* (stones pierced with holes), in red Verona marble or white Istrian stone, concealed the mouths of the drains which gathered rainwater and channelled it into wells. These rather unusual stones are a fundamental feature of the city's pavements.

37

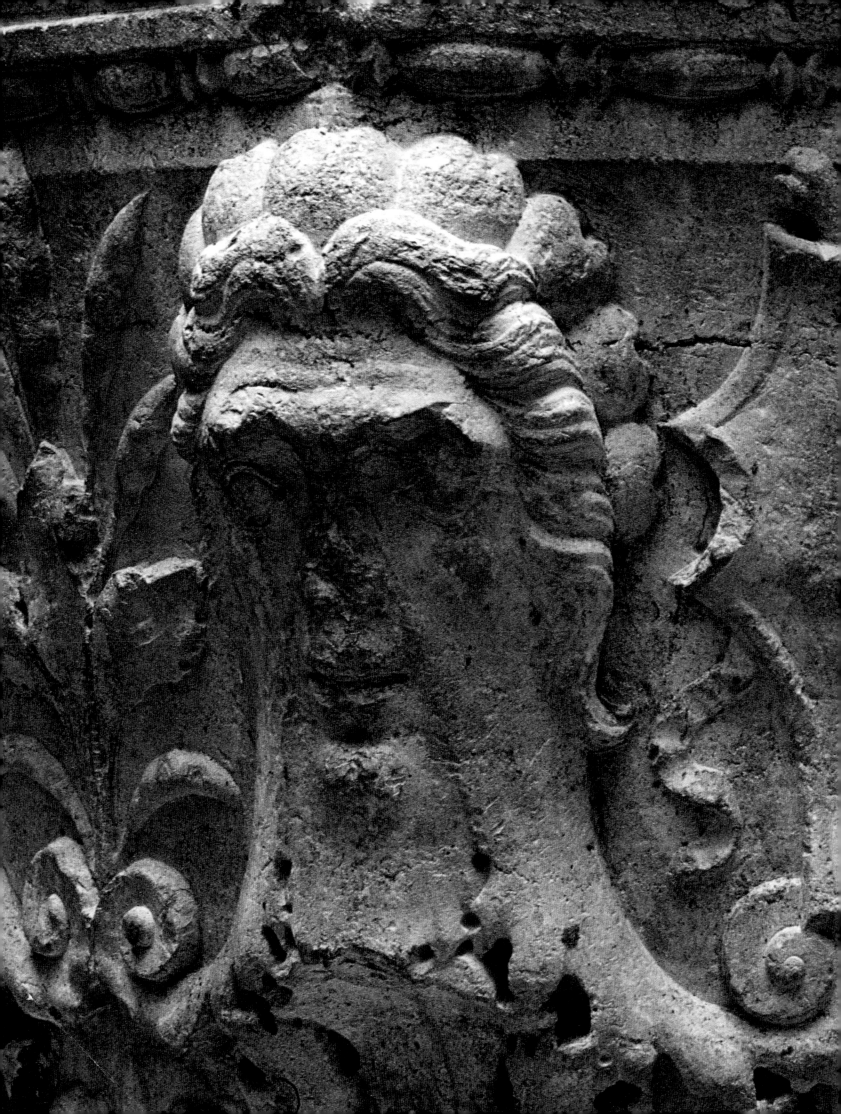

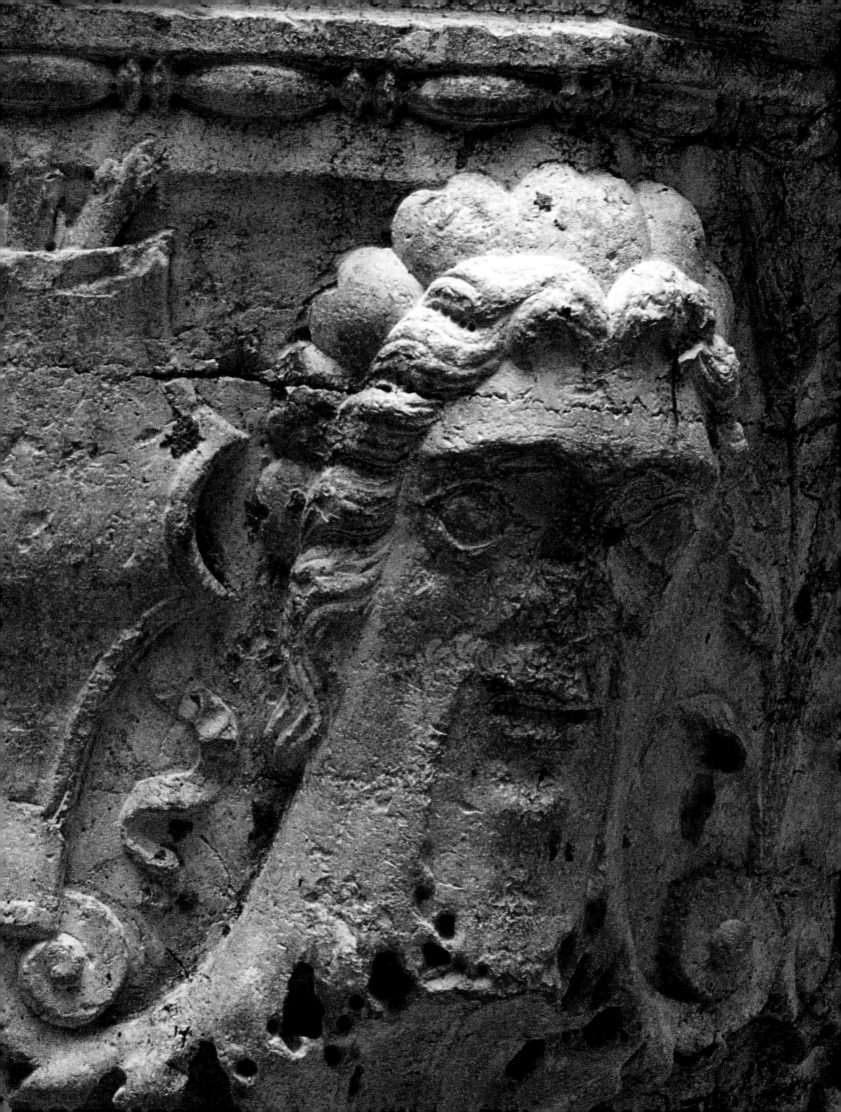

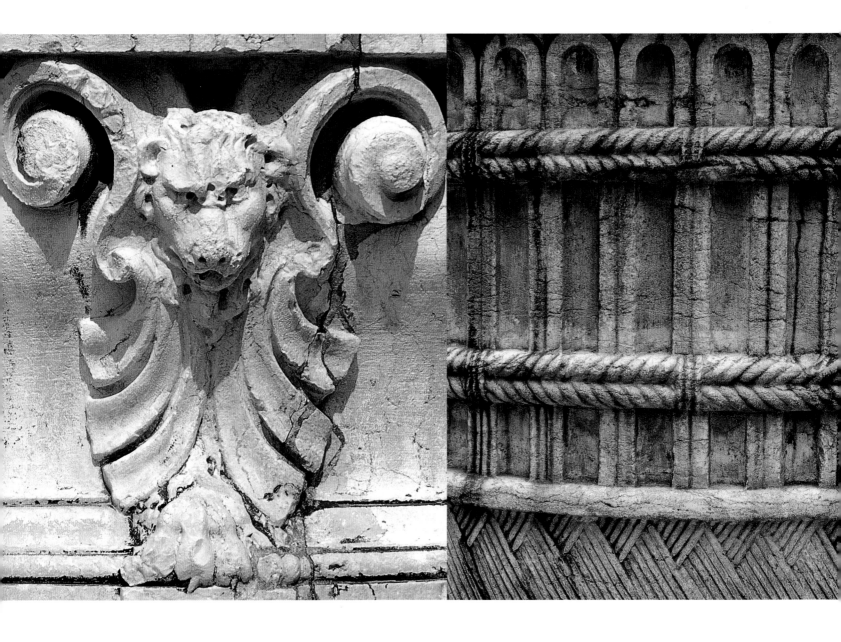

recalled the great arcades, slightly distorted by time, as well as his own footsteps on the marble and glass mosaics on the floor, already aware, as an anxious and thoughtful child, that everything would become lost in the past and would one day need to be recovered through his writings. He imagined these floors to be a kind of ever-changing constellation of blue, orange, yellow and red. The floors of Venetian interiors can indeed resemble otherworldly, infinite skies, whether they are made up of terracotta, uniformly sombre like a stormy sky plunged into darkness and riddled with brownish cloud-like flecks; or of granite, grey as lead; or else of *marmorini*, small stones shot through with flashes of light, like sparkling jewelry set with topazes, emeralds and

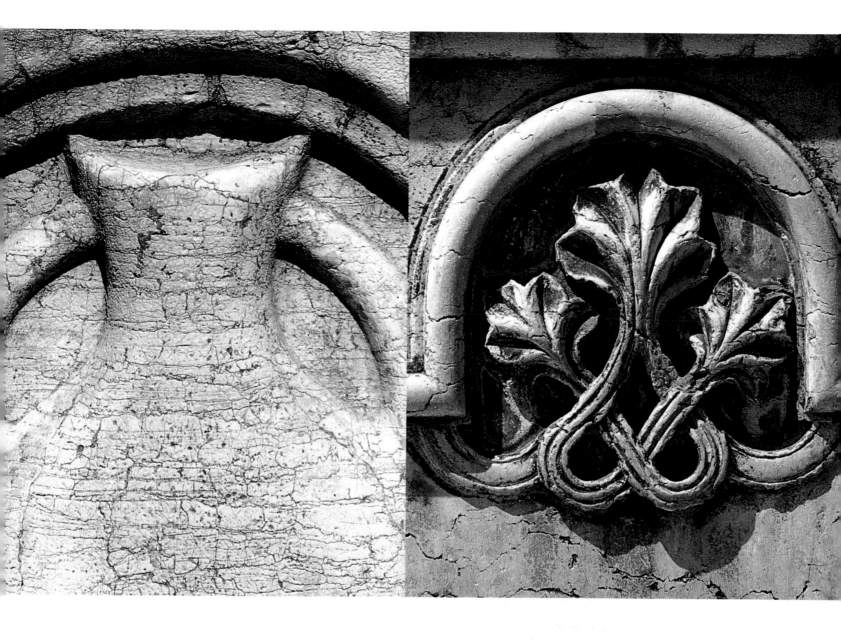

rubies, creating the appearance of well-ordered or chaotic galaxies, or perhaps of multicoloured storm clouds.

Access to a house may be through a gateway opening directly on to the lapping waters of a canal, allowing boats and gondolas to be pulled right up to the entrance and to take shelter there. These staircases are invitations to walk up to the salons on the higher floors, particularly the *piano nobile* containing the reception rooms, where once more may be found the dizzying illusion of a topsy-turvy firmament reflected in salons in which the fireplaces are

Wells were an essential component of Venice's urban space, and are recorded in documents dating back to the end of the 11th century. The sculptures ornamenting the *vere*, or well-heads, are extremely varied and feature zoomorphic, anthropomorphic (**preceding pages**) or vegetal motifs. The 15th-century well in the Gregolina courtyard in San Marco imitates a finely worked wicker basket.

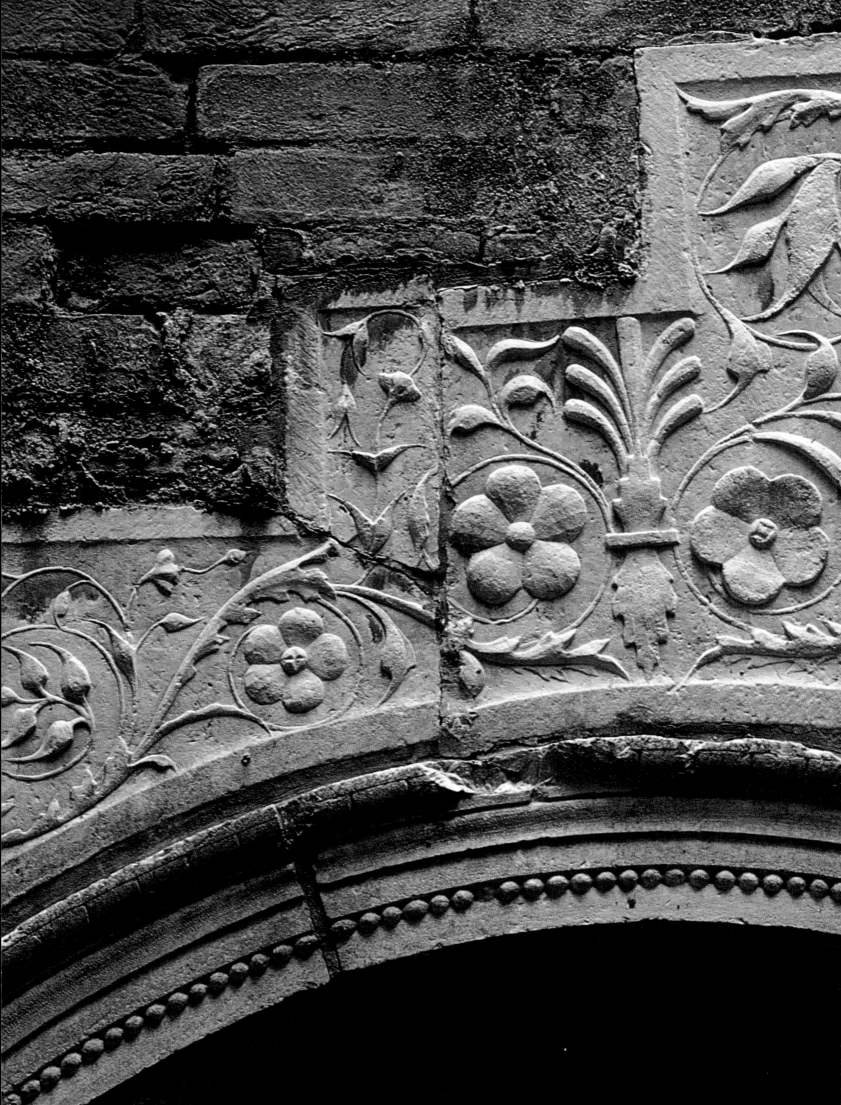

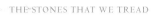

In Venice, staircases are also
transformed by naturalistic
elements. The staircase wall in
the Magno courtyard, in the
sestiere of Castello, was decorated
in the 15th century with a
display of flowers inhabited
by small animals.

43

These staircases are protected by exquisitely carved parapets, like those of the outer balconies, with lions or grotesque heads set on the angles and with true projecting balconies on their landing-places. RUSKIN, *The Stones of Venice*

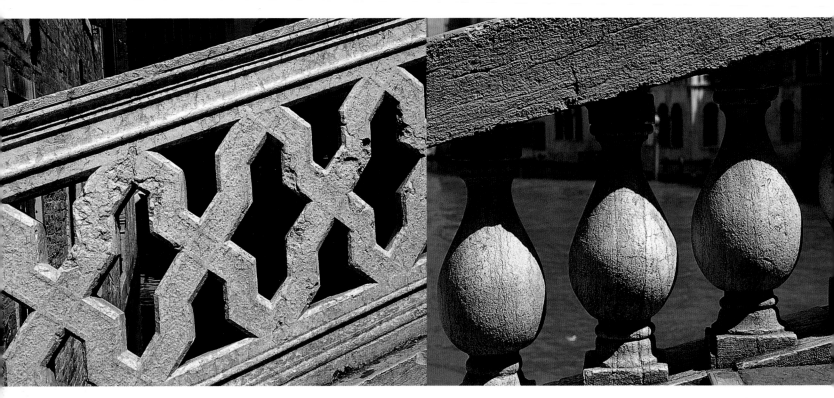

embellished with open-mouthed masks, jaws aflame, or where there is a bold and fanciful display of uprights, cornices, scrolls and volutes, and andirons in the form of dragons or snakes. But sometimes staircases rise in a spiral inside a graceful circular tower, encased in a whirl of arches, or consist of steep flights of steps under a barrel-vaulted ceiling, leading to a double window where one can rest on the way up.

There are also flights of monumental steps on a number of bridges, whose lightness depends upon the breadth of their spans (elevated, flattened or with the vertical thrust of an ogival arch), and which stretch across the irregular canals, sometimes bending in mid-course in order to unite *calli* and *fondamenta* with their unpredictable twists and turns. In a publication entitled *De origine, situ et magistratibus*

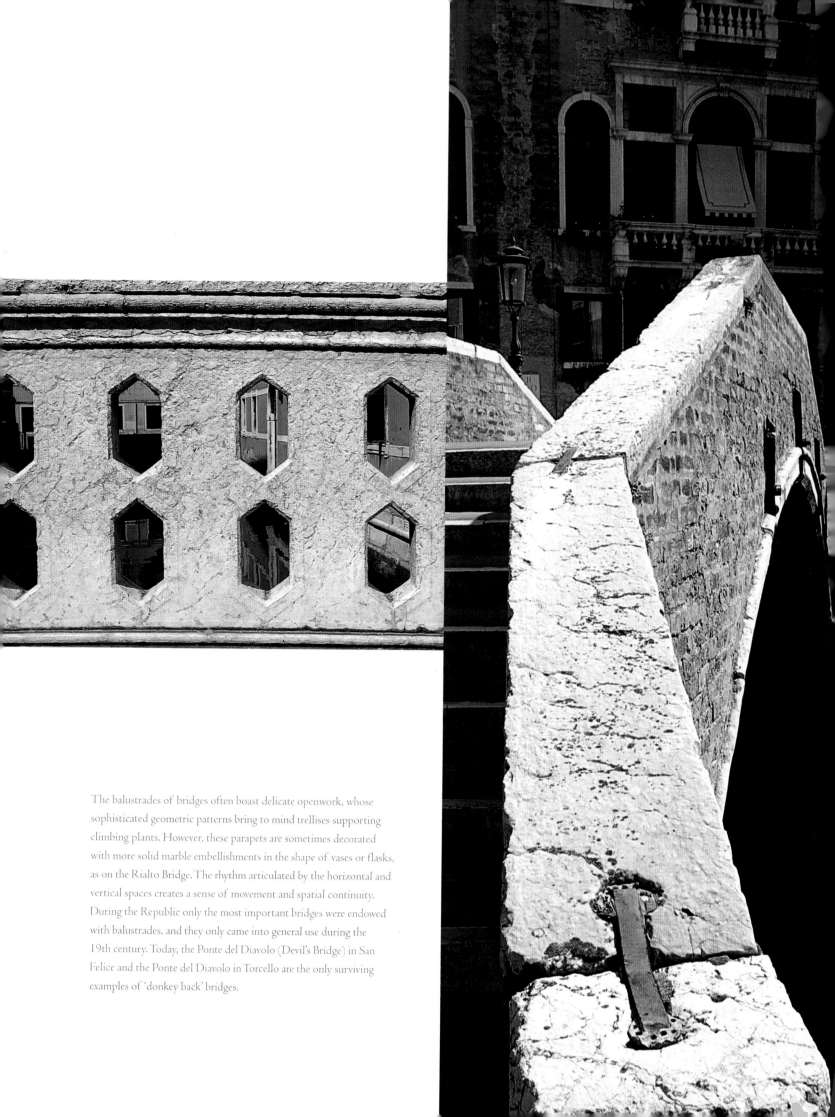

The balustrades of bridges often boast delicate openwork, whose sophisticated geometric patterns bring to mind trellises supporting climbing plants. However, these parapets are sometimes decorated with more solid marble embellishments in the shape of vases or flasks, as on the Rialto Bridge. The rhythm articulated by the horizontal and vertical spaces creates a sense of movement and spatial continuity. During the Republic only the most important bridges were endowed with balustrades, and they only came into general use during the 19th century. Today, the Ponte del Diavolo (Devil's Bridge) in San Felice and the Ponte del Diavolo in Torcello are the only surviving examples of 'donkey back' bridges.

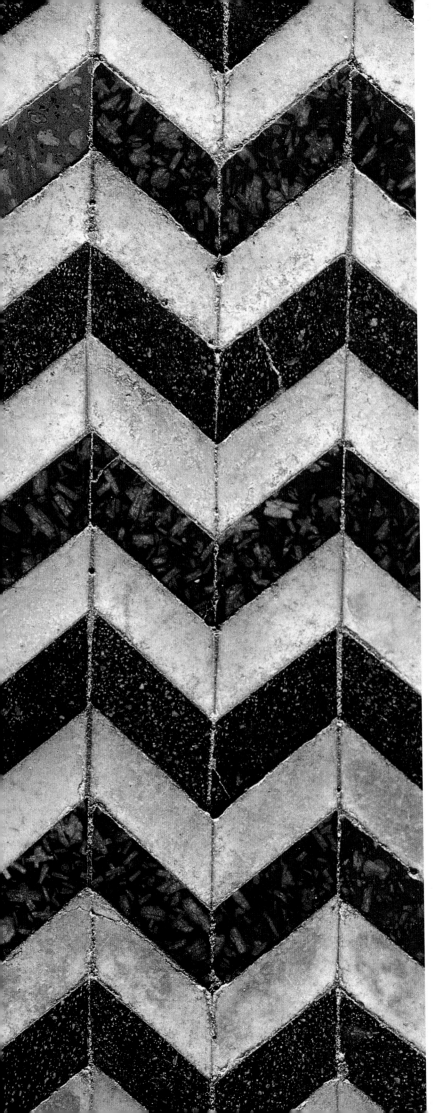

urbis Venetiae, put together between 1493 and 1530, Marin Sanudo, an indefatigable chronicler of the Venice of his time, meticulously studied the muscles and sinews of the mythical city he found. In his chapter on bridges, he listed thirty-three *traghetti*, crossing points for gondolas and other vessels, which the ordinary people of Venice still used to cross from one bank to the other, and only thirteen bridges, all of whose names have entirely disappeared from the city of today. The author identified these and amused himself by playing with the interpretations and meanings that captivated the imagination of the local population. The *Ponte della Pietae* (compassion), 'since it lets everybody go across', was situated near the Orphans' Hospital; the *Ponte di Feralli*, also known as the *Ponte dei Fanali* (lanterns), 'which can be crossed without need of candles', was rebuilt in iron in the 19th century. Today it straddles a canal of the same name that runs past the church of San Zulian (Giuliano) and emerges on the Calle della Fiubera where the stalls of the *fibbie* makers (a term used for belt and shoe buckles as well as lanterns) used to be. Then there was the *Ponte della Fava* (bean), 'which the pigeons don't deign

Water is the essential component of Venice, 'Queen of the Seas'. Without it, no garden – even one made of stone – could exist. The undulating movement of waves is stylized in an astonishing marble design on the floor of the Basilica of San Marco (**left**), and on the parvis of the church of San Michele in Isola (**right**), where stone seems to dissolve into and merge with the green waters of the lagoon.

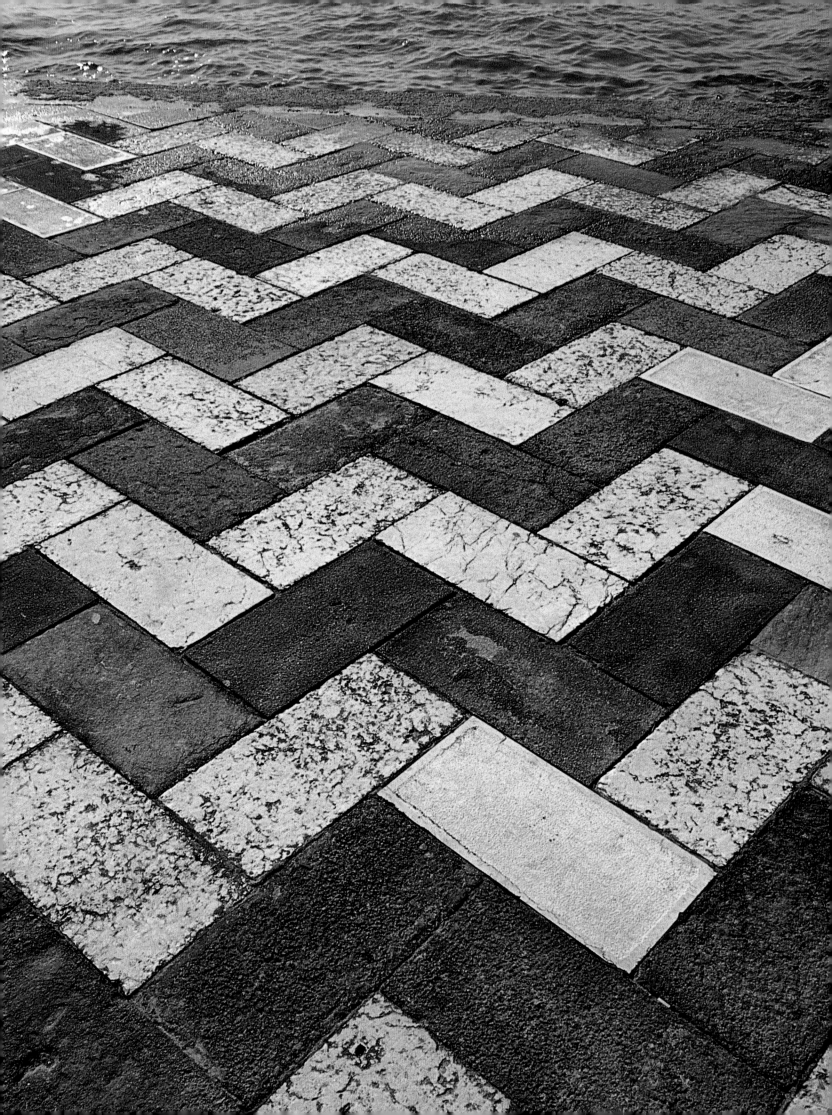

Left Water wears away at stone, as seen here on the steps leading up to the quay in front of the Tolentini church; the water slowly transforms the stone back into a natural element, in a paradoxical process of involution. If Venice is the most artificial city ever to have been built, it is also the one closest to nature – a 'miracle within a miracle' of Creation.

Right Steps leading to the sumptuous church of Santa Maria della Salute are a clear reference to Solomon's temple in the Bible, thus proclaiming Venice as a New Jerusalem, an ideal city, a paradise on earth.

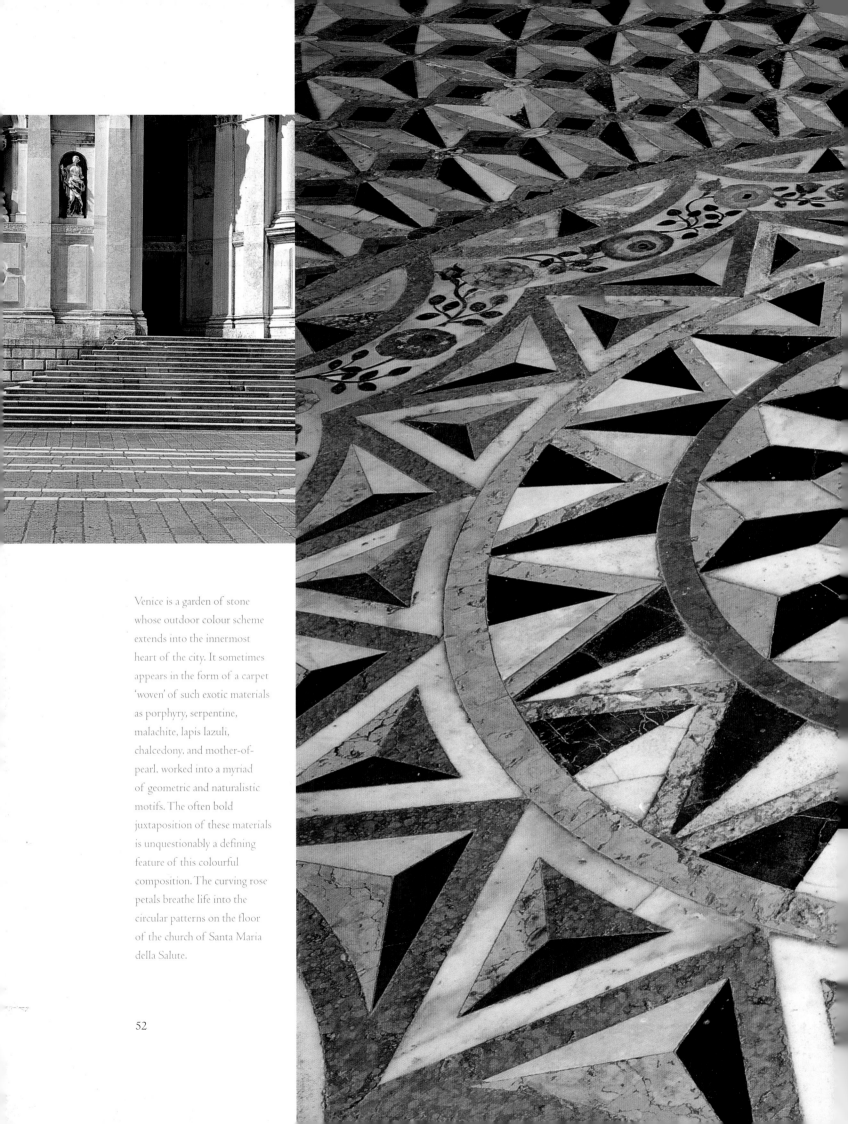

Venice is a garden of stone whose outdoor colour scheme extends into the innermost heart of the city. It sometimes appears in the form of a carpet 'woven' of such exotic materials as porphyry, serpentine, malachite, lapis lazuli, chalcedony, and mother-of-pearl, worked into a myriad of geometric and naturalistic motifs. The often bold juxtaposition of these materials is unquestionably a defining feature of this colourful composition. The curving rose petals breathe life into the circular patterns on the floor of the church of Santa Maria della Salute.

52

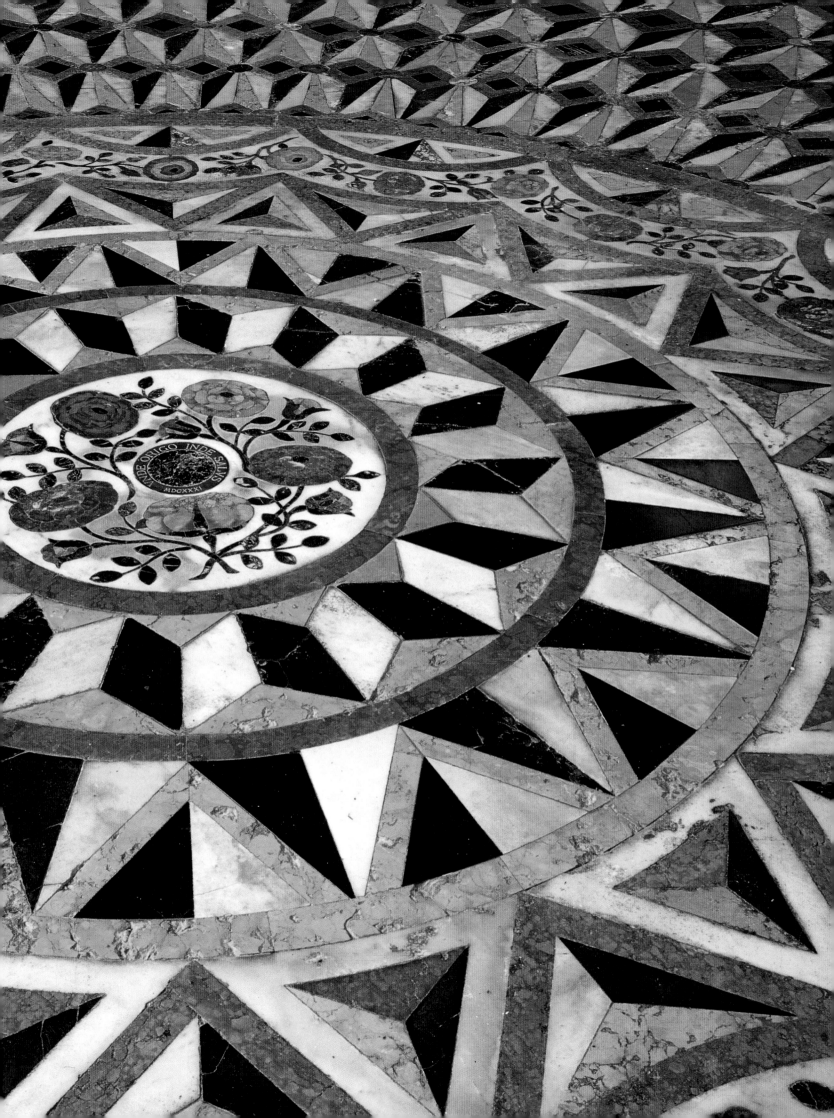

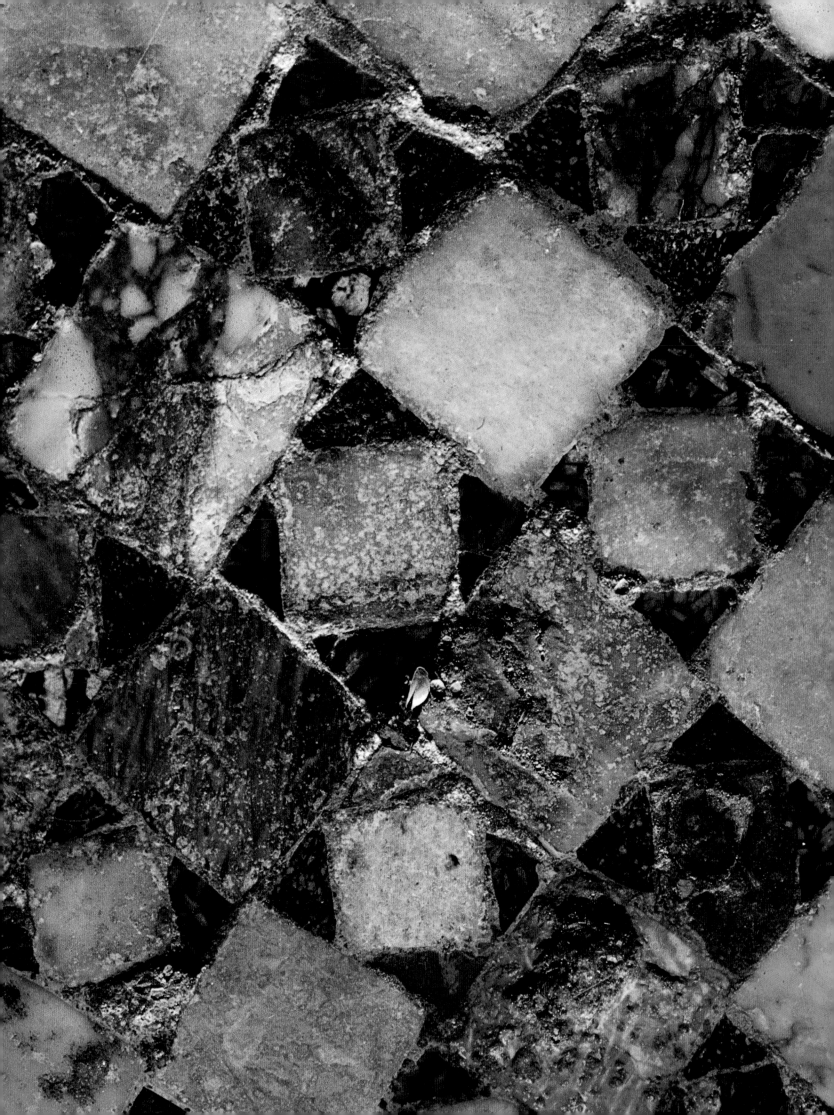

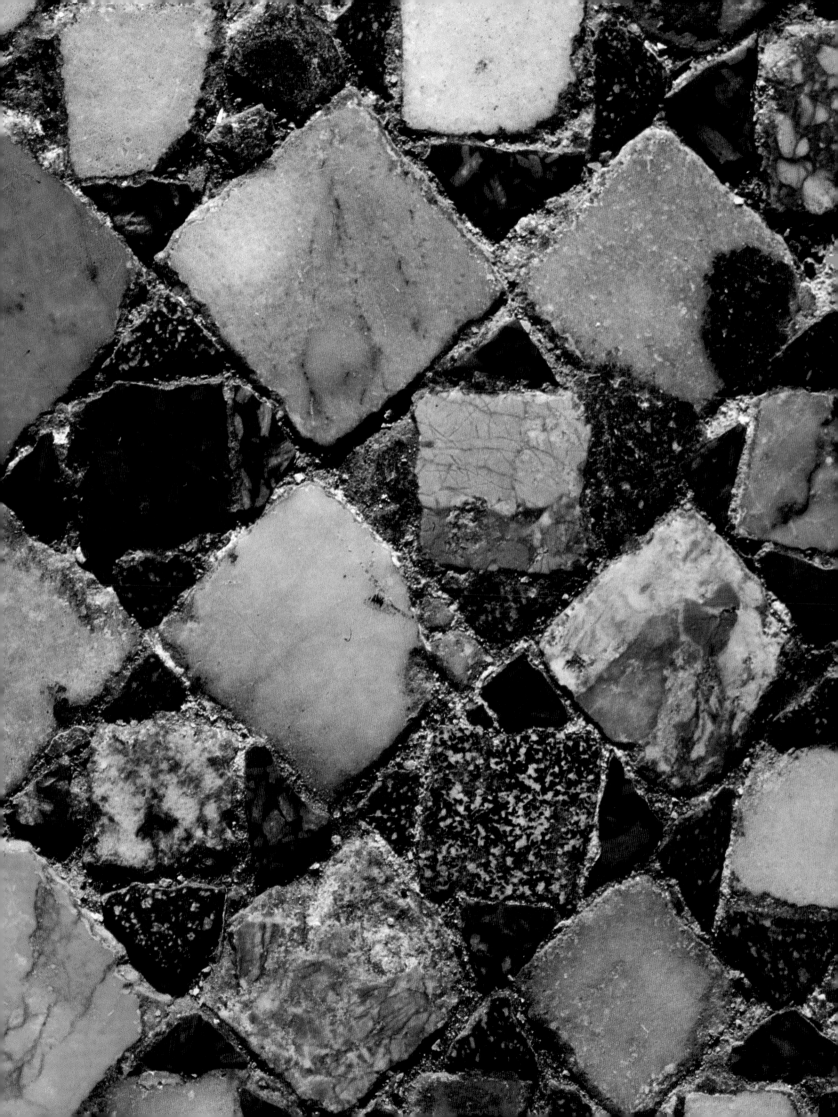

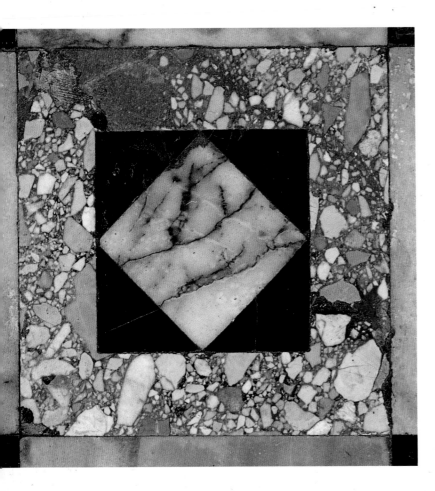

Above The floor of the church of Santa Maria dei Miracoli, built in the 15th century, is a precious carpet of lozenges, enriched by cipolin marble from Greece and Carrara, as well as rose-tinted and black marble from Verona and Iseo.

Preceding pages and opposite The mosaics covering the floor of the Basilica of San Marco, made between the 11th and 18th centuries, form a complex geometric design in rare marble and semi-precious stones that transfigures the architectural space.

to eat', which still links the *sestieri* of San Marco and Castello and which most probably got its name from the legendary intercession of a miraculous image of the Virgin Mary, which earned a pardon for a seller of dried pulses who had been convicted of salt smuggling. The *Ponte della Paia* (straw), 'for which a pitchfork is rarely needed', made originally of wood, then rebuilt in stone in the second half of the 14th century and doubled in width in 1854, was so named, if we believe the *Savina Chronicle*, because boats laden with straw used to dock here; it also links the *sestieri* of San Marco and Castello. Although it was well known for the drowned corpses which were laid out there for identification, it also recalls the distant Venetian memory of the wonderful ceremony of the 'delivery of the ring', and the story of when the patron saints of Venice gave a poor fisherman the task of bringing to the Doge the ring of St Mark. The *Ponte delle Berrette* or *dei Bareteri* (caps), 'which nobody puts on their head', leads to the haberdashers' district where headgear was made. Built of stone in 1508 and later restored, it served to speed up the flow of people by sending them off in five different directions, much like the shape of a fan produced by the skilful fingers of the lacemakers of Burano.

The *Ponte delle Ancore* (anchors), 'which are not used for boats', and the *Ponte degli Assassini* (murderers), 'who are never hanged', are both difficult to identify today. However, the *Ponte del Asedo* (vinegar), 'which nobody

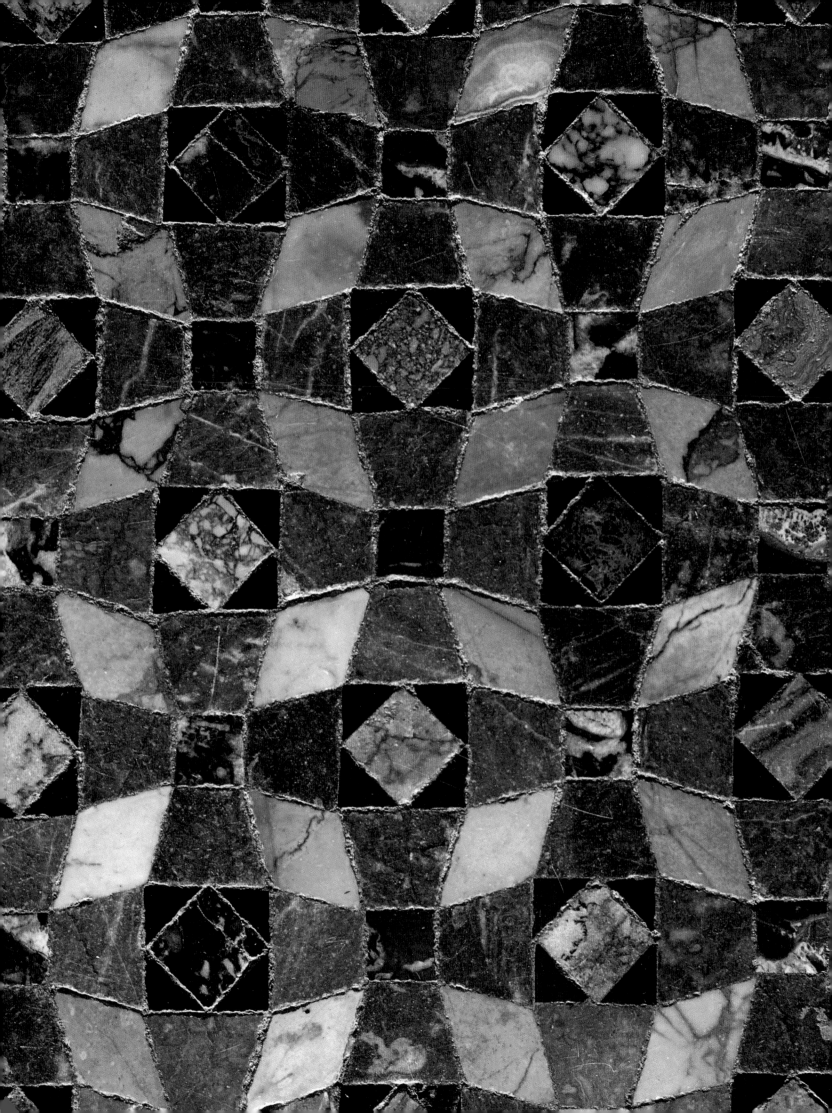

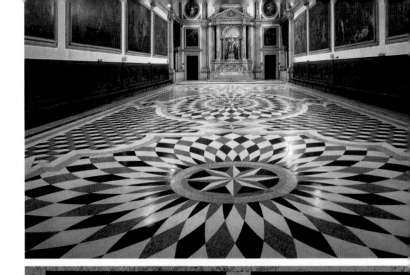

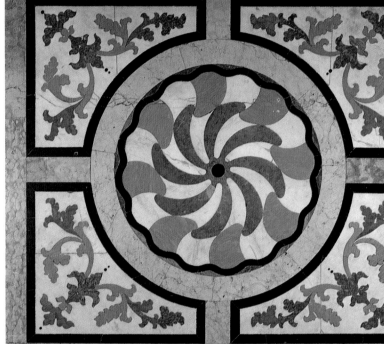

... every fragment is in itself variegated, and all are arranged with a skill and feeling not to be taught, and to be observed with deep reverence....

RUSKIN, *The Stones of Venice*

58

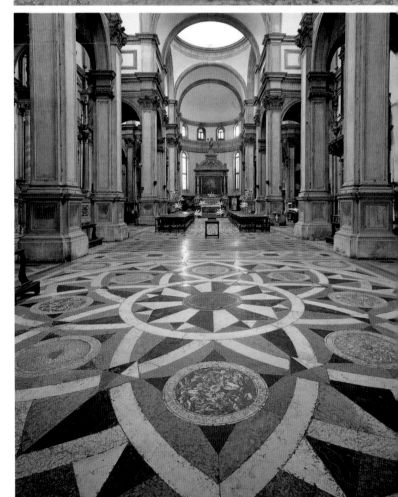

consumes', still stands on the Fondamenta degli Ormesini, near a former well-known vinegar maker. The *Ponte dei Fuseri* (spindles), 'which nobody spins', leads us immediately after the Campo San Luca towards the Frezzeria, and probably owes its name to the proximity of nearby weavers; and the *Ponte di Dai* (dice), 'which gamblers don't throw', shows off its complicated form behind the Procuratie Vecchie, the Old Procurators' Palace, in Piazza San Marco, welcoming the gamblers who were able to buy their dice in a nearby shop. And finally came the *Ponte della Latte* (milk), 'which nobody drinks', *dell'Agnello* (lamb), 'which is not butchered', and *di Cavalli* (horses), 'which nobody hires', which linked the *sestieri* of Santa Croce, San Polo and Dorsoduro. All of these have misleading names, since they have no connection with trade or commerce, but refer instead to the names of families who resided in the area.

In 1581, Francesco Sansovino wrote in his book *Venetia città nobilissima* that there were '450 bridges, if not more, in stone', a figure undoubtedly leaning towards exaggeration. However, *Venezia e il suo estuario*, the renowned guidebook written by Giulio Lorenzetti, first published in 1927, mentions only 175, while Giannina Piamonte, in her *Venezia vista dall'acqua* (1963) counted 409, of which 56 were private, that is to say leading to individual dwellings or warehouses, and 9 lacked steps. Tiziano Rizzo's 1983 publication, *I Ponti di Venezia*, lists 72 private bridges, while Giampietro Zucchetta gives a

Above The ancient mosaics on the floor of the Basilica of San Marco are very different from later styles.

Opposite, from top to bottom The 18th-century floor of the Scuola Grande di San Giovanni Evangelista by Giorgio Massari; that of the Palazzo Pisani Moretta, laid at the same time to a design by the painter Francesco Zanchi, using yellow marble from Mori, black marble from Iseo and red marble from Cattaro; the floor of the church of San Salvador was laid in polychrome marble during the second half of the 17th century.

59

total of 437, of which 90 were private, in his 1992 book, *Venezia ponte per ponte*. Although this last figure is probably the most reliable, a purely quantitative analysis is of no real interest for our purpose, since it includes a great many bridges built in the 19th and 20th centuries, after the fall of the Venetian Republic, when there was a campaign to fill in a great many canals, and thus excludes many of the older bridges which were demolished during the extensive works that were undertaken to attach Venice to the mainland, a master plan that also involved the building of rail and road links. This plan, which permanently joined Venice to Mestre, deprived the city of much of its distinctive insular character. The wooden bridges have rotted away and no longer creak beneath our feet; and there are very few remaining that have steps with carefully inlaid tiles of finely modelled

Opposite In the 18th century, elegant floors were made from *terrazzo alla Veneziana*, a technique mixing stucco, marble tesserae and other natural stones of different consistencies, in order to obtain a malleable and light composite that was well suited to the flexible foundations of Venetian buildings. Here, the *semina fina* (meaning 'fine seed') technique uses incorporated fragments of Delft ceramics to embellish the salons of the Palazzo Querini in San Barnaba.

Left Flowers form part of the geometric pattern decorating the 18th-century *terrazzo* floors of the Palazzo Barbarigo in Santa Maria del Giglio and the Palazzo Pisani Moretta in San Polo. The flowers in black Iseo marble stand out against a background of white stones which, in turn, are set in a framework of lozenges made from the yellow marble of Torri.

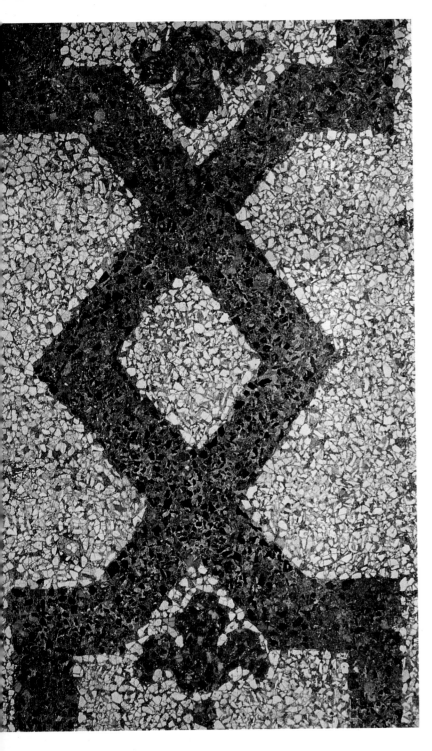

clay, skilfully baked and often arranged in highly sophisticated geometric designs, or made of fragments of fireproof stone from the hills of Montecchio, near Vicenza, much in demand for its coal-black colour. Parapets, when they existed, consisted of slender marble columns or openwork slabs of friable stone from Nanto. Today, it is the large slabs of *masegne*, or grey stone, and the iron volutes of the guardrails that dominate this aspect of the Venetian landscape, although they do not detract from its inescapable elegance.

The bridges are like tiaras that have been modified over the years; as time has passed, the type of stones that are used has changed, as has the rhythm of the steps, causing one to go up and down them differently. The curve of their arches has become more pronounced or less; their parapets, made up of narrow shafts or ornamented with spiral, diagonal or star shapes, have also seen many changes. But all these bridges continue to span the ring of solid *fondamenta* which, plunging into the waters of the open lagoon, encircle Venice with a veritable city wall, albeit an absent or invisible one, its straight, concave or convex banks covered in stone slabs of varying shapes and sizes, whose divergent, convergent, right-angled and labyrinthine segments mingle with the two colours of the stone surface.

The Riva degli Schiavoni stretches from the Piazza San Marco and the Piazzetta towards the red ramparts of the Arsenal which grew up near the wide basin of the

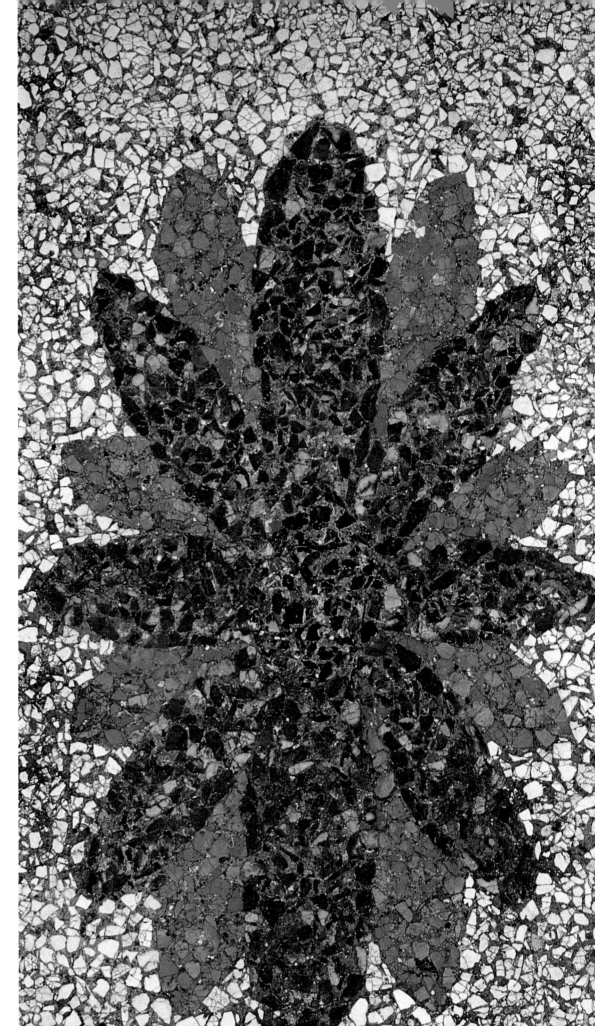

These pages and overleaf
The sumptuous 18th-century
floor of the *salotto del doge* (Doge's
salon) in the Ca' Tron in San
Stae, an area of nearly ninety
square metres, is covered in
exquisite plant motifs, creating a
priceless carpet of flowers. In an
unparalleled feat of technical
virtuosity, chromatic contrasts
are created by the juxtaposition
of such different materials as
Bardiglio marble, lapis lazuli,
and red, yellow, green and black
marbles from Cattaro, Torri, the
Alps and Iseo respectively.

lagoon, hiding the subtle line of distant *lidi*, or offshore beaches, on the horizon; it was here that the Bucintoro, the great State barge, once reigned. The Zattere stretch from the tip of the Molo, where there were once warehouses filled with precious salt, to the new port with its deafening noise and frenetic activity, from where one can contemplate the nostalgic spectacle of the Giudecca with its Palladian temples. Finally, there are the Fondamenta Nuove, so cherished by Canaletto who loved to paint the paved surfaces of Venice; they look out to the cypresses of the cemetery island of San Michele and the glistening white cupola of its church, made of plaster mixed with lime, and beyond it to the brown line of the glass-blowers' furnaces of Murano, where the watery plain fades on the horizon into a sky streaked with flights of marsh birds.

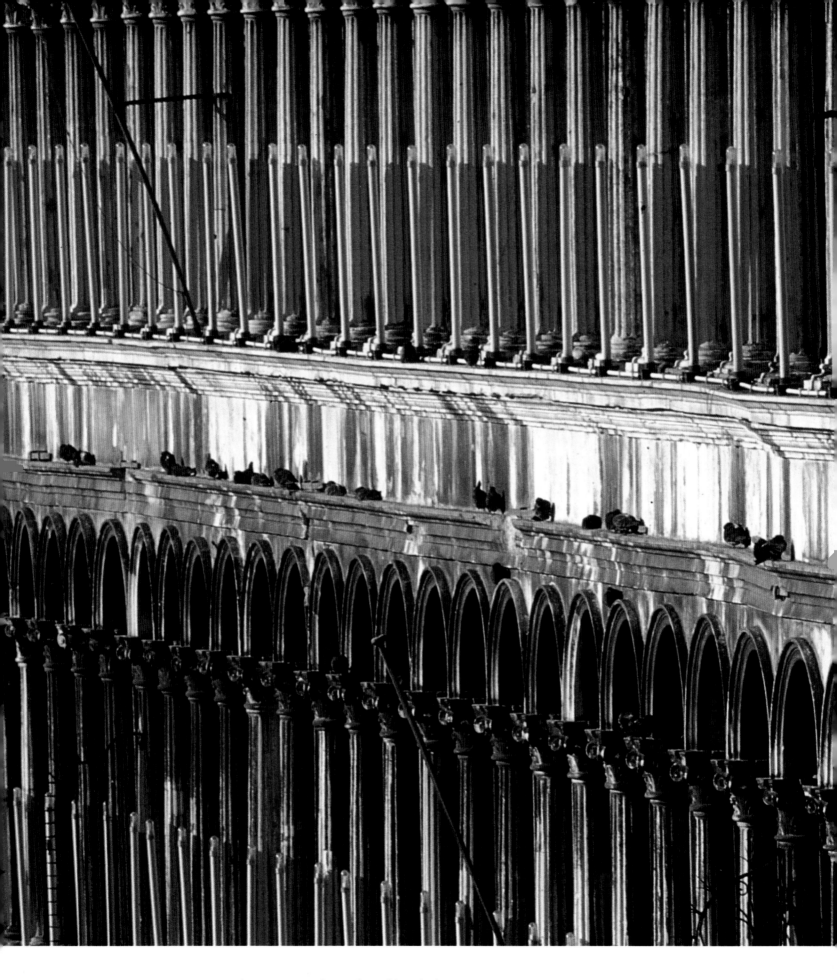

No architecture can be truly noble which is not imperfect. RUSKIN, *The Stones of Venice*

Surrounded by Stone

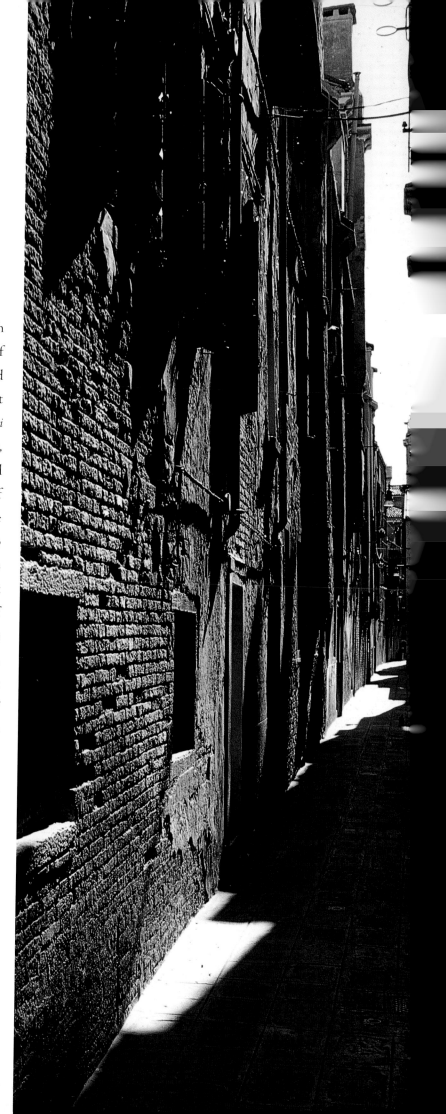

All this fabulous display (in which the destiny of each
stone seems so clearly defined) is obviously the result of
the integrity and virtuosity of artisans who inherited
age-old skills along with an unerring taste for elegant
and free forms. Countless generations of *terrazzeri*
(navvies), *marangoni* (joiners), stonecutters and architects,
masters of all the secrets of stone – both newly quarried
and reworked – humbly obeyed the idiosyncrasies of
this unrivalled *genius loci*, which so perfectly upheld the
myth of Venice in all its grandeur. But Venice could also
take advantage of the technical knowledge and rigorous
controls set in place by its magistracies, which were set
up to serve the needs of the city. These magistracies of
justice were beholden to the *Provveditori di Comun e al Sale*
(responsible for wool, communication routes and salt),
to the *Giudici del Piovego* (judges or protectors of public
places), to the *Savi Esecutori alle Acque* ('wise executors of
the waters'), to the *Provveditori all'Arsenal* (responsible for
the Arsenal), and, after the fall of the Republic, to the
Commissioni all'Ornato, who were the equivalent of a
public body responsible for bridges and streets. These
included *officiales supra canales, rivos, piscinas*, as well as *super
pontibus et viis* (in other words, the officials responsible for

The walls that enclose the stone garden, a true *hortus conclusus*,
are an essential part of the city. The different colours of stone
animate the surfaces and a clever transformation of raw materials
makes the walls become elusive, almost invisible.

All good colour is in some degree pensive, the loveliest is melancholy, and the purest and most thoughtful minds are those which love colour the most. RUSKIN, *The Stones of Venice*

70

The fact is, that, of all God's gifts to the sight of man, colour is the holiest, the most divine, the most solemn. RUSKIN, *The Stones of Venice*

keeping clean the canals, waterways, and pools, as well as bridges and streets), and the *Signori di notte* (responsible for safeguarding the city at night) and the heads of the *sestieri*, the six different districts of the city.

The building of the Rialto Bridge attracted a wealth of talent, with Michelangelo, Vignola, Palladio and Scamozzi all competing for the project in vain. For many centuries the Republic took the greatest care to look after this bridge and ensure its preservation, since, in their eyes, it was highly symbolic as the only means of crossing on foot the vast waterway which separated the two urban centres of Venice. As the Scalzi and

Even here, chromatic contrast is essential. It is created partly by the use of different shades of marble, both newly quarried and recycled; of limestone from places once ruled by the mainland, such as Istria; and of brick that was often once covered by frescoes. Most importantly, the contrasts of colour result from the juxtaposition of different materials, and are inextricably linked to the exquisite effects created by the ephemeral reflections of the water and the subtle chiaroscuro variations of Venetian light.

71

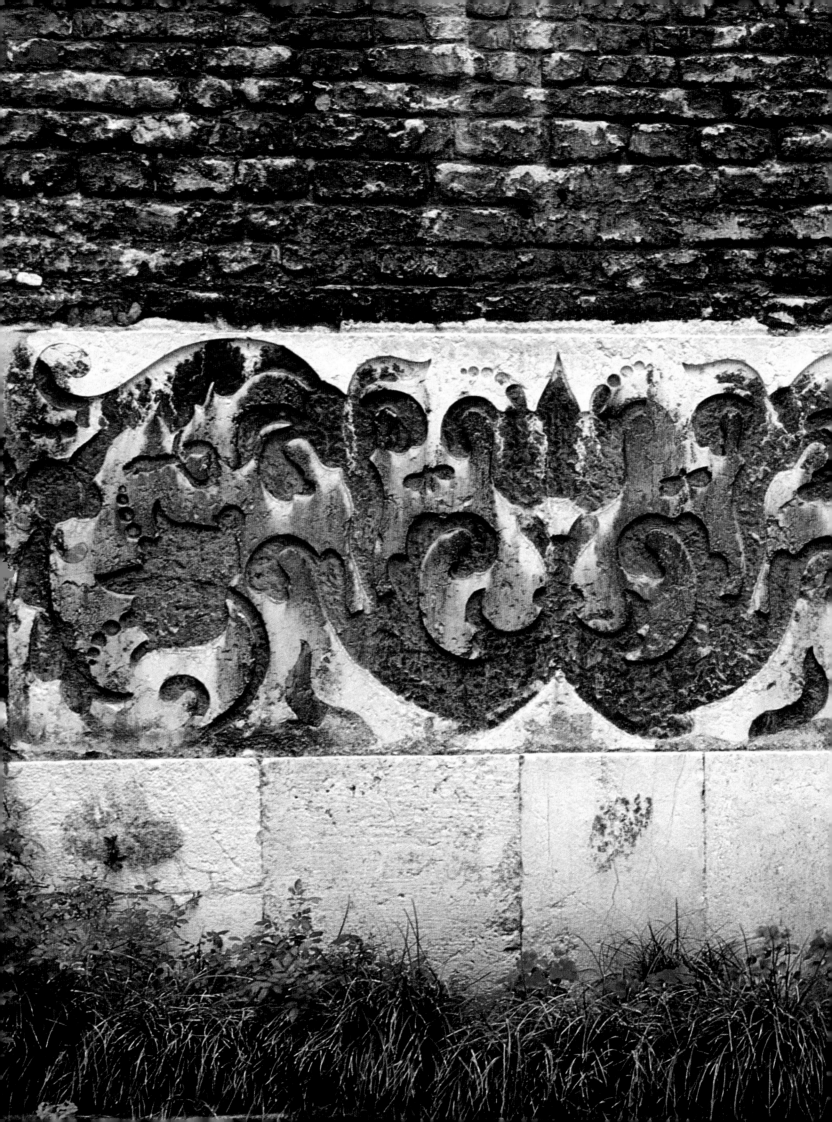

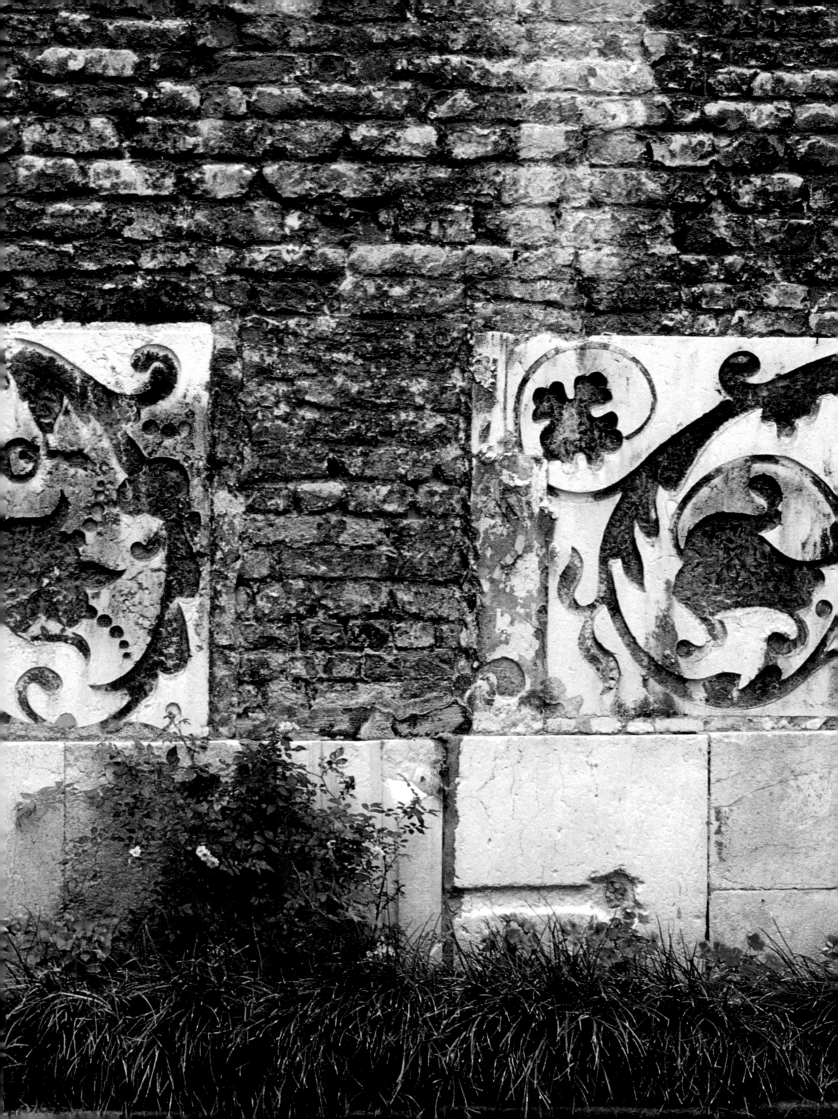

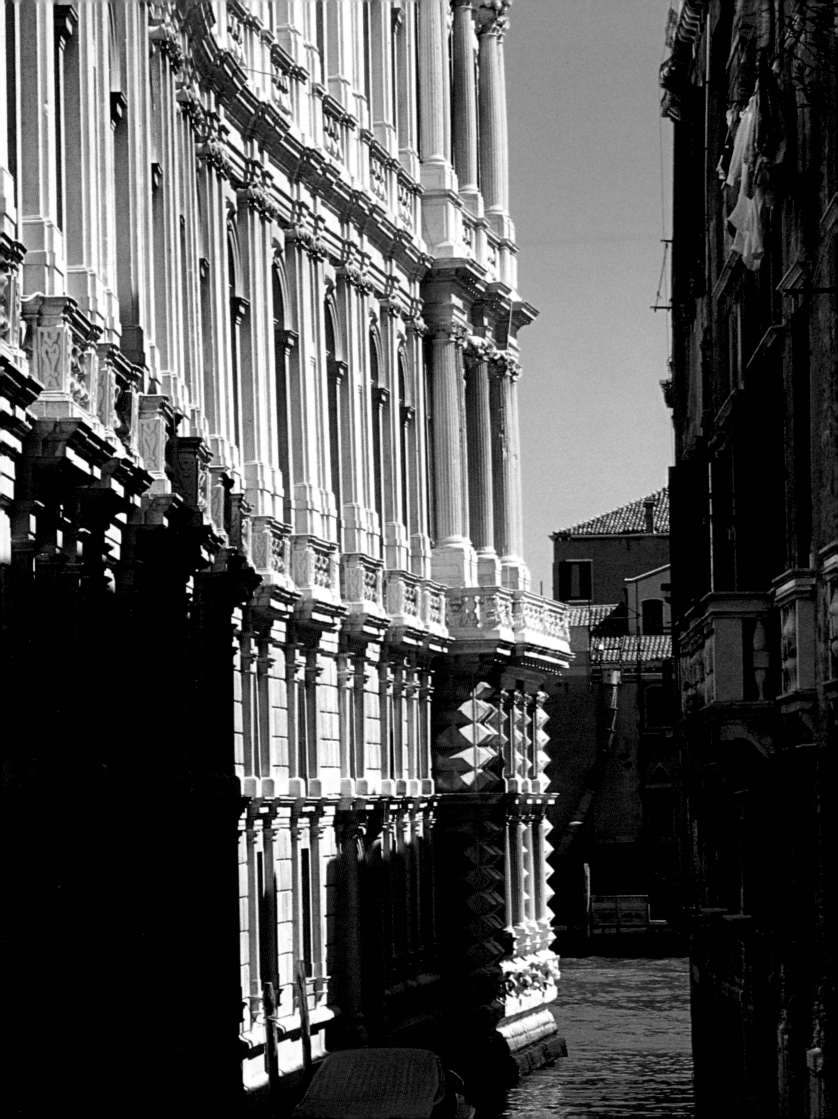

Accademia bridges were not built until much later, for a long time the Rialto Bridge was a tangible symbol of the unity of the *Civitas Venetiarium*. It was for this reason that *La Serenissima* wanted the bridge to be a 'grand affair made of stone, fully ornamented and beautiful', in accordance with the principles of Vitruvian and Albertian harmony and their notions of *firmitas* (stability), *utilitas* (usefulness) and *venustas* (great beauty). On both its smooth outer surfaces and the under-curve of its arch are images of the patron saints of the city and scenes of the Annunciation, all harking back to the founding of Venice and the wise premises of its myth. Its grand central staircase, which brings to mind the *Scala dei Giganti* (Giants' Staircase) in the courtyard of the Doge's Palace, beckons us on to what appears to be a never-ending ascent, inspiring feelings of apprehension and dizziness more befitting an ascent to heaven. But the earthly climb is lined on both sides by small workshops, their eaves covered with sheets of lead sagging between light wooden ribs. Narrower side ramps, flanked by

The walls, although made of stone, breathe like the thick undergrowth of a forest, allowing the subdued voices of those who live there to filter through them in the twilight hours. Given life by decorative shapes, colours and chiaroscuro effects, the walls become towering and inaccessible cliffs that shelter curious creatures, as seen on the side wall of the Ca' Pesaro (**left**), built by Baldassare Longhena and Antonio Gaspari in the 17th century.

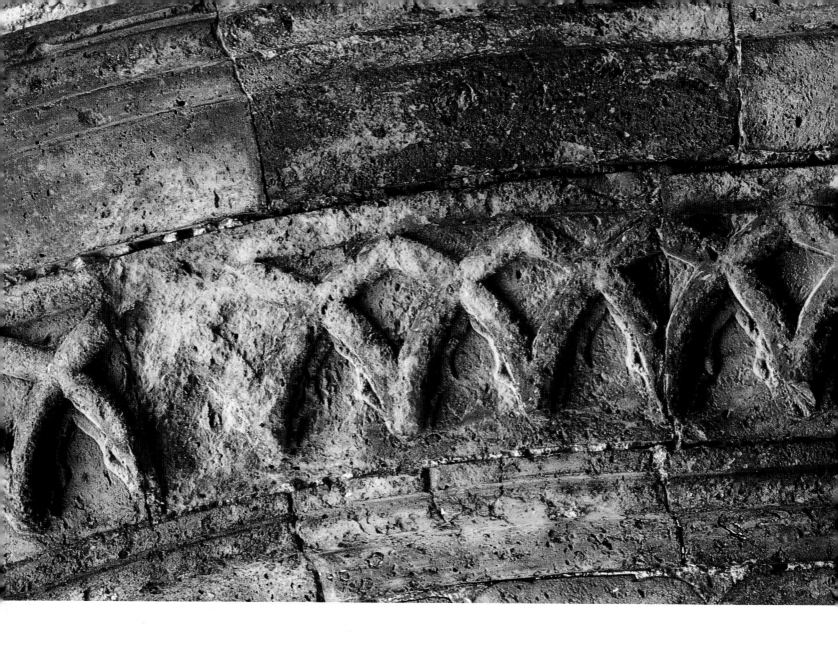

balustrades surmounting a sweeping cornice, encourage the visitor's gaze to roam outwards and come to rest on the facades of the nearby buildings. On either side of the canal, the buildings soar as high towards the skies as their reflections plunge deep into the cloudy mirror of the rippling waters below. Immediately adjacent are winding streets that link the palace once belonging to the *Camerlenghi*, or city officials, to the portico of the Fabbriche Nuove which tightly abuts it, up to the point where the Erbario widens out, and to the rose-coloured and asymmetric facade of the church of San Giacometto, its roof resting on delicate columns that cast a white halo on the grey *masegne* parvis.

The area around the islet that includes the houses of San Bartolomeo and the massive palace of the Fondaco dei Tedeschi (whose facade was frescoed by Giorgione) used to be teeming with craftsmen; it was a place where everybody could find what they

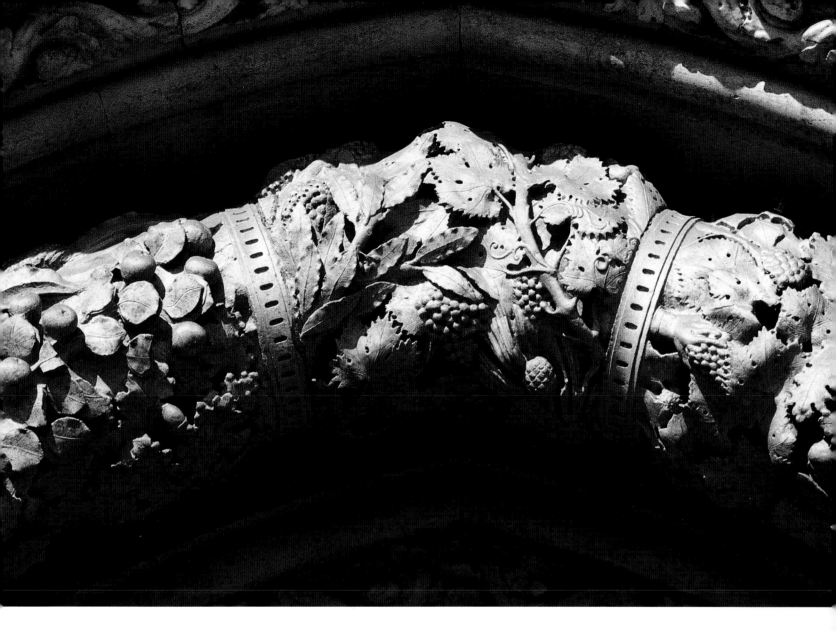

were looking for. For example, it contained the *Ruga degli Orefici* (goldsmiths' street), the *Ruga degli Spezieri* (grocers' street), the *Campo delle Beccarie* (butchers' square), the *Calle dei Botteri* (coopers' street), the wine alley where the precious sweet wines of Crete were sold, and an alley selling oils pressed from sweet almonds. There were also the many hidden-away and obscure places where one could go to *sulimar l'acquavita*; here, different liqueurs were distilled by a laborious process involving sulphur, arsenic and vermilion-coloured cinnabar. These strange little places were surrounded by *furatole di bievaroli* (small wheat shops), *pistori* and *forneri* (pastry makers and bakers), *casaroli* (cheese makers), *luganegheri* (pork butchers) and *frittoleri* (sellers of various fried confections). Then, there were the *lasagneri* and *scaletteri* (pasta makers and cake sellers), street stalls where the *strazzaroli* (ragmen)

Above Venetian buildings are often decorated by festoons of fruit, vine shoots, laurel wreathes and many other plants – fit for the earthly paradise that the city claims to be. The sumptuous, late Gothic porch of the church of Santi Giovanni e Paolo is a wonderful example.

Left The arched lintel of the 13th-century porch of the Casa Bosso in San Tomà owes its beauty to the regularity of its geometric lines.

77

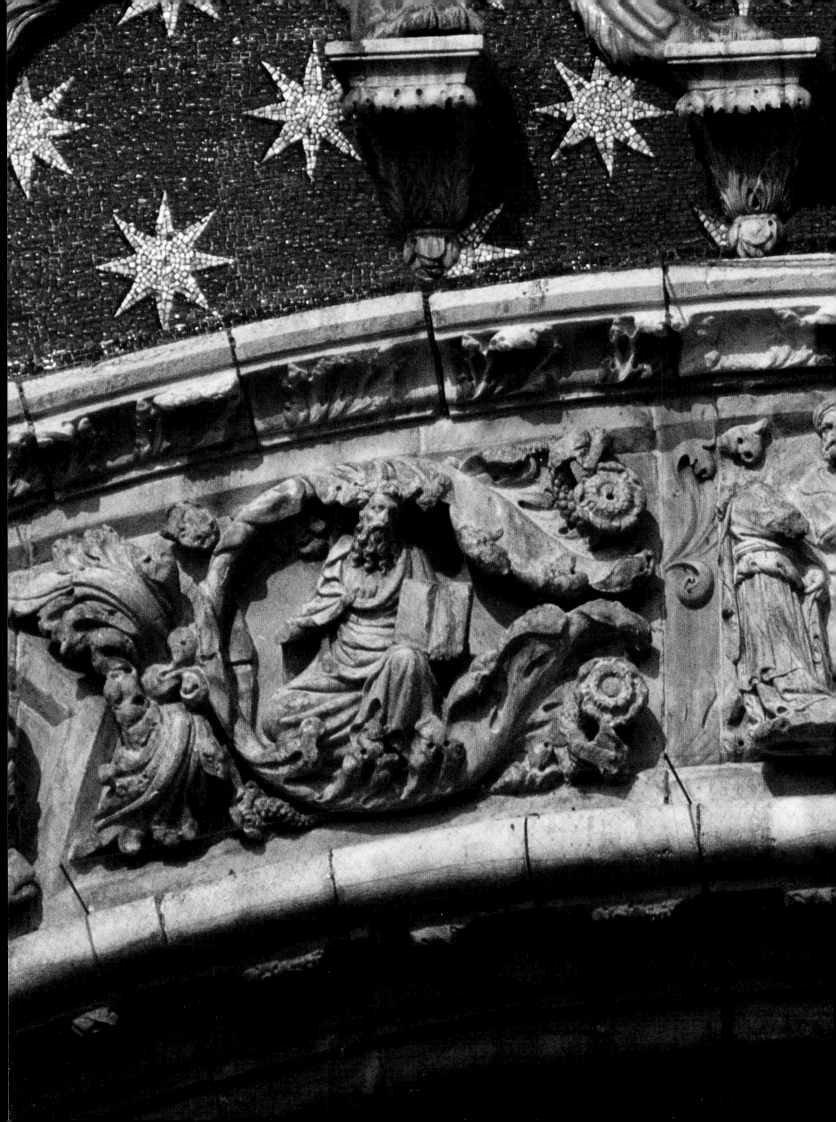

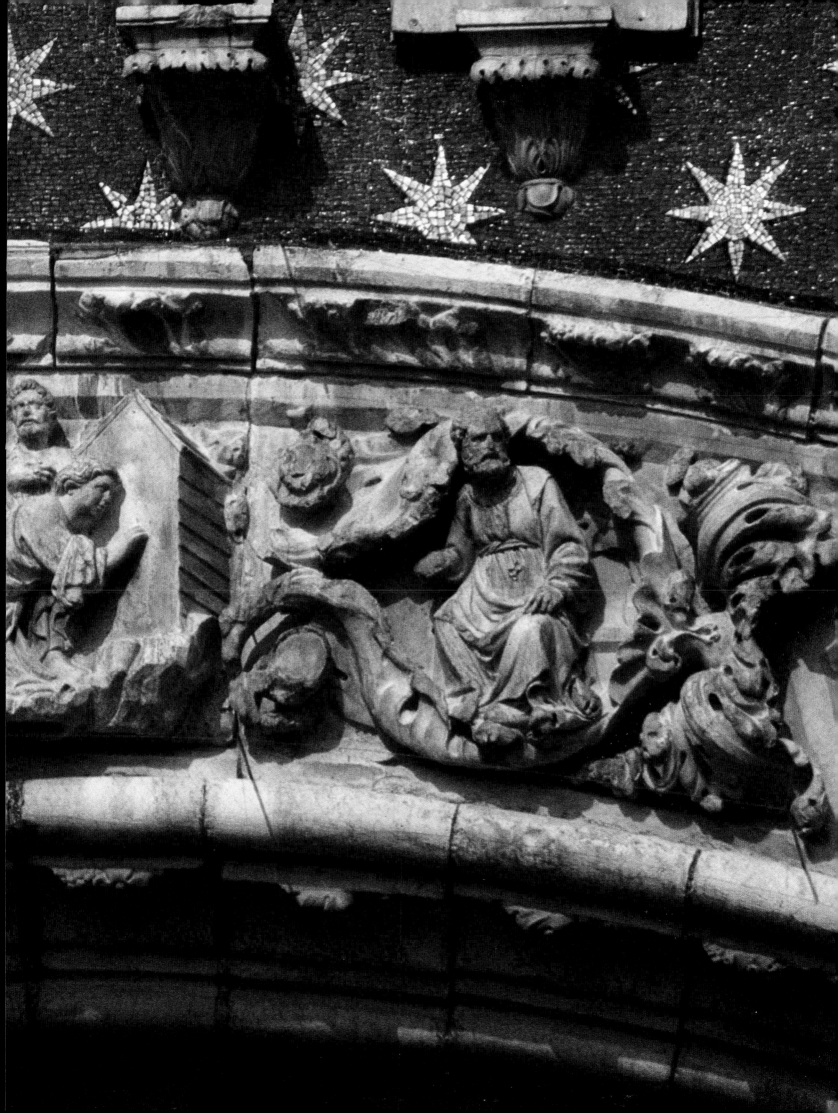

displayed their wares, alongside *fustagneri* and *linaroli* (fustian and linen merchants), *maschereri* and *fenestreri* (mask makers and window makers), *fioreri* (florists), *margariteri* (pearl sellers), blacksmiths' workshops, and the *marangoni* and *carboneri* (both sellers of different types of coal). Also in the area were the famous inns bearing the names and standards of the Paradise and the Sturgeon.

Rivalry and competition flourished, with quarrels exploding regularly since, as the Venetian merchants complained, 'for a long time, many foreigners from different countries have attempted to sell merchandise on the Rialto Bridge or in Piazza San Marco. They display their wares on benches or in unauthorized shops, on both feast and work days, which is destroying our merchants' profession.' But soon the death knell would ring, ending the successful thousand-year-long history of the Venetian Republic,

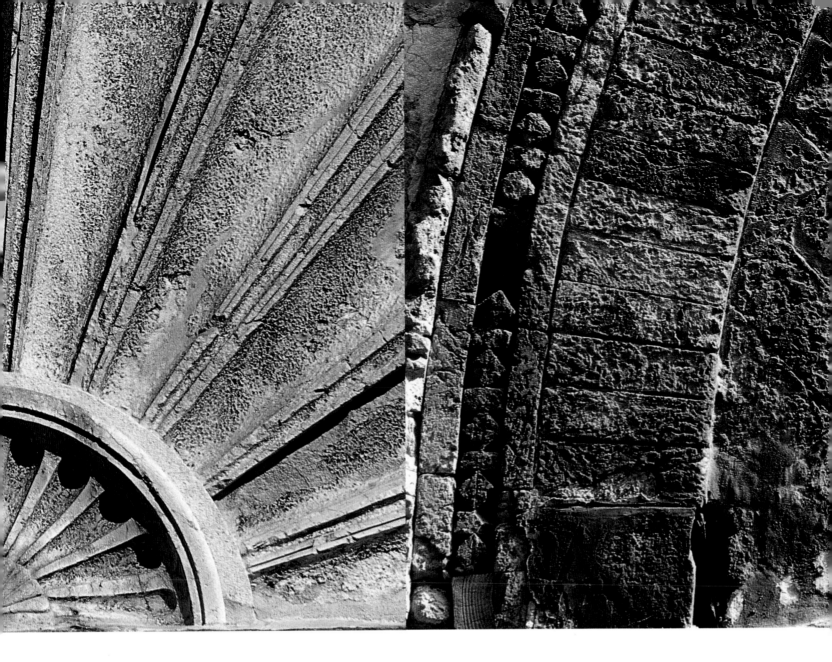

a catastrophe that would destroy the illusion of eternity created by the city's myth. International visitors would begin to flood into the city and this new breed of traveller had demands and appetites which nothing ever seemed to quench.

Francesco Sansovino, whom we have already mentioned, wrote in his celebrated book *Venetia città nobilissima*: 'As our people wanted to demonstrate unity and equality in all things, houses were built of the same height, following the Dula law. But once wealth accumulated through commerce (always the lifeblood of this Republic), building heights fell or rose according to the greed of those who built them,' and

Left For the pointed lunette of Ca' Magno in San Luca, an anonymous Byzantine architect designed a scheme in which the warm colours create a shimmering effect across the brick surface.

Centre The Istrian stone that Andrea Palladio used for the porch of the church of San Francesco della Vigna gleams as brightly as the sun's rays and makes the porch seem less solid.

Overleaf A detail of a French-style 14th-century bas-relief in the lunette of the Casa Corner Foscolo in Santa Margherita shows a naturalistic chessboard on which imaginary games are played.

81

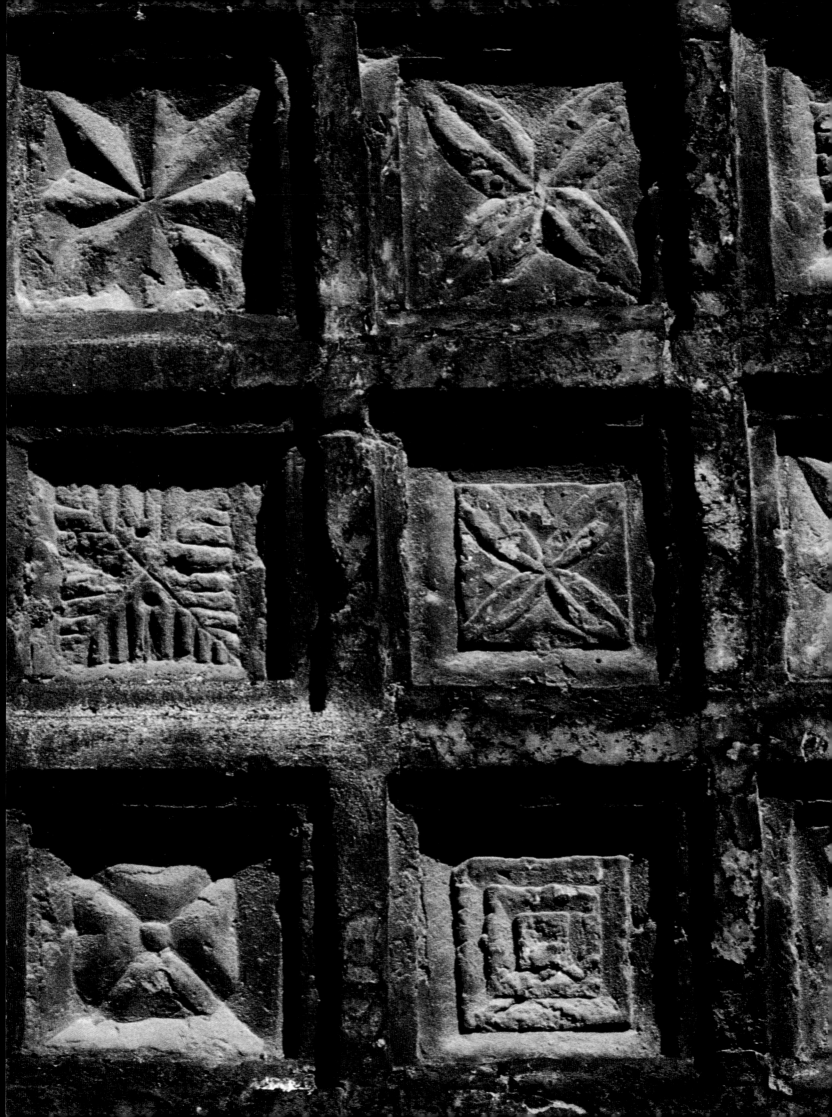

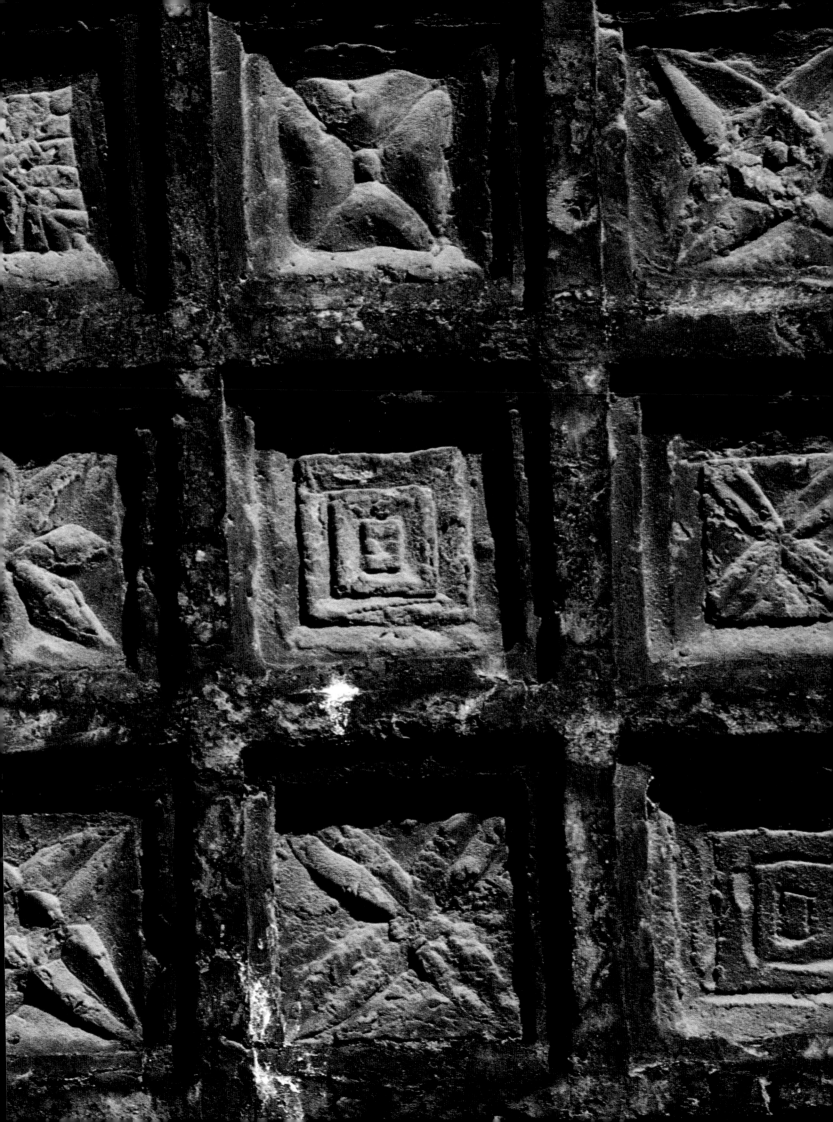

... the effective disposition of the light and shade, and in the vigour and thoughtfulness of the touches which indicate the plumes of the birds or folding of the leaves. RUSKIN, *The Stones of Venice*

Above A Roman tombstone, inset into the base of the bell tower of the 13th-century church of San Vitale gives a sense of antiquity. Venice was determined to demonstrate that it was more ancient than Rome itself, and this relic is a witness to the fact that Venice was *alterum Bisantium, altera Roma,* and, to assert its Christian importance, *altera Hierusalem.*

Right The ear of corn sculpted in delicate Carrara marble on the porch of the church of Santi Giobbe e Bernardino in Cannaregio was also intended to recall the ancient world.

this is why the houses vary enormously in size. Whether overlooking the Grand Canal, bordering a *campo* or *campiello*, or lining the narrow length of a *calle*, every house displays unbridled creativity in terms of ornament, which might be seen as excessive were it not for its implacable sense of order and dignity of form. These buildings also bear witness to an imagination inspired by the presence of ghosts that lurk in the dark abyss of the city's dreams. We can see this on the facades, which use an eclectic language that mixes Byzantine, Gothic Classical, Baroque, Rococo and Neoclassical visual vocabularies, all bathed in a diffuse, dappled and iridescent light.

From the banks of the great watery passage of the Grand Canal, one could, of course, watch the transit of huge vessels, overflowing with the most diverse selection of goods, on their way to the Rialto warehouses. This is also a place from which to observe gondolas making pleasure trips, gliding through the velvety softness of the water to the mechanical rhythm of an oar being pushed through a *forcola* or rowlock. But these shores were once also a stage on which competition and rivalry – even treachery – were played out in terms of architectural exhibitionism. It is well known that even when displaying the greatest feats of daring, these buildings were never supported by solid foundations but relied on crumbling and sinking sand embankments for their stability. In fact, the heavy masses of brick

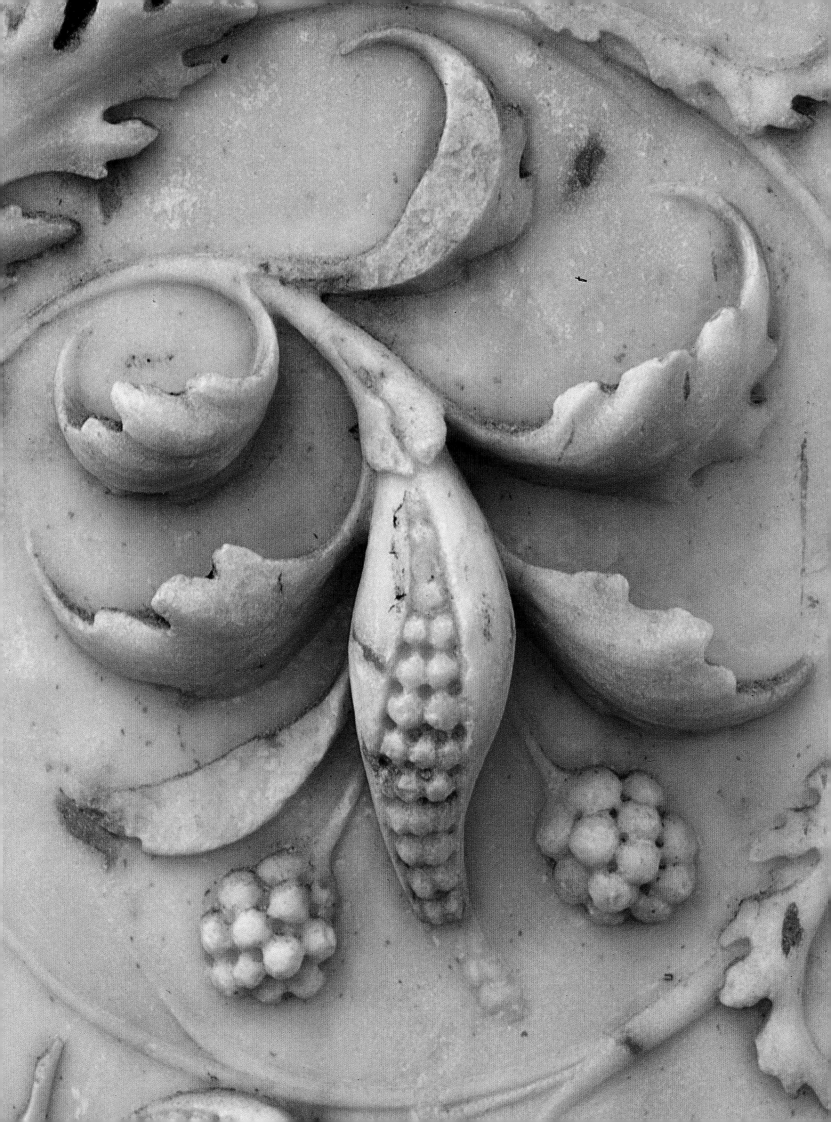

For the finer the nature, the more flaws it will show through the clearness of it....

RUSKIN, *The Stones of Venice*

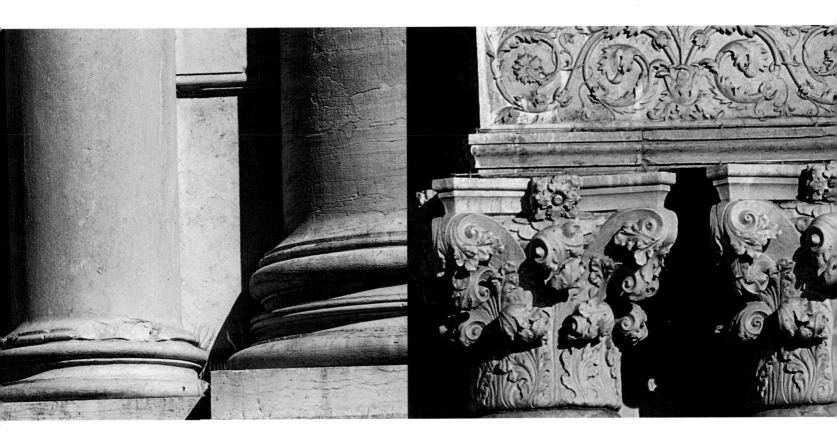

and stone could only be supported by an indirect type of foundation. Stakes were pegged in to the sand to support a solid platform on which, in turn, the structural walls of buildings were erected before the lavish decorative elements were added to the palaces. At first, unsurprisingly, Ducal residences and the palaces of the magistrates who safeguarded the wisdom the State served as prototypes for other buildings, although there was no need to imitate them slavishly. The buildings all adhered to a system known as *platea*

Left to right From the bare brick of the unfinished facade of Jacopo Sansovino's Scuola Grande della Misericordia to the decorative exuberance of the exterior of Ca' Pesaro, from the formal severity of the Palladian facade of San Francesco della Vigna to the rose-tinted marble foliage on the porch of the church of Santi Giovanni e Paolo, everything adds to the variety and richness of Venice's stone garden.

Overleaf The intricacy of the stonework is even more remarkable in the details of the porch of the church of San Polo, where different materials take on the most astonishing appearance.

87

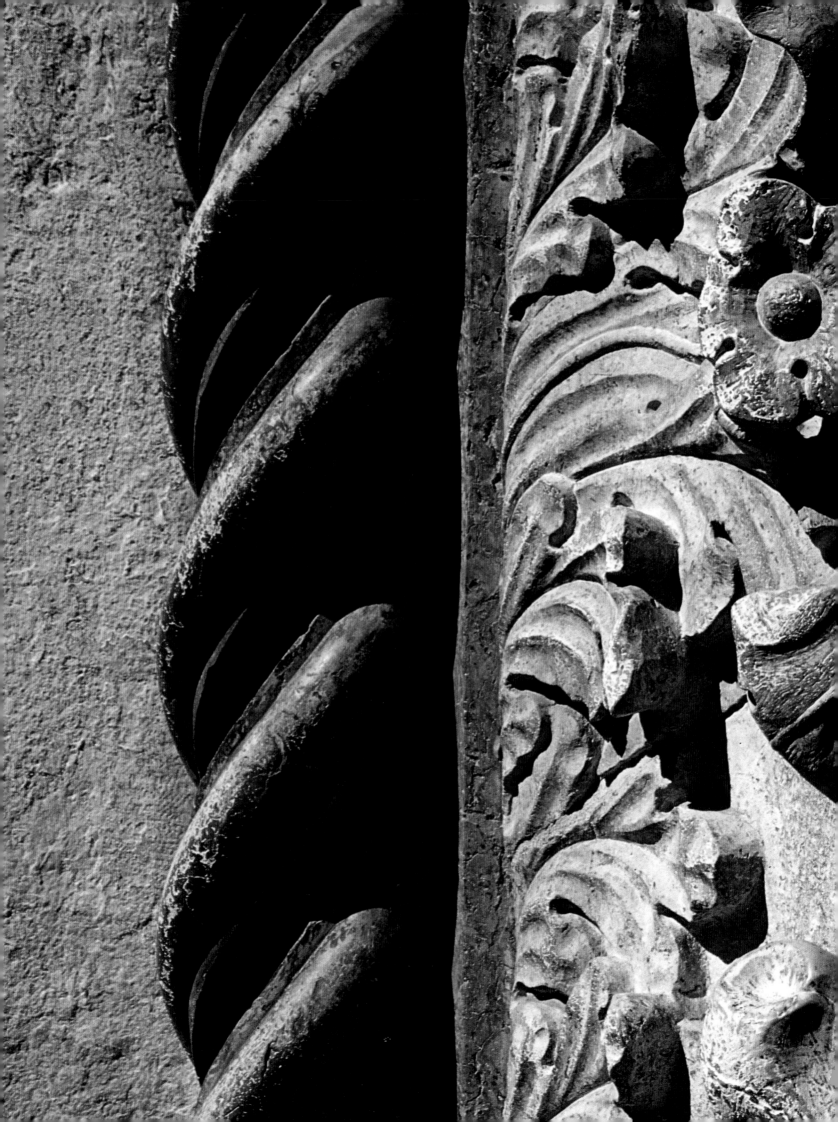

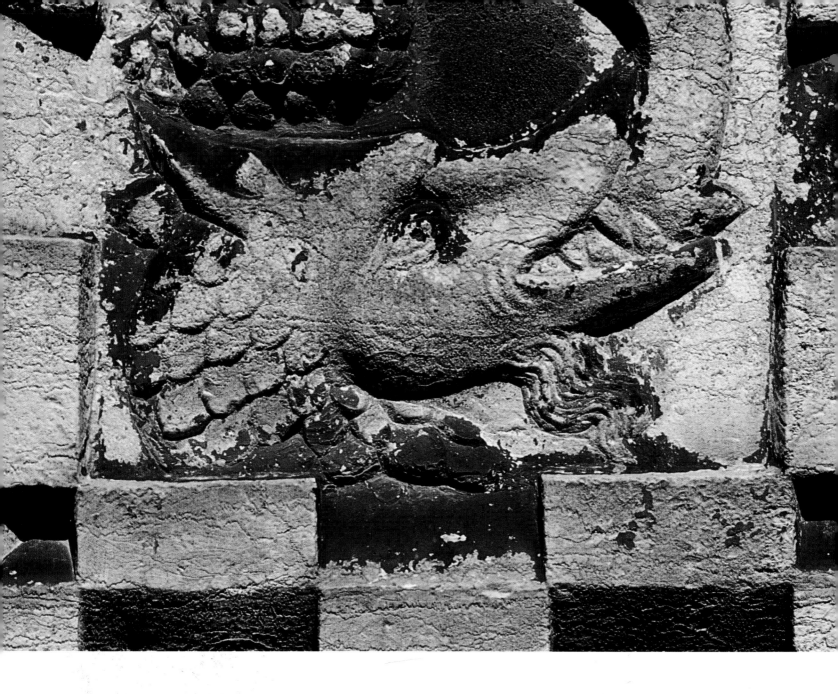

divi Marci Venetiis which Francesco Bertelli, in one of his 18th-century engravings, firmly attributes to Jupiter, thereby adding a further layer of complexity to the myth of *La Serenissima*. Jupiter is reputed to have said to the gods: 'Prepare yourselves to see what I am adding to the seven great wonders of the world.'

According to legend, Filippo Calendario is the man responsible for cladding the Doge's Palace, built between 1340 and 1434 and preserved intact throughout the centuries due to meticulous restoration and continual repair work, after an earthquake reduced it to rubble and several fires blackened it with smoke and ashes. Calendario was also responsible for very capably and competently directing an armada of *marani*, fast ships, which transported from Istria the enormous blocks of stone that were used to

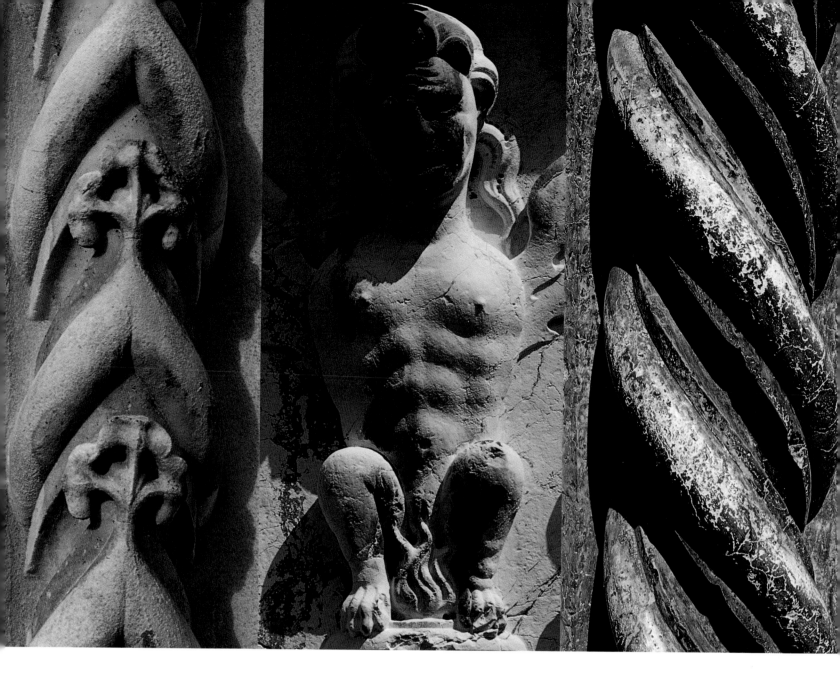

build solid dykes on Venice's *lidi* to protect the city from the storms which were continually threatening to devastate it by churning up the calm waters of the lagoon. However, deeply dissatisfied with himself, Calendario became an accomplice of Marin Faliero, and plotted against the State, ending his days reduced to silence after having his lips sewn together with iron thread. He was hanged between the two large red columns at the entrance to the Piazzetta. On the same ill-fated day, the bells of Venice rang out to mark the decapitation of Faliero, a prince guilty of treason. After the head had been severed, the corpse of Faliero – the instigator of the

Left to right A dragon biting its own tail, the symbol of eternity, in the lunette of the Casa Agnusdio; an elegant flowering stem growing up one of the jambs of the church of the Frari; the cryptic 'lady on fire' on the Palazzo dei Camerlenghi; and the twisted braid on the church of Santi Giovanni e Paolo: all these give the stone a magical quality, as if under the spell of some unknown demiurge.

Overleaf This worn and worrying face in Istrian stone looks out from the side wall of the church of San Martino di Castello.

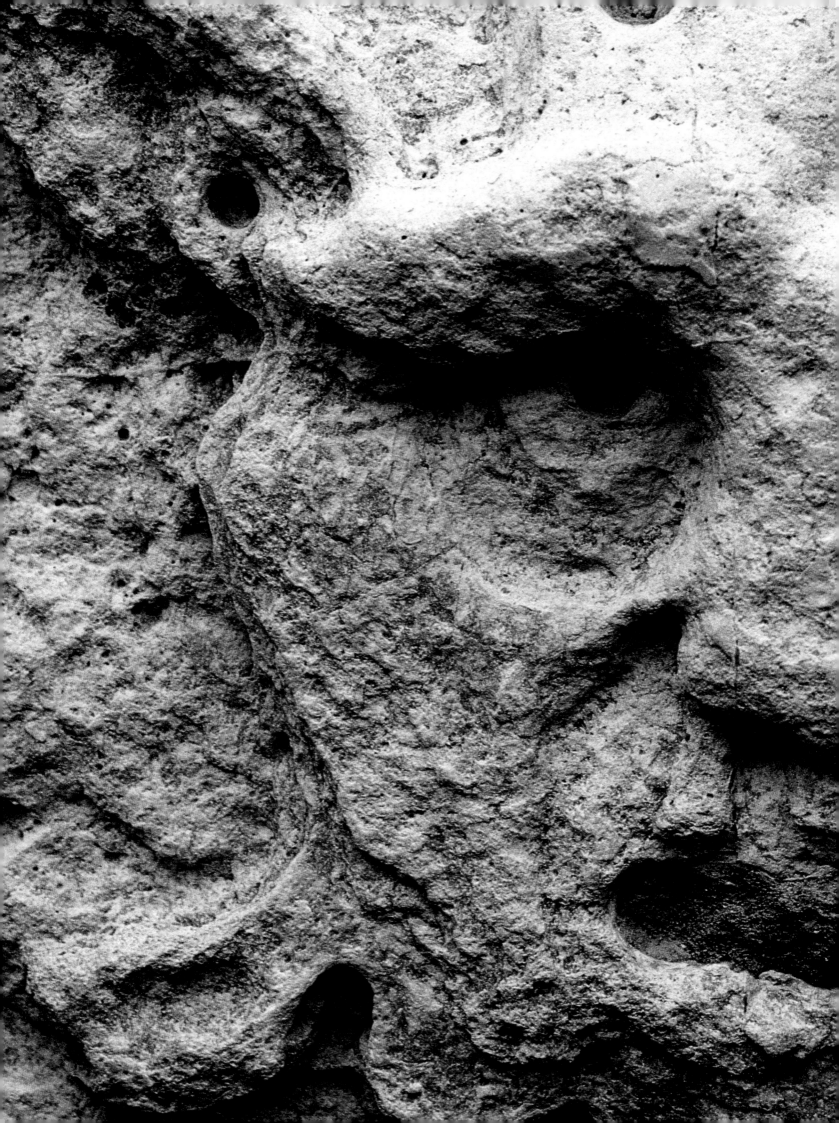

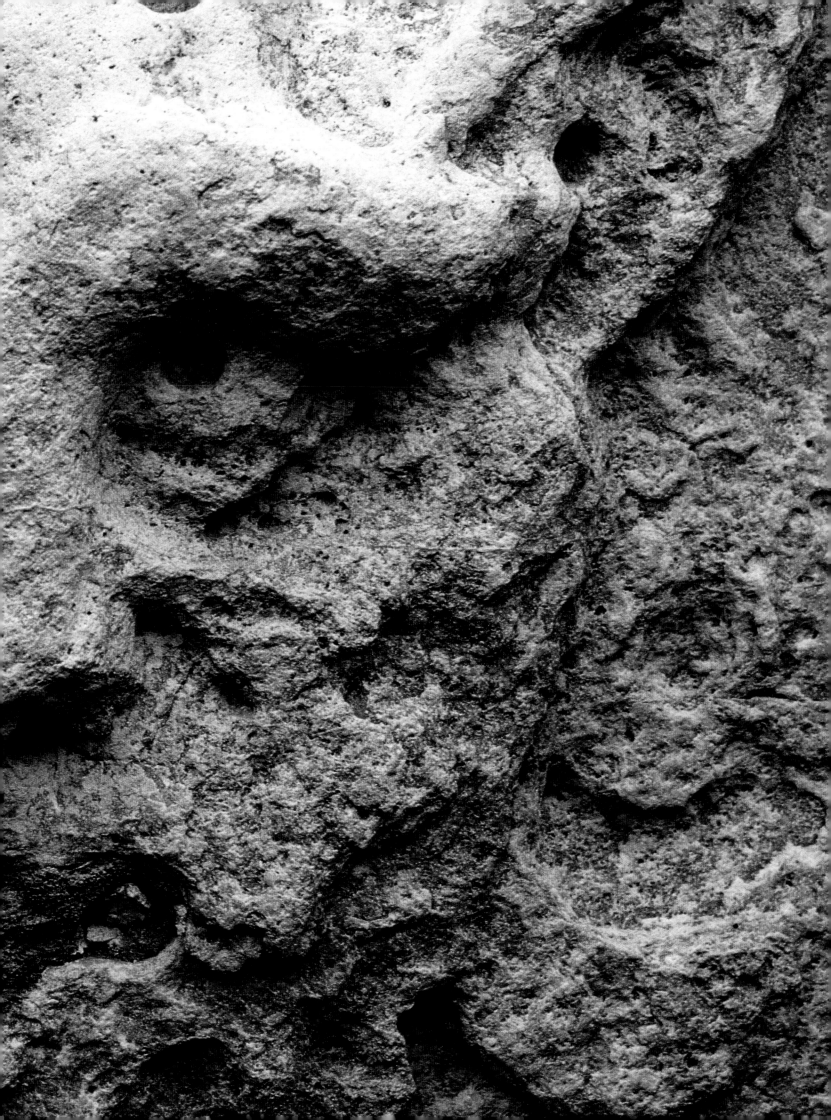

plot – was rolled, step by step, down the great staircase of the Doge's Palace and his blood stained the courtyard of the building that is more commonly associated with the genius of Calendario, his accomplice.

The rhythm of the capitals which run along the two-sided facade of the ground floor of the Doge's Palace, forms a sort of cryptic 'time poem'; from the capitals springs a curve of great arches that support a cornice punctuated by slender columns, articulating the balustrade. The elegant lacework of ogival arches is further enriched by the delightful quadrilobe motifs which support smooth fascias of wall, defying all the laws of logic; they animate the rose-coloured rhomboid patterns set into the cruciform

cornice pierced by great windows that are very slightly pointed. In the whirlwind of interior rooms, vast epics are depicted, narrating the history of wars or describing the heavenly hierarchy in an explosion of colour. These monumental scenes are interrupted only by the sudden protrusion of a balcony or by a succession of intricate pinnacles and spires. Amid undulating greenery, represented by the tightly furled leaves and climbing vegetation of a dreamlike or imaginary garden, Adam surveys his many progeny; ancient heroes are concealed in the very midst of leafy designs, as are crowned holy warriors, while Moses

The head of a Roman emperor, the lovely marble oculi encircled by festoons of acanthus leaves, and a once polychrome peacock presiding over a wheel, against a variegated background of ancient marble in a trilobite window: all of these decorate the facade of the Ca' Gritti, creating one of the most remarkable and delightful examples of Venetian Gothic architecture in the Campo San Giovanni in Bragora.

95

and Solomon discuss justice and law with Aristotle. The Virtues mock the impetuous assault of the Vices, the months of the year are grouped together into clement or hostile seasons; loving caresses illustrate the union of married life; the arts and trades present their associated tools; monstrous creatures, finally tamed, dare to grimace or growl one last time, still hoping in vain to appear threatening; sovereigns parade like emperors ruling the world; there is an abundant array of faces representing the peoples of the world; biblical prophets predict the future like infallible soothsayers; *putti* and children laugh; and the planets mark the inescapable destiny and inexorable cycles of universal history. Also engraved in stone are epigraphs that defy any attempt at decipherment.

The magnificent destiny of the Republic is also represented by allegorical statues, or narrated in prophetic scenes that are drawn in relief in the warm and iridescent tones of marble hewn from both local and more distant quarries. The white marble from Rovigno, the rose-red of Cattaro, the lustrous black

Left Small flowering roses in lively colours embellish the Gothic porch of the abbey of San Gregorio alla Salute.

Right The Byzantine water door of the Casa Bosso in San Tomà represents the symbolic passage from the nautical to the terrestrial world, a perfect osmosis between nature and culture.

Overleaf Wave-like veins striate the marble surface into which the ogival windows of the Casa Meraviglia are set, a reminder of the green waves of the lagoon.

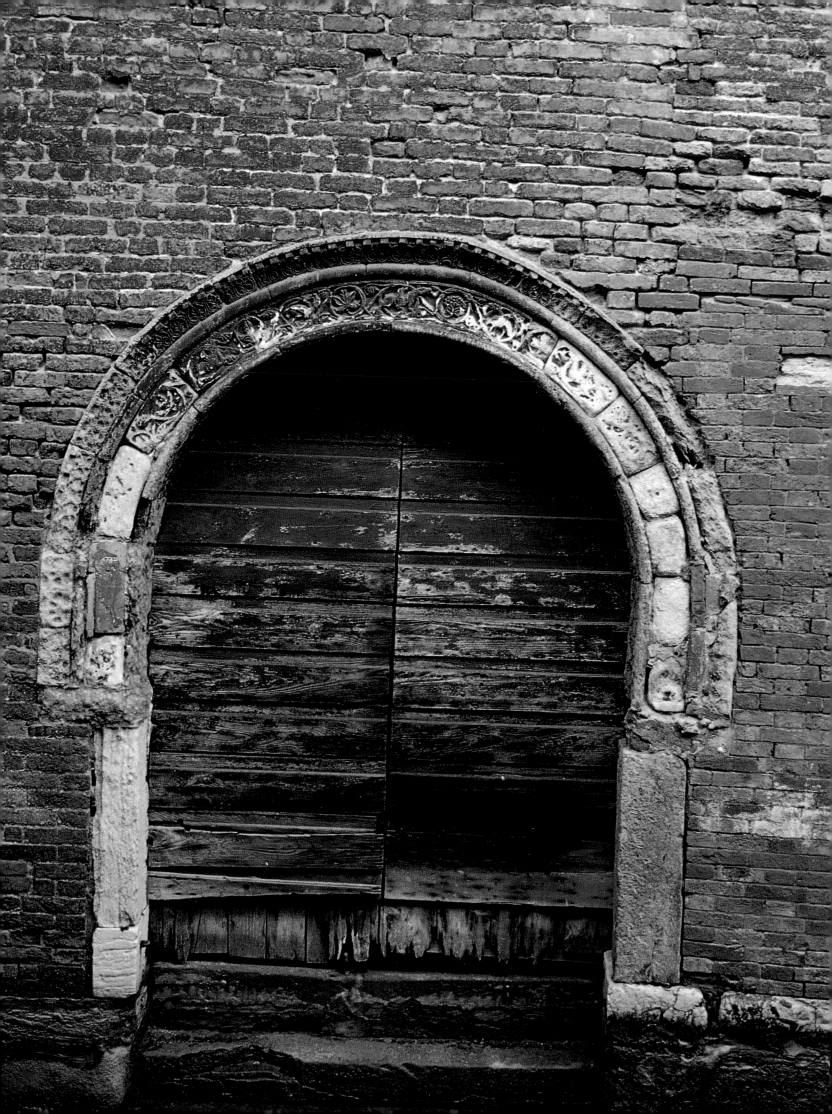

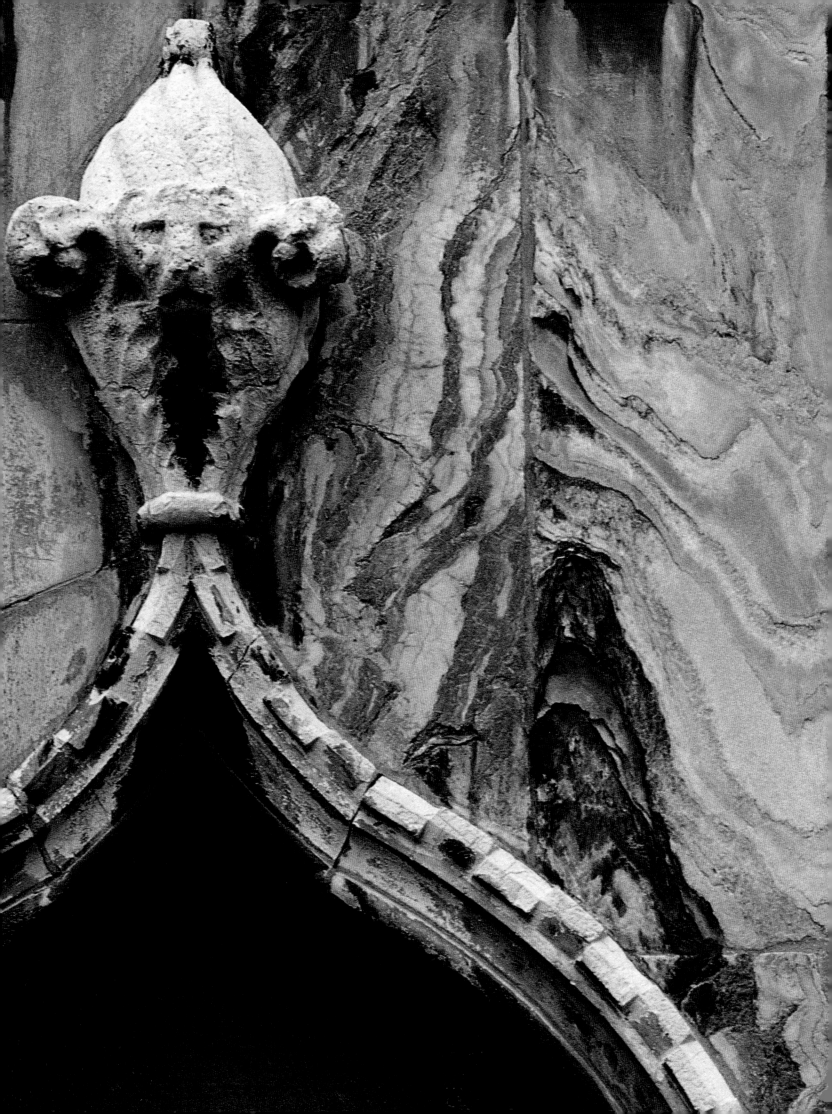

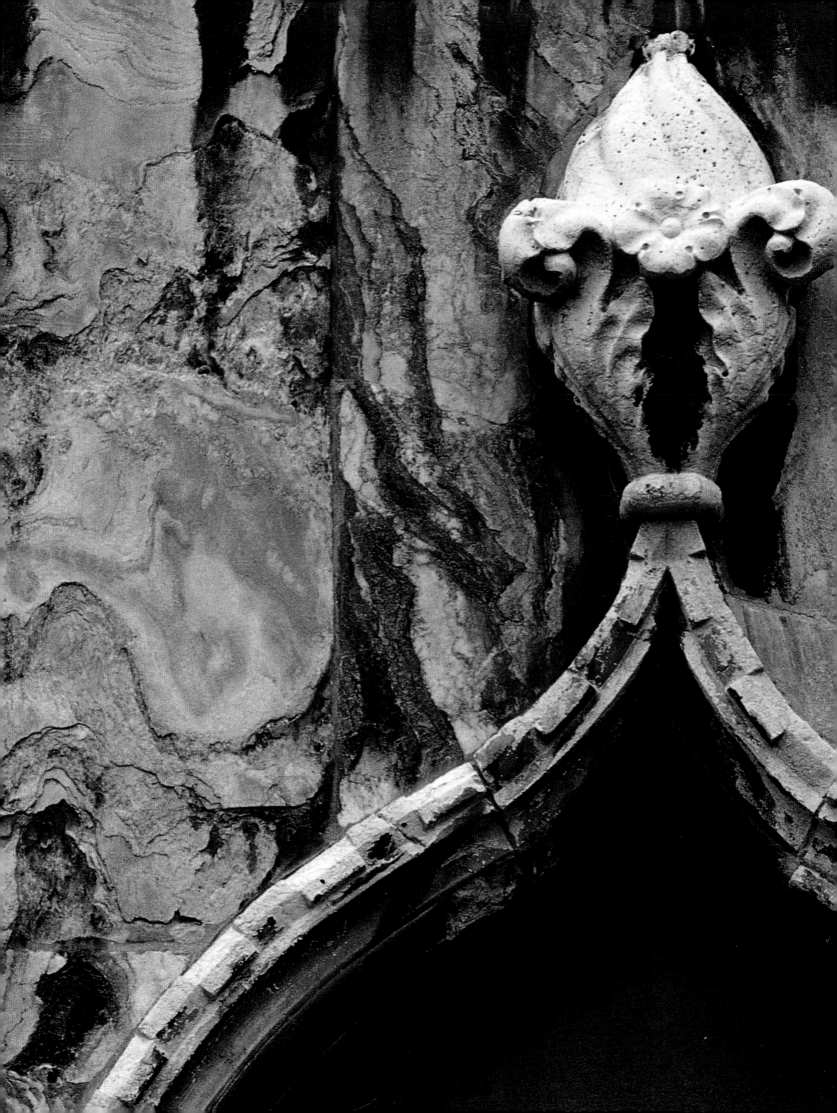

from Iseo and the yellowish hues found near Lake Garda all embellish the small loggia at the foot of the *campanile*, or bell tower, whose crowning pinnacle seems poised to spike the passing clouds. We must not forget to mention the procession of naked men and women, all undoubtedly imbued with some rhetorical meaning, balancing on the small pillars, that lend rhythm to the balustrade, which crowns the Library, the Mint and the Procuratie.

The facades of the great palaces echo and give new emphases to the architectural features of the Ducal buildings: the perfect ovoli enveloped in twisting and flamboyant stone tendrils; the daring proportions of the ogival arches; the understated elegance of spiral columns; the casual clusters of delicate pillars; and the refinement and never-ending variety of openwork capitals. Those smooth surfaces, sometimes differentiated by rectangular or square patterns, or by a light vermiculated boss – in the shape of either crosses, circles or diamonds – would later host a vertical dialogue between the different Classical orders. As described by Vitruvius, the orders obey the rules of proportion suggested by the human body: the Doric column evokes the solidity of the male body; the Ionic recalls the delicate female figure; and the Corinthian stirs thoughts of the svelte charms of virginal purity.

The love of change... at once soothed and satisfied as it watches the wandering of the tendril, and the budding of the flower.

RUSKIN, *The Stones of Venice*

Column shafts and half-pillars frame the simple or tripartite windows, whose keystones bear the dumbfounded faces of black slaves from the Barbary Coast, the heads of Minerva and Medusa, angry turbaned Saracens, bearded wild satyrs and the heads of wild animals. Over the graceful curves of the arches hover the slender figures of winged Victories, wrapped in transparent organza. On moulded cornices, the Victories seem to support friezes that capture forever, in a frozen moment of time, the fluttering dance of a *putto* or the quivering of laurel or myrtle leaves in a festoon. Later the facades would feature the tortured and superfluous motifs of the Baroque: jutting

A detail of one of the Byzantine pillars of San Giovanni d'Acri in San Marco, with a naturalistic bas-relief of vine leaves and grapes.

An unusual palimpsest of ancient marble decorates, in a profusion of detail, the great bay of the Byzantine facade of Ca' da Mosto, located on the Grand Canal near the church of Santi Apostoli.

Left More floral decoration
on the facade of the church
of Santi Giovanni e Paolo.

Right Istrian stone, marble and
brick combine, in an example
of *concordia discors*, to decorate
a neo-Gothic house on the
Campo Santa Maria Formosa.

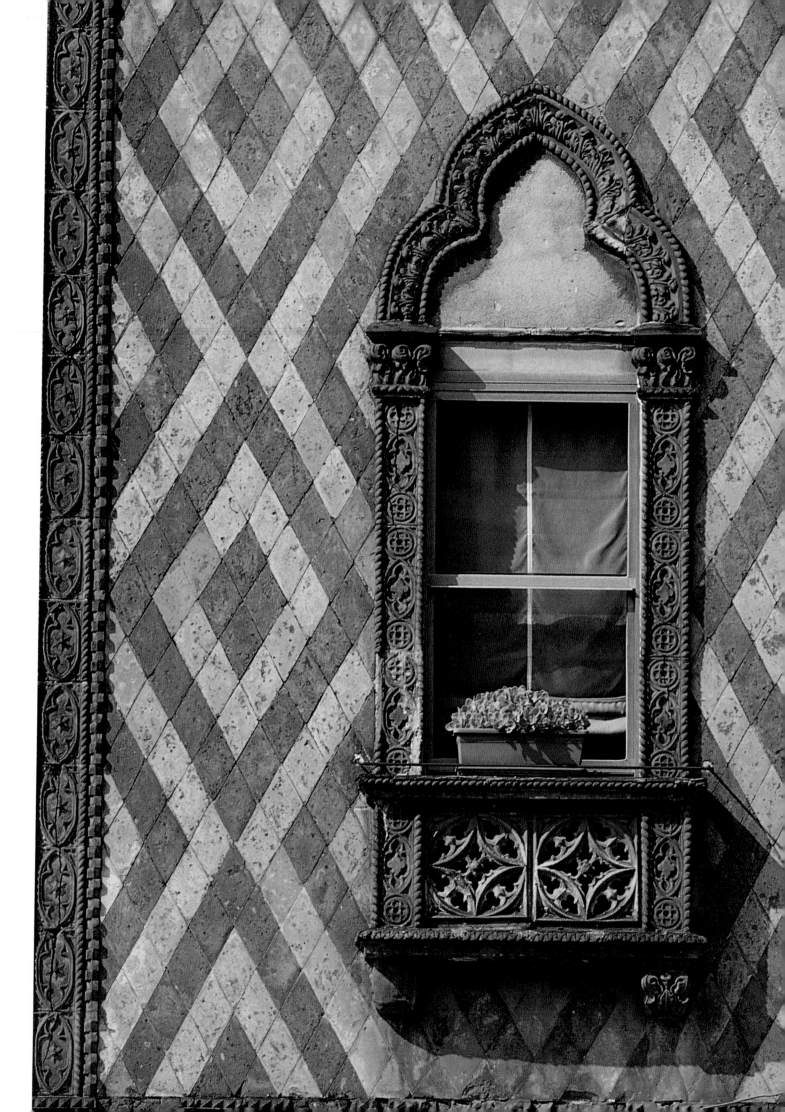

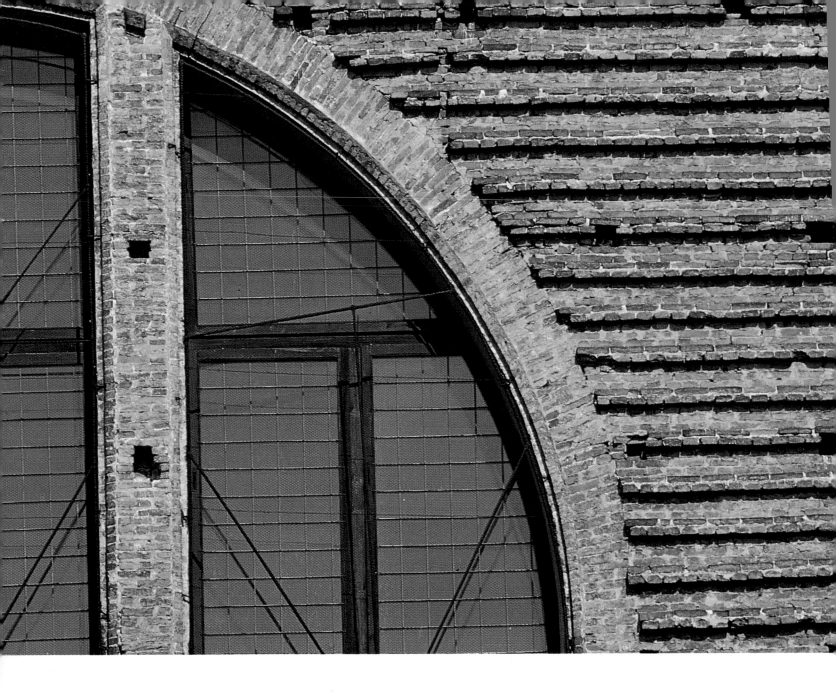

eaves and spouting gargoyles; bulging, muscular Atlases groaning under the weight of architraves decorated with bull's heads; concave or convex cartouches, embedded in a sandstone mantle, which boasts many coats of arms, crowned with crests, embellished with miniature obelisks and pyramids and decorated with lambrequins and flourishes, as well as oversized scrolls wrapped around massive volutes.

Suddenly and unexpectedly – at the end of a *calle* or at a sharp turn in the street or in the corner of a square – one may stumble across an endlessly surprising array of doorways and porches. Simple and square-framed, round-arched or low-arched, or with a pointed oval or symmetrical arch, the white stone of these doorways is sometime untreated and sometime smoothly polished. There may be intricate or triumphal

settings of pilaster strips striated with fanciful zoomorphic and botanical carvings and surmounted by balconies or tympanum pediments, with wooden imposts that are sometimes smooth and shiny, sometimes coarse and rotten, sometimes embellished with geometric carvings, sometimes studded with rusty nails and bolts, or covered with strips of bronze or brass. The doors creak on their hinges and open on to tiled entrance halls that are often covered by a film of stagnant water, creating the effect of a Persian carpet studded with shells, lapis lazuli, sapphires and mother-of-pearl.

But the primary aim of all this opulent decoration is not to celebrate the glory of patrician dynasties nor to flatter personal vanity. Such glories and personal achievements are,

The warm reddish colours of the unfinished and imposing 16th-century facade of the church of San Lorenzo (**left**) contrast with the cold, greenish hue of the marble on the facade of the Basilica of San Marco (**above**), creating an ever-varied dialogue.

107

of course, recorded and represented in retables brimming with unmistakeable allusions and clear references to noble families and individuals, such as the eagle and unicorn found on the palace built by Andrea Loredan. Richard Wagner spent the final days of his life in this building, which is considered to be one of the greatest palaces along the Grand Canal and is a building of both great substance and height. Almost an island in itself, it is noble not only because of its interiors, but also because of the marble-covered facade, punctuated by large windows flanked by Corinthian columns. The opulent decoration is, above all, a homage to the infinite beauty and extraordinary splendour of the city. It also serves as an offering and hymn to the divine grace which protects Venice, even if some over-ambitious and particularly extravagant families overestimated their might only to see their palaces later reduced to a few stone blocks.

This was the case with the Ca' del Duca and the Ca' Venier dei Leoni (now the Guggenheim Museum), whose original foundation stones are still visible, standing like stone phantoms in the waters of the Grand Canal.

'*Non nobis Domine*' or 'Not unto us, Lord': a reference to the statues of St Mark. Far from arrogance or blasphemy, this exclamation simply demonstrates the extent to which the Venetian people were aware of their special position and their city's unique standing in the world, as a city impervious to treason. In a similar way, there is no church in Venice that attempts in any way to rival the Basilica of San Marco. Constructed in accordance with the canons of the Apostoleion of Byzantium, the Basilica was built around the shrine housing the relics of the patron saint who

This marble fragment (**left**), part of the interior decorative scheme of the church of Santa Maria dei Miracoli, rivals in beauty the ancient brickwork of the lunette of the 13th-century porch of the Casa Bosso in San Tomà (**above**).

109

protected a 'city that appears not to be made by the hand of man', and who predicted that Venice would be a place blessed by piety, justice and happiness, qualities constantly reaffirmed by the strength of the city's myth. The Basilica was also used as the Chapel of the Doges whom God had made guardians of the holy relics. This immense space, crowned with cupolas, is made even more splendid by the wonderful mosaics that adorn its walls and cupolas. Their polychrome glass tesserae have set the stories of the Bible against a timeless gold background for all eternity, illustrating the lesson of Redemption and the exemplary life of saints, under the impenetrable gaze of Christ the Pantocrator, the supreme judge. The Virgin Mary at prayer also watches over the Basilica, her eyes filled with sweetness and ecstasy.

The churches of Venice — just like the seats of devotion of the religious brotherhoods — are striking in their seemingly endless variety. The facades or side walls of some demonstrate the incredible architectural, sculptural, structural and decorative talents of the artists who designed them, in terms of both vocabulary and grammar. Palladio, in particular, while glorifying a Christian God, seems to evoke the ancient lightness of pagan temples. In every way, Venice's churches equal, or

Left Red Verona marble, though worn and damaged by the ravages of time, still clads the base of the facade of the church of Santi Apostoli.

Right This vine shoot, blackened by the patina of age but still inhabited by animals, is part of the rustling foliage on the Istrian stone cornice of the lunette of the Casa Agnusdio in San Stae.

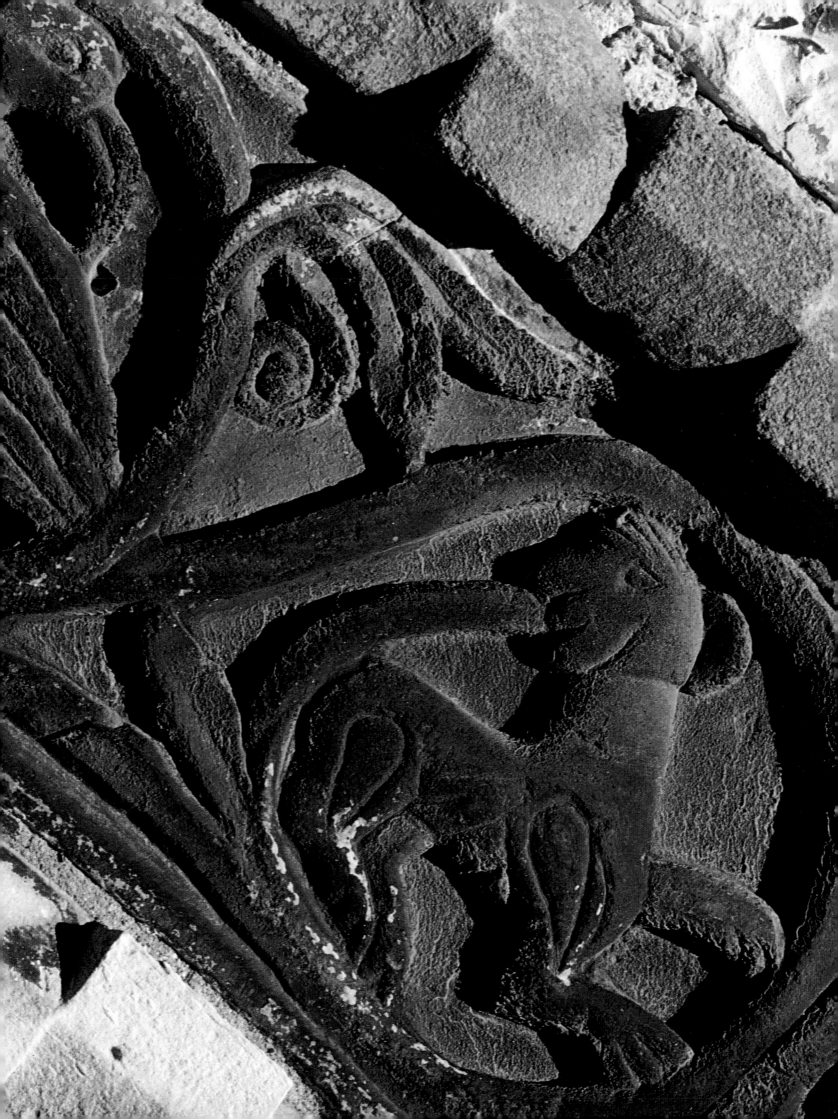

Left The stone blocks used for the facade of the 16th-century Palazzo Zen near the Gesuiti are just one example of the array of materials that clad the walls of Venice and make them so distinctive.

Right A twisted corner pillar, whose leafed capital is crowned by a ball of Istrian stone resting on an imposing base, decorates a high wall of a fine garden.

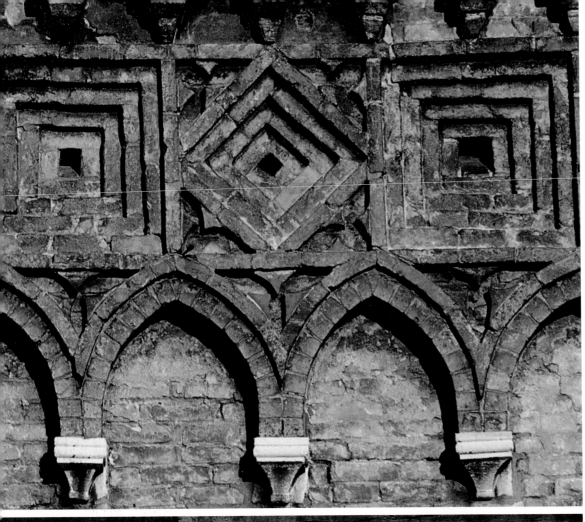

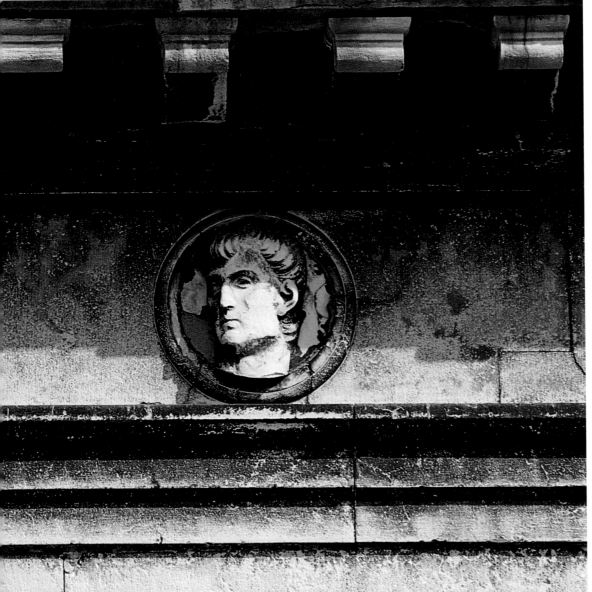

The walls that surround the colourful and lively space of the garden of stone are an integral part of the garden itself. Their chromatic and decorative elements enrich and complete them, particularly at their crests where ethereal crowns in the most disparate shapes alleviate their density. The skilful juxtaposition of different materials renders the walls light and almost transparent.

Overleaf Here is a perfect example of the many decorative forms that are creatively used to top the tall facade of the church of Santi Giovanni e Paolo.

even surpass, all the architectural elements that we admire in the city's sumptuous aristocratic palaces. But these holy churches may also renounce all ornamental fantasy and sometimes content themselves with the most humble brick covering, protected by white or red roughcast that has often been eroded by inclement weather. Some churches are adorned with small, elongated arches supported by plain pilasters, or are pierced by rose windows set in rough-hewn stone or by Palladian windows. Such churches sometimes lurk behind the cumbersome wooden mass of a boathouse or within a long row of the most unassuming houses, whose bare doorways lead to a humble stairway and on to the granite paving stones of the Strada Nuova (the 'new street'), which was once a water-filled *rio*, before it was filled in with earth when Venice ceased being an island and a sovereign Republic.

The church of Santa Maria dei Miracoli is a precious casket of white marble of an alabaster-like transparency, studded and crenellated with porphyry and serpentine crosses, disks, plaques and strips, similar to the polychrome inlays of wheels, circles and interlaced rosettes on the facade of the Palazzo Dario – a house that has been cursed, so they say, by evil spells that can never be exorcized. Opposite lies the Scuola della Misericordia, with its chimerical portico, rectangular niches and wide windows cut straight into the porous, fired clay of its brick; its cornices and friezes are created

115

from piles of hollowed tiles and bricks that were originally intended only as a temporary measure, later to be replaced by a sumptuous marble covering that was specified in the original plans but never realized. Together, all of these facades – whether they belong to rich or humble houses, whether they plunge into the water or line the filled-in canals, blocking out the strong rays of the midday sun and keeping the buildings cool – form the most important element of Venice's architectural decoration; they embody the very essence of the city's embellishment. This is an architecture of display, whether it be intricate altar frontals and stone retables, or the fine white lacework surrounding the Gothic or Serlian Renaissance windows, whose narrow

This graceful white braid, enriched by a plant motif, is set against the sky in the form of a gentle curve that follows the more rigid line of the fluted cornice. It provides a finishing and dignified touch to the red-brick Gothic facade of the Scuola Vecchia della Misericordia.

frames rest on voluted consoles or are surmounted by a variety of arches, sometimes ennobled by an overhanging balcony or loggia where geraniums and hydrangeas flower.

The way in which the facades align, intersect, meet and abut, gives the entangled and inextricable labyrinth of this miraculous city a theatrical dimension; multiple scenarios are played out and visual illusions abound in an Eden-like garden of stone. The avenues, the flowerbeds and the borders serve as aisles, catwalks and the stage — marked out by lines on the ground — while the scenery, the wings and the backdrop are created from the unequal heights of the facades and the profusion of decoration that adorns them. Enter the actors: the pergolas, the bowers, the hedges and the gazebos.

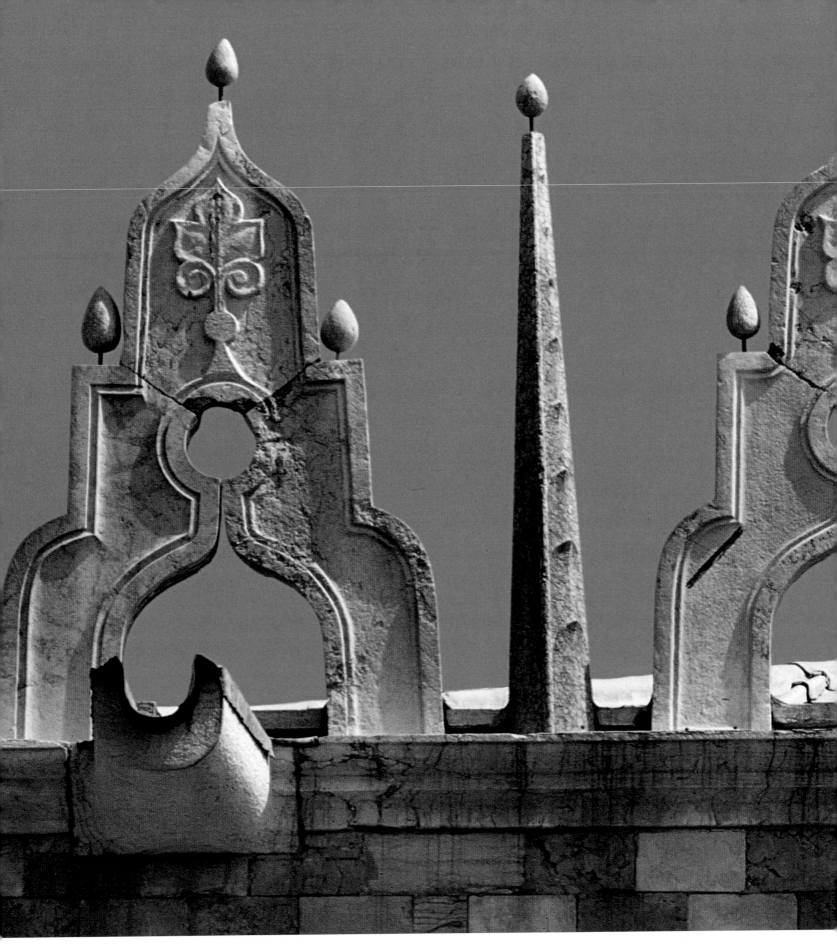

They are not battlements, properly so called... but merely adaptations of the light and crown–like ornaments which crest the walls of the Arabian mosque. RUSKIN, *The Stones of Venice*

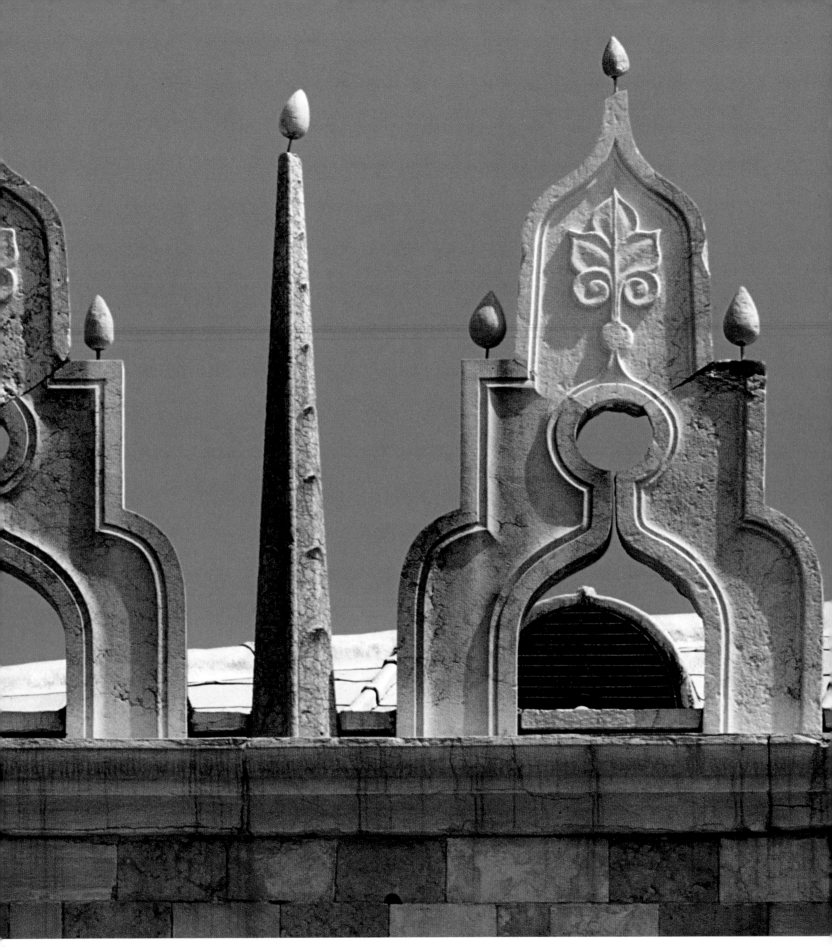

Enchanted Stones

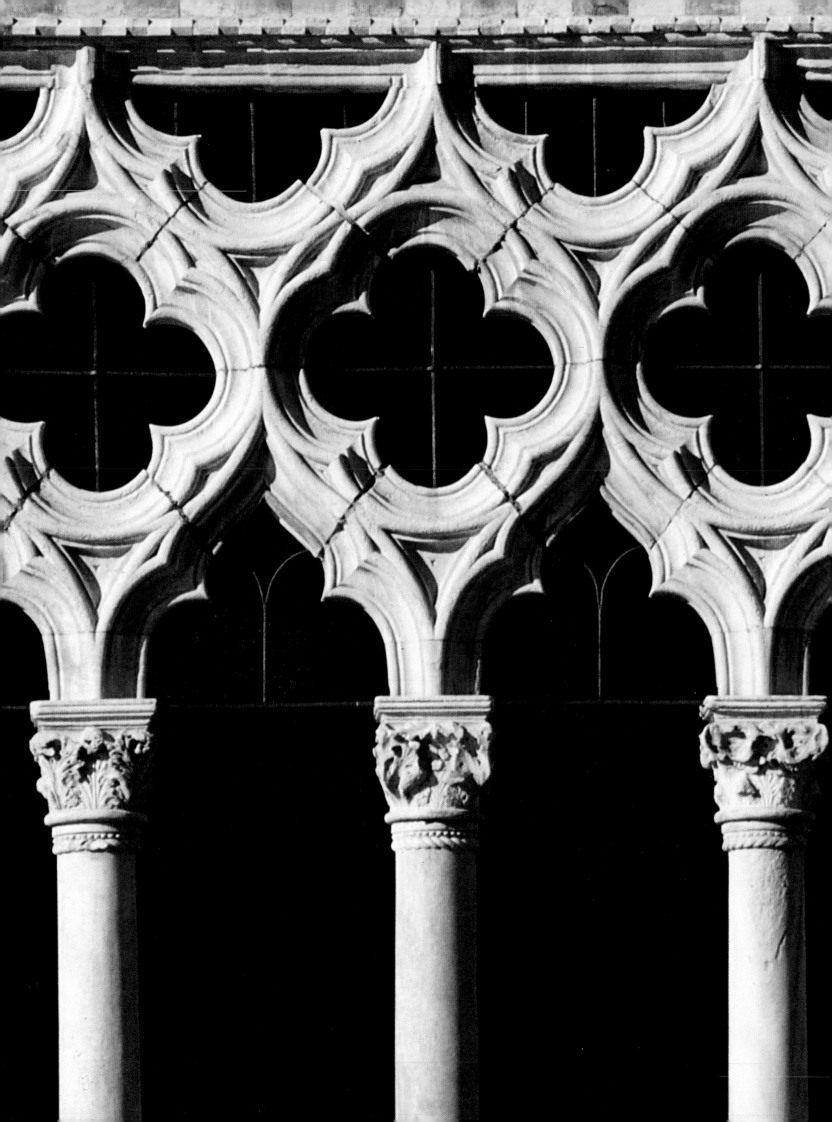

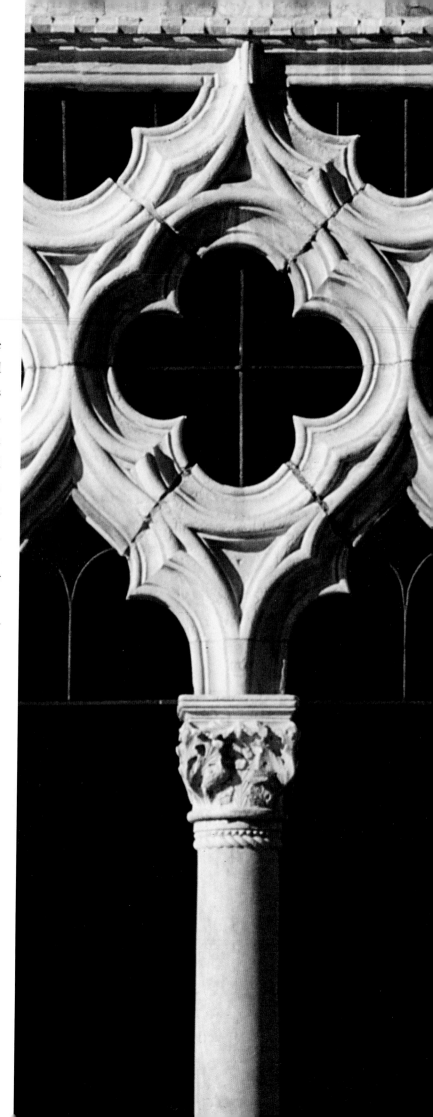

She looks a sea Cybele, fresh from ocean,
Rising with her tiara of proud towers
At airy distance, with majestic motion,
A ruler of the waters and their powers:
And such she was...
LORD BYRON, *Childe Harold's Pilgrimage*, Canto IV

The stylistic virtuosity of ornate facades that dazzle the eye from the front often disappears as soon as the wall turns the corner. Behind these elaborate facades are walls hidden from view, whose bare surfaces of flaking brick, rough lime and smooth, white *marmorino* are set with rectangular windows with rough wooden frames and sills, punctured with breccias and grill holes. But even on these walls, sober though they may be, we can make out what, at first glance, appear to be extremely strange and even absurd works that look as though they have been created under cover of night by sculptors in the grip of madness. But these are merely stone stigmata of a kind, which time has left behind on the stone, like marks of piety, memory and family pride, demonstrating a playful exuberance. This is to say nothing of the work of the stonecutters who operated by daylight, masters of their trade endowed with extraordinary patience, or the surplus stonework abandoned on the construction sites of eminent places of political or religious power, or the

In Venice, it is the hard work and expertise of the tireless stone masons that gives form to raw materials. This extraordinary *ars topiaria* has created the most varied and surprising motifs, such as can be seen on the windows of the Ca' d'Oro, a 15th-century palace whose trilobed and quadrilobed openwork metamorphoses into climbing plants, complete with thorns and flowers.

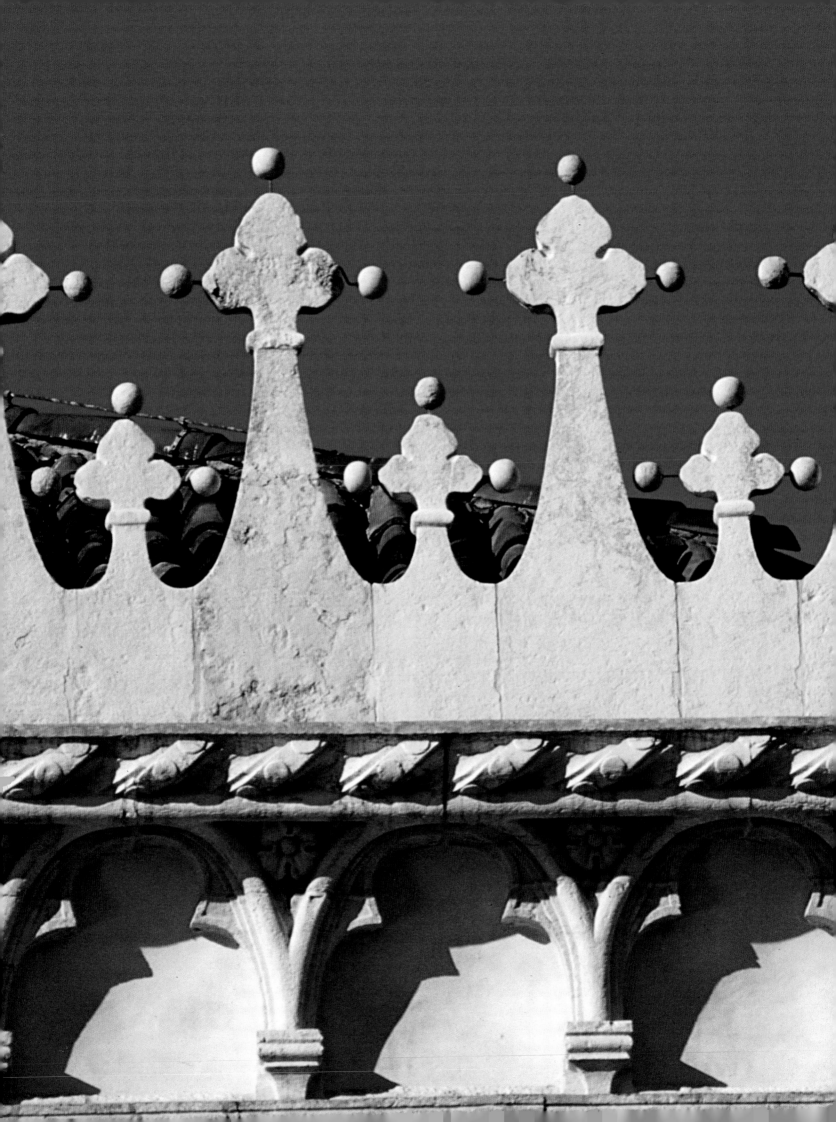

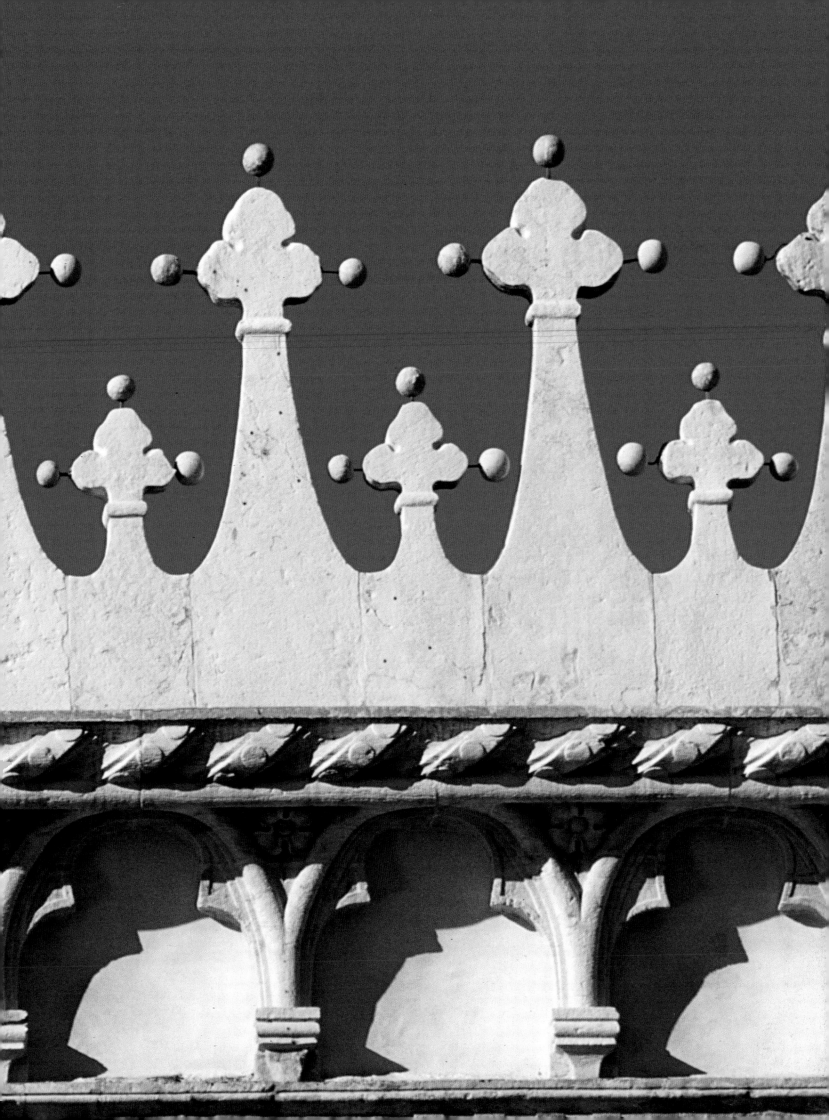

trophies plundered after many savage raids and foreign incursions, or the valuable pieces that may have been brought back by an ambassador, a *bailo*, or simply purchased by a dealer in a huge and plentiful Levantine or African bazaar, or in a Greek or Balkan market. There are tabernacles sheltering gentle Virgins that cradle a chubby Christ Child in their arms or mourn Christ after his descent from the Cross; small stone altars in which Virgins of Mercy open up their cloaks to give refuge to needy beggars who shelter beneath the protection of their mantles; niches housing Virtues or Prophets; figures of St Nicholas leaning on his bent crozier and St George plunging a sword into a writhing dragon; the lion of St Mark holding his gospel or sword, either embossed in full relief, or etched in high and low relief in medallions or lunettes; travertine or slate icons; fragments of stelae or sarcophagi; images of armour, coats of chain mail and breastplates; and outlines of candlesticks, monstrances, chalices, ampulae, amphorae,

incense burners, banners and standards. On well-heads, an infinite number of patterns and motifs can be found, in the shape of notches, lozenges, scrolls, almonds, circles, ovals, triangles, or hearts. We find shields surmounted with crested helmets and bunches of feathers relating to an improbable heraldic scheme, with an exhaustive repertoire that borrows from an amazing and fantastical zoological vocabulary: harpies and three-headed dogs; mandrakes and basilisks; griffons and hippogriffs; centaurs and minotaurs; celestial stags and unicorns; sphinxes and chimeras, phoenixes and salamanders; sirens and tritons. These heavenly winged creatures recall the wondrous coincidence that, by a supreme and inscrutable act of God, on the very same day of the Annunciation, the *Civitas Venetiarum* was founded in the midst of the swamps. And on that day,

Preceding pages The crenellations of the Ca' d'Oro's facade boast these pinnacles of Istrian stone – once completely gilded – which call to mind slender stalks studded with exotic blooms.

Above On the ancient crenellations of the Arsenal, nature has begun to reconquer lost ground; flowers and weeds are sprouting in the crevices between its bricks.

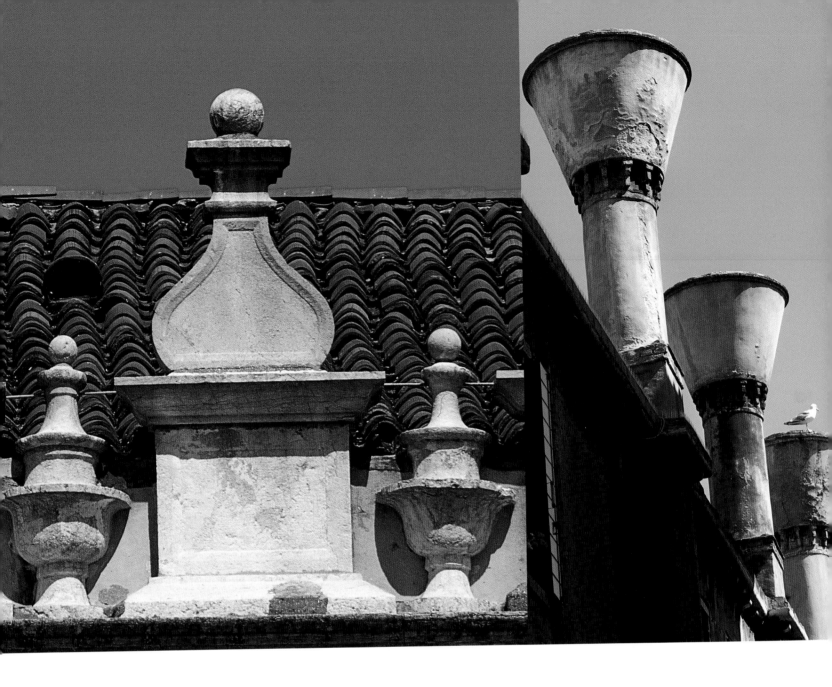

all these winged creatures imprinted their images in the stone garden, either on the walls rising ever higher towards heaven, or poised to take flight from the sharp pinnacle of a *campanile*.

But the city's wonders do not cease here. From the *campanile*, the most soaring of monuments that stands proudly on the Piazza San Marco, one can see all the way to the *lidi*, where the dykes that hold back excessively strong tides are interspersed with efficiently defended openings. These passageways granted access to the city's basin and, from there, on to the warehouses of the Rialto where laden ships once docked; unsurprisingly, such activities were spied upon by the perfidious Ali Bey, who wanted to reveal secret information to the Sultan and the Sublime Porte. Alternatively, from

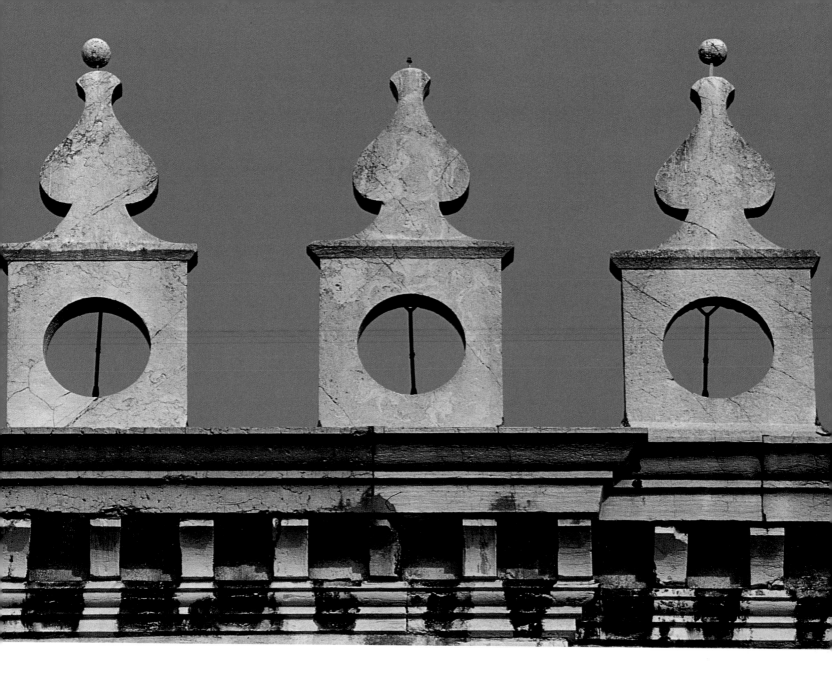

the top of the *campanile*, one can raise one's eyes to the sky and contemplate the dome of the heavens, as Galileo used to do, in order to uncover the secrets of the stars and planets.

'The *campanile* in Piazza San Marco is not, as we might suppose, a tower that is part of the Basilica', notes the Andalusian journalist Pedro Antonio de Alarcón. In the course of his many travels, he arrived in Venice the day after All Souls' Day in 1860, and was quite astonished to cross the railway bridge that linked the city to the mainland and violated the hitherto unsullied freedom of the lagoon. He goes on to say that 'the *campanile* is an

Left to right The facades of buildings become lighter as they rise towards the sky. On their crests grow curious crowning elements (once more numerous than they are today), such as these 'vases' that ornament the 15th-century Procuratie Vecchie on the Piazza San Marco; the great Gothic chimneys, shaped like inverted cones, that adorn the roof of a house near the fish market; or the elegant crenellations of the 16th-century Fondaco dei Tedeschi.

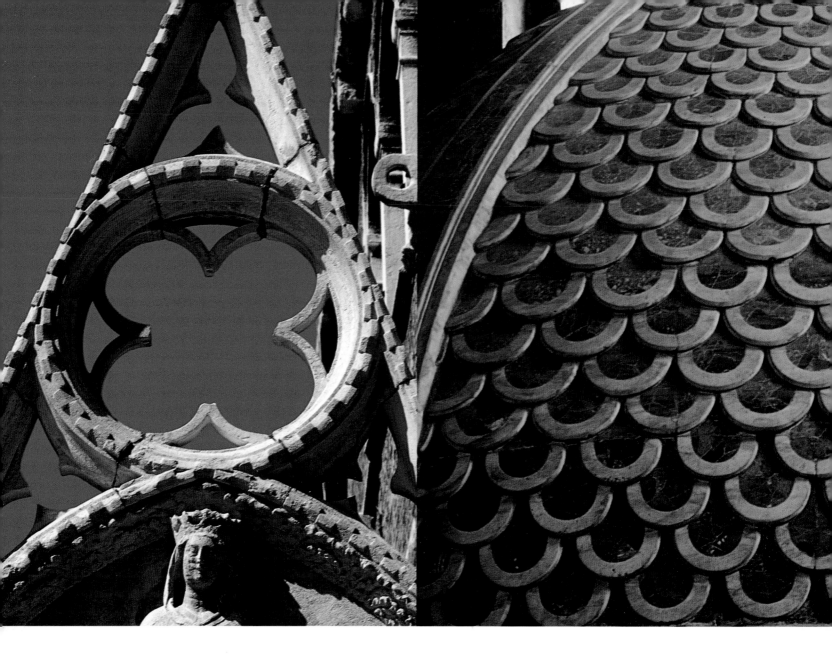

isolated building (adjacent to the excesses of the cathedral, where a sepulchre and mausoleum once stood, that were later taken under the care and protection of the Doge). It stands all alone and totally upright at one corner of the square, rather like an obelisk. This bell tower dates back to the 9th century and originally served as a watchtower from which to survey the Adriatic so that the town authorities could receive an early warning of any sailing vessels appearing on the horizon. Halfway up the tower we can still see the spot from which a wooden cage once hung; priests were imprisoned inside it, fed on a diet of bread and water, until they confessed themselves guilty of their misdemeanours. This fact, however, is soon forgotten once we reach the summit of the tower. It is quite true that, from up there, a single glance can embrace the whole of Venice; luminous, the entire city is surrounded by glittering waters, as if

inlaid within them, and divided into two parts by the immense snaking "S" of the Grand Canal.'

In 1492, Peter Fassbender, a German from Koblenz who was waiting for a boat to take him to the Holy Land, wrote that, 'From up there, we saw the entire city of Venice, and it is fair to say that in the entire world there is no city to equal it.' Who knows if Fassbender and Alarcón could make out, from this bird's-eye view of the city, a shape which resembles a dolphin, the sea creature loved by Venus. It is the fastest animal that lives in water, according to St Isidore of Seville. It can understand

Left to right While some stone reaches towards the sky – like this arch in the Calle del Paradiso in Santa Maria Formosa – other stone takes on unusual forms, such as the cupola crowning the 18th-century tabernacle of the main altar of the church of the Gesuiti, whose structure resembles the shell of a huge tortoise, or the uneven surface of the bricks that clad the top of the San Barnaba *campanile*, bringing to mind the scaly skin of an extinct reptile.

Overleaf We can but admire the beauty of the great ogival windows of the Gothic Palazzo Ariani Cicogna in Angelo Raffaele, whose luxuriant floral motifs recall a splendid rose garden.

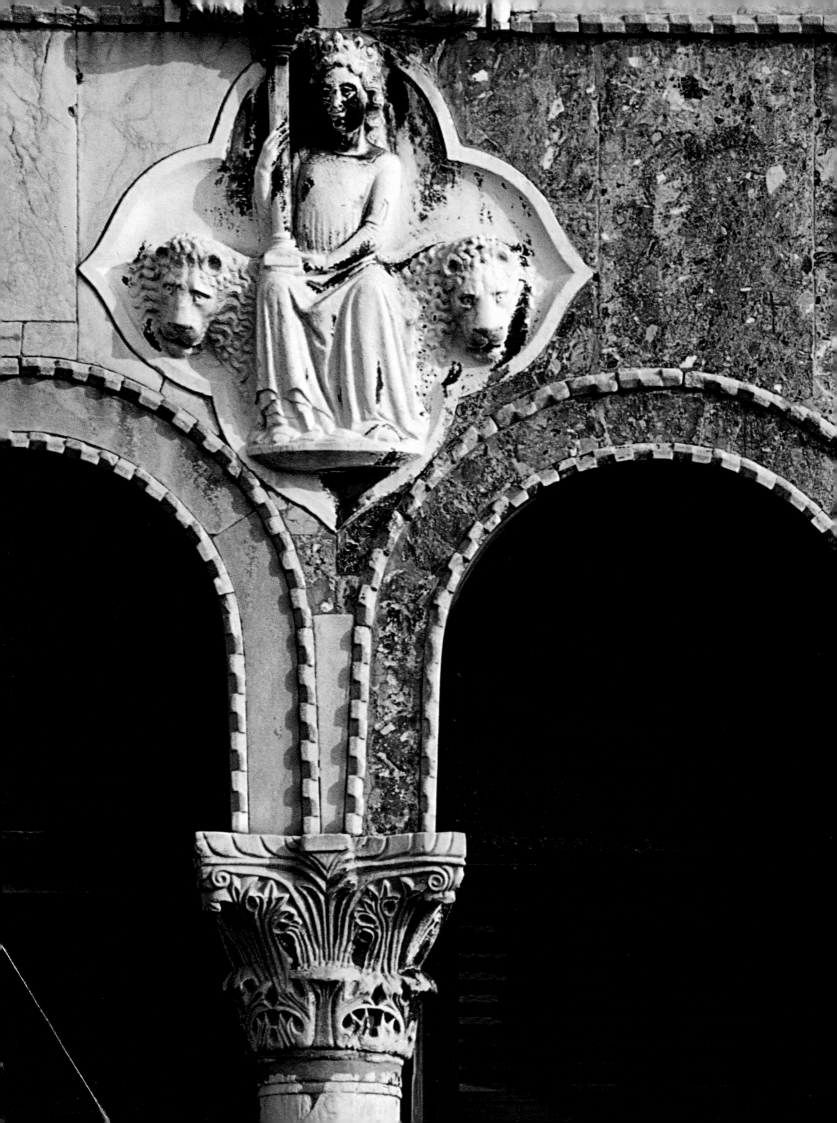

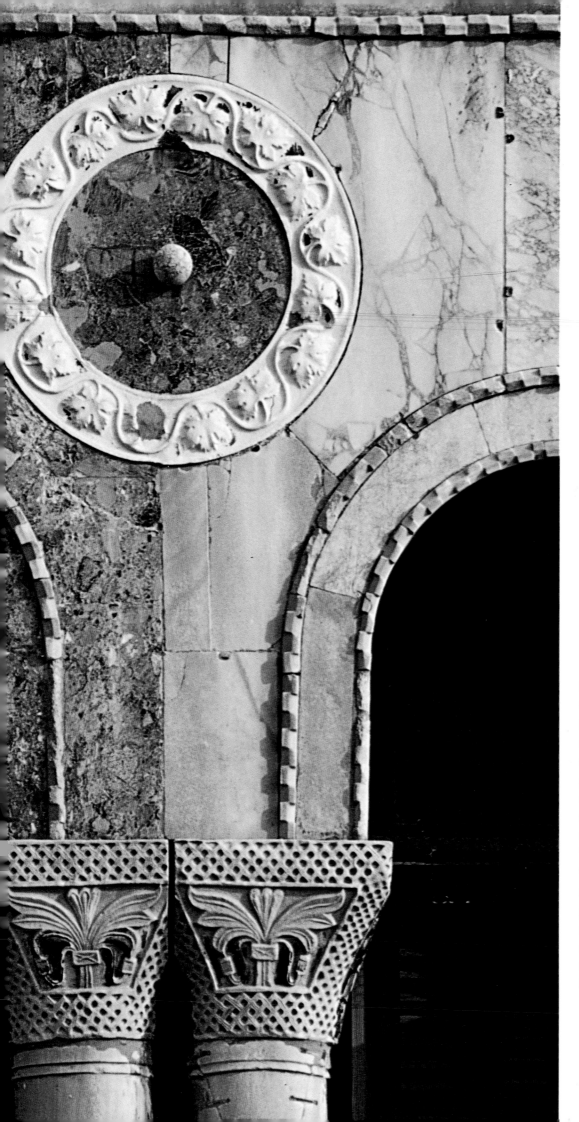

On the Byzantine façade of the
Ca' Corner della Piscopia
Loredan, embellished with
ancient and rare marble, the
quadrilobe – surmounting the
great window that opens on to
the *piano nobile* – shows Venice as
an allegorical figure of Justice,
enthroned between two lions.
These are symbols both of
Venice and of Solomon, once
more evoking Jerusalem. The
plant motifs – the vine leaves
around the medallion and the
stylized leaves on the capital –
demonstrate an inexhaustible
imagination and invention.

135

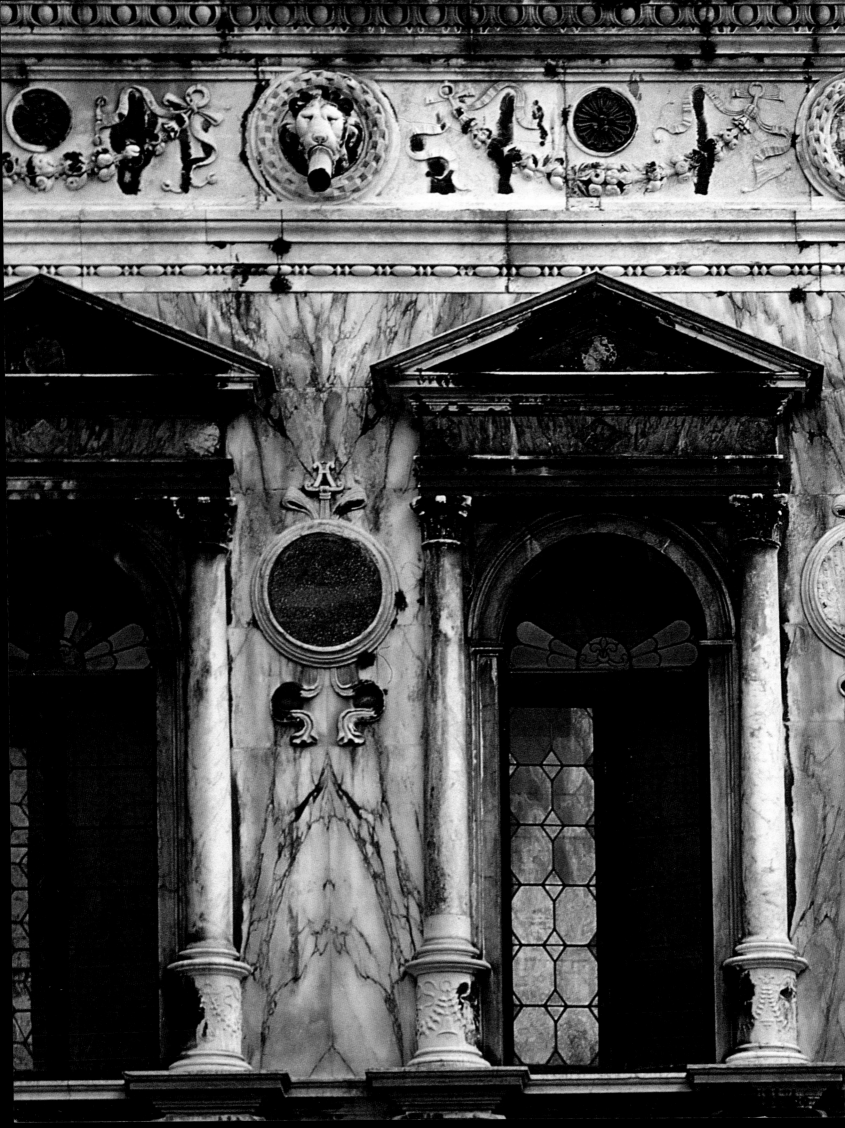

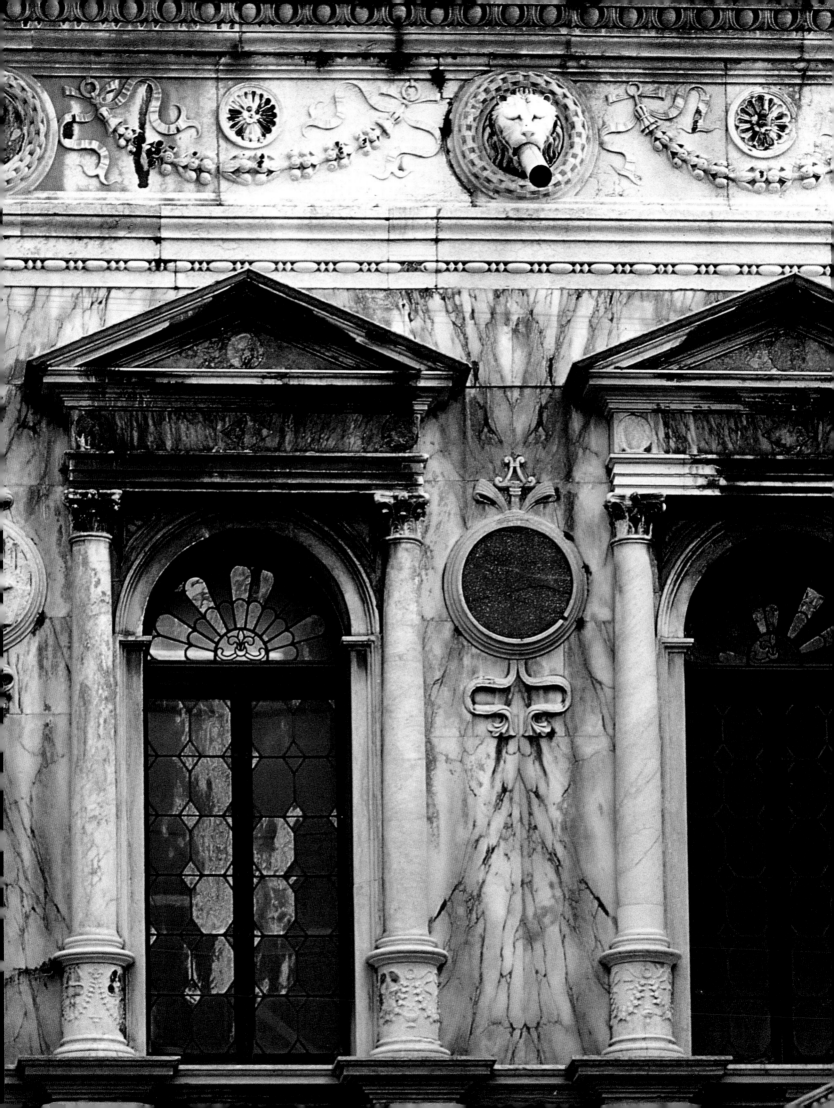

human speech and is fascinated by musical sounds, and is also a symbolic and visual allusion to the Crucified Christ. The dolphin also appears wound around an anchor as the colophon of the printer Aldus Manutius, who produced the famous book of *Hypnerotomachia Poliphili*. But if, as they claim, the shape of the *Civitas Venetiarum* really is that of a dolphin (as it was depicted by Jacopo de Barbari in a magnificent engraving he made in 1500, representing Mercury and Neptune in conversation, one bearing a caduceus, the other a trident), the creature also brings to mind the charming movements of a young girl who, Venus-like and virginal, eases the sinuous curves of her hips into the waters that bathe and gently caress her.

Seen from up above, from a bird's-eye vantage point, we are struck by the disparity of height in Venice's buildings; by columns rising from tall pedestals; by the luxuriant profusion of the city's chimneys; by the varying degrees of overhang in its tiled roofs; by the

The Istrian stone lions that stud the balcony balustrade of the *piano nobile* of a 15th-century house in Santa Fosca have a serene gaze, despite their haughty posture.

Preceding pages The rare facade overlooking the courtyard of the Doge's Palace was given one of the most complex decorative schemes of the end of the 15th century. One of its faux Renaissance shields – still harking back to the city's Byzantine heritage – shows a lion *in moleca*, or relaxed on its haunches.

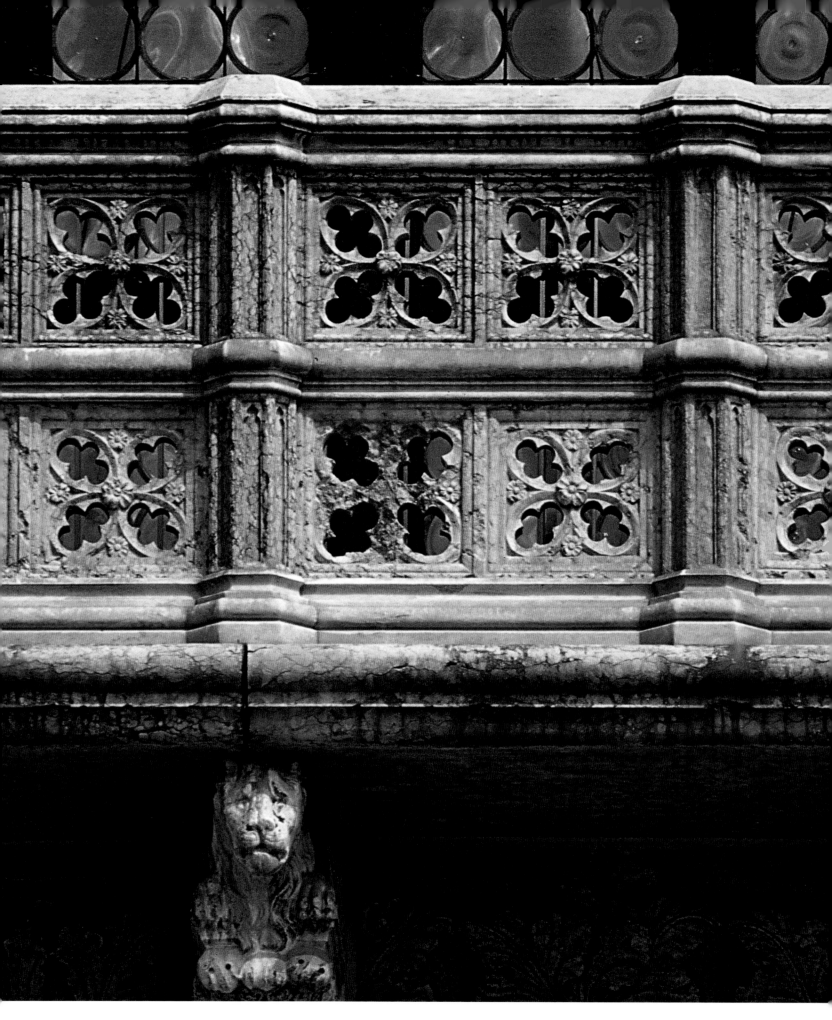

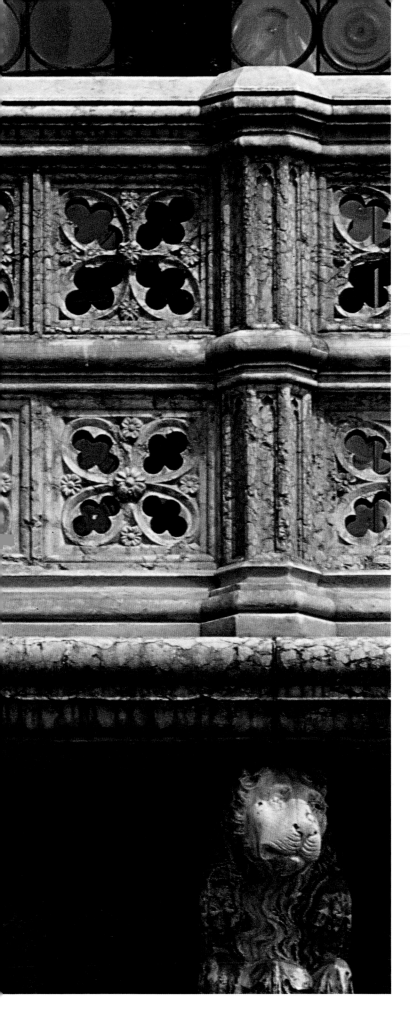

irregular curves of its rounded cupolas; and by the scattered forest of its remarkable belfries. Warlike crenellations can sometimes still be spotted here and there on what were once fortified houses, but these have better survived along the long wall that jealously guarded the secrets of the Arsenal's shipyards and workshops, where once 'in winter, there used to boil away the tacky pitch used to protect the wood' of galleys and galleons. Here, hundreds of craftsmen toiled away making ropes, cables and cords, hollowing out the trunks of trees felled in the forests of Cadore, and smelting shafts for culverins, springals and falconets, in conditions so deafening that people may well have believed that secret charms and black magic were being practised there.

Felix Faber, a Dominican friar from the city of Ulm, who visited the lagoon twice en route to Jerusalem at the end of the 15th century, tells us: 'The common

The Gothic balcony of the Doge's Palace, which runs along a wide facade overlooking the lagoon, has a sturdy balustrade pierced with quadrilobes, whose remarkable coloration and subtle chiaroscuro effects imitate dandelion leaves and flowers. The lions' heads ornamenting the sculptural supports of this balcony peer out from the shadows beneath.

people say, although I've heard no expert vouch for it, that in Venice there was an underground place, hidden from the eyes of everyone except a very few governors of the Republic. In this secret place worked blacksmiths, who possessed the art of separating gold from other non-precious metals; it was because of them that Venetian merchants were so enormously rich.'

But while the crenellations which traditionally embellished the castles of noble families are today reduced to little more than fragments, the surrounding buildings have now embraced them as ornamental curiosities, bringing them back to life in the form of embroidered polychrome marble shapes on the top of the Doge's Palace. According to Felix Faber, this was 'like a stone garden containing pomegranate trees and other aromatic plants'; on the walls enclosing the vast courtyard, the crenellations

seemed to teeter on a cascading wall of arabesques, dissolving into a shimmering haze of arches and mullions. The sublime Doge's Palace, as we have already noted, is echoed in other private palaces that the Venetians built, and its spirit haunts public buildings too. The Procuratie Vecchie, in particular, has inherited the palace's crenellations, transfiguring them into blunted and rounded pinnacles, which dissolve into an even more impetuous cascade of colonnades.

The warlike crenellations are rather like a larva destined to outgrow its crude cocoon and play out the eternal miracle of the chrysalis blossoming into an angelic butterfly. Like a chrysalis, the crenellations metamorphose into polyhedral shapes, engendering an endless variety of angles and revelling in

In the skilful hands of stonecutters, carvers and masons – all expert 'gardeners' in stone – the ornamental balustrades that embellish the palazzo facades are transformed into strange and unusual plant designs such as those on the Gothic Palazzo Gritti on the Campo Sant'Angelo, whose design is apparently inspired by the thorny leaves of thistle plants.

143

inventing the most extravagant and capricious forms imaginable, creating effects of transparency and immense refinement. In the case of Marin Contarini's palace, built in the first half of the 15th century, not even the tarnishing of the original gilding has succeeded in impoverishing the sumptuous crenellations. Dazzled by the glittering mirage of the mythical East, Contarini, a Venetian nobleman, hired a great many stonecutters from the lagoon and from Lombardy to decorate his palace with a flock of fantastical winged creatures, born from the Gothic imagination.

Among the countless stone monuments in Venice, there are none which so embody the wisdom of the State nor come close to the majestic vertical thrust of the two gigantic columns from Syria that stand in the Piazzetta, the ancient cove whose waters bathe the base of the campanile and the side of the Basilica.

Made of granite from ancient Egypt, speckled with shadows of purple and ash-grey, they rise symmetrically

Left (from top to bottom) More balustrades, featuring curious naturalistic elements, as seen on the Palazzo Gritti in Sant'Angelo and the Palazzo Michiel Olivo in San Polo, and lyre-shaped forms, as on the Palazzo Molin in San Stin. Also worthy of note is the intricate work on the balustrade of the Palazzo Priuli Ruzzini on the Campo Santa Maria Formosa.

Right On the small 17th-century Palazzo Malipiero on the Rio Marin, the decorations are both vegetal and anthropomorphic, and the end baluster boasts a figure with a body made of leaves and a human face with a sardonic grimace.

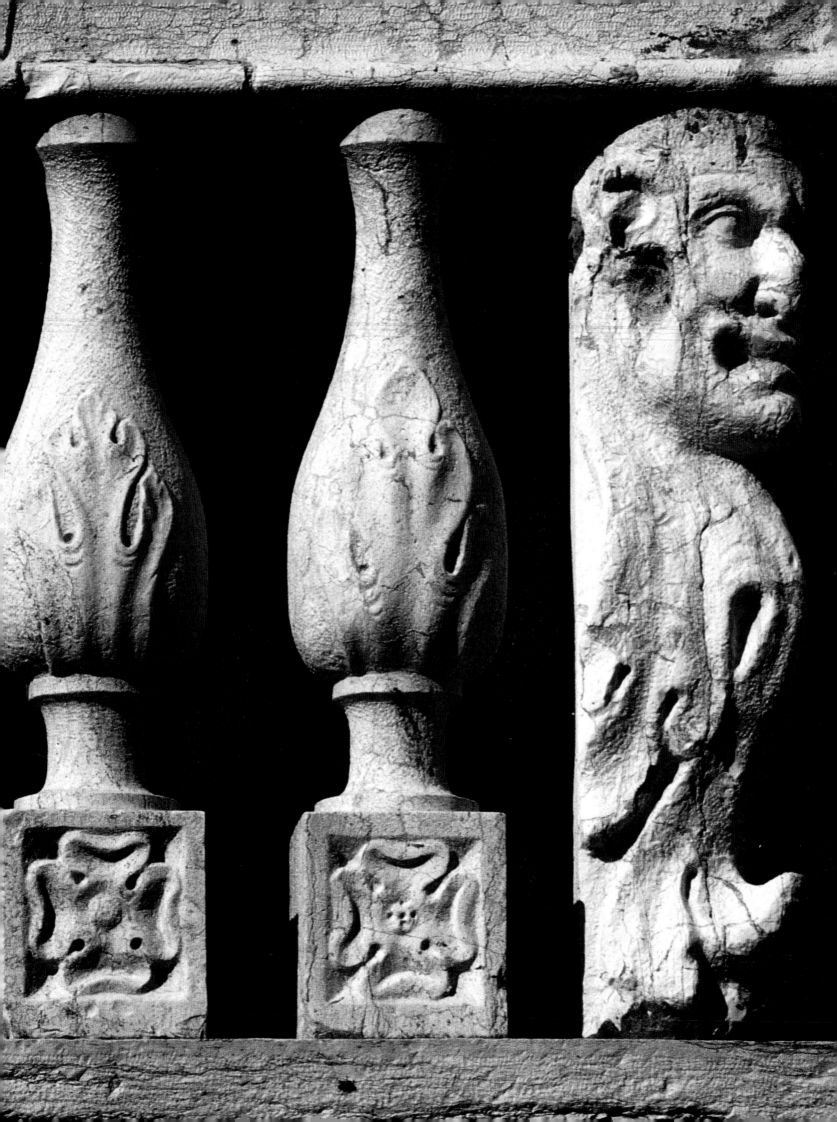

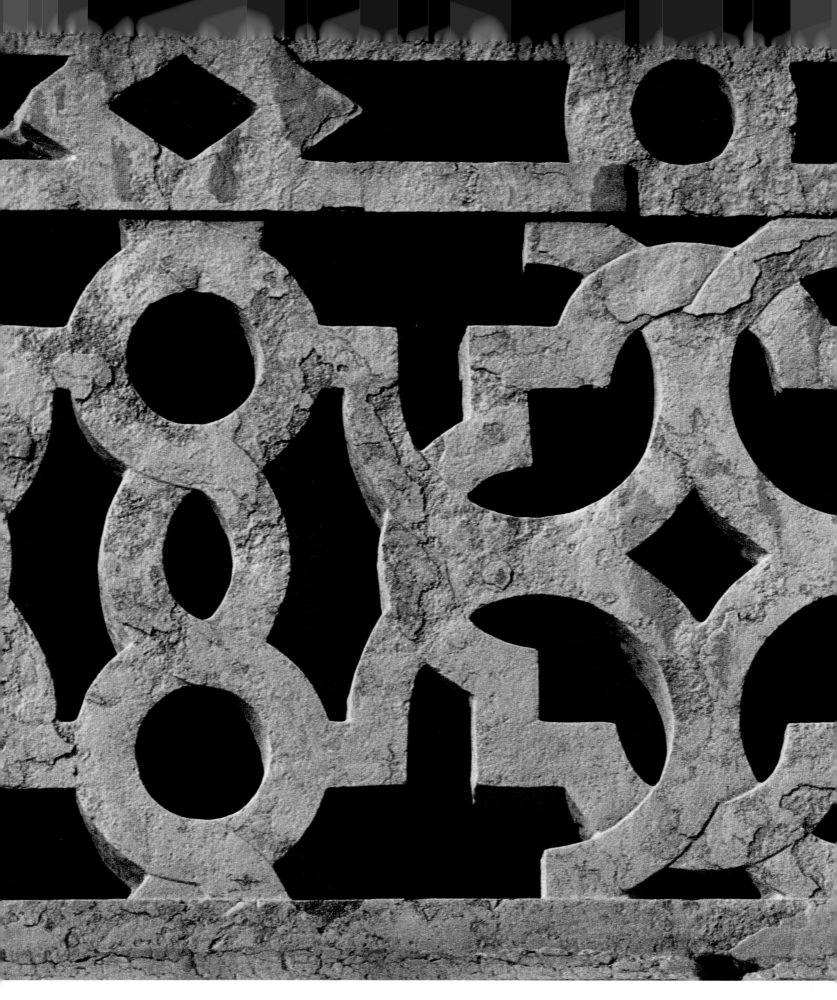

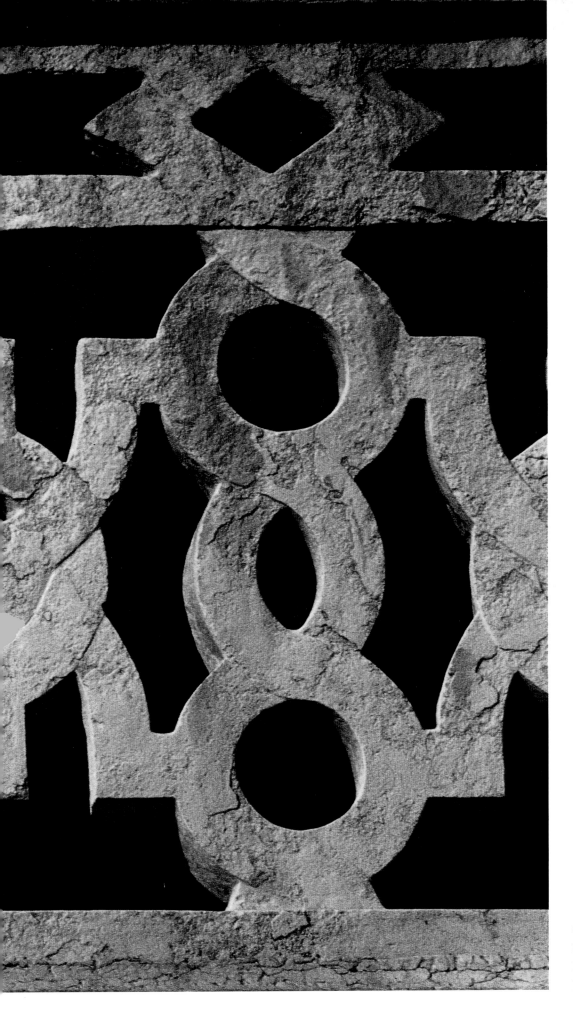

Geometric motifs on the
balustrade of the Palazzo
Mastelli on the Rio della
Madonna dell'Orto.

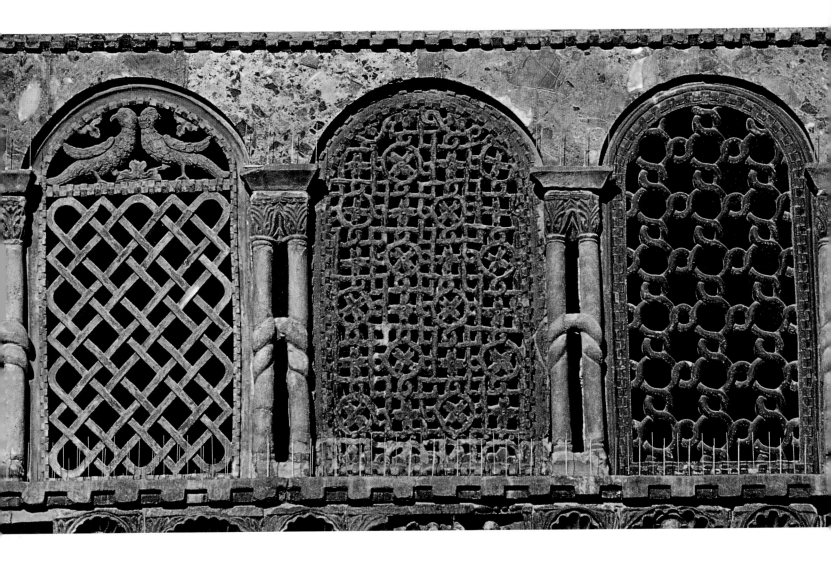

from their pedestals, whose high steps are covered with heavily worn carvings. These powerful pillars symbolically form an enormous gate to close the invisible walls of the city. They also serve as supports for two statues: a winged bronze lion, dedicated to Venice's patron saint, born of the strange manipulation of an Etruscan or Persian mythical beast, and much later subjected to the ravages of Napoleonic soldiers; and a statue of St Theodore, once patron saint of the city when it was under Byzantine rule, and fashioned almost magically from a marble head from ancient Greece and a torso from the age of Emperor Hadrian. It was between these two columns that the dreaded scaffold used to stand, watched over imperiously by Justice, armed with her sword and scales, from her medallion on the loggia of the Doge's Palace. It was no coincidence

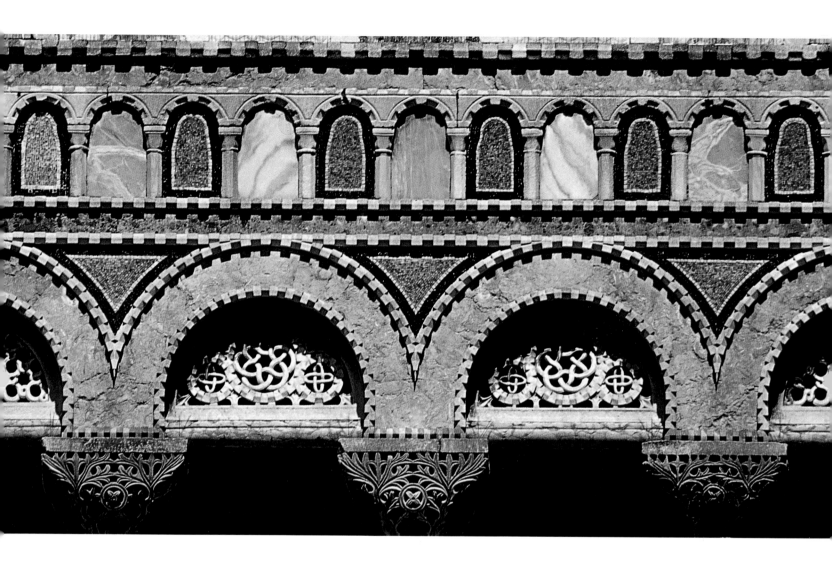

that the columns were painstakingly erected in the Piazzetta at the end of the 12th century by Nicolò Barattieri, who created the first wooden bridge at the Rialto. For those arriving in the Piazzetta by boat, they frame, at a distance, the great archway leading to the Mercerie. Above the arch is a gilded blue enamelled sundial, which both tells the time and indicates the cycles of the sun and moon. On the next level up is a niche housing an effigy of the Virgin and Child in copper. Above them stands the lion of St Mark, against a background littered with stars and, on the terrace crowning the building, there is a large bell that, when struck by hammers wielded by muscular

The openwork surfaces of the medieval Sant'Alipio porch of the Basilica of San Marco are striking; the subtle tangle of the motifs creates fascinating and playful chiaroscuro effects, which enhance the chromatic contrast of its different rare marbles, some of which are pillaged from other sites.

Overleaf An elegant marble grill from the church of Santa Maria dei Miracoli is decorated with naturalistic motifs.

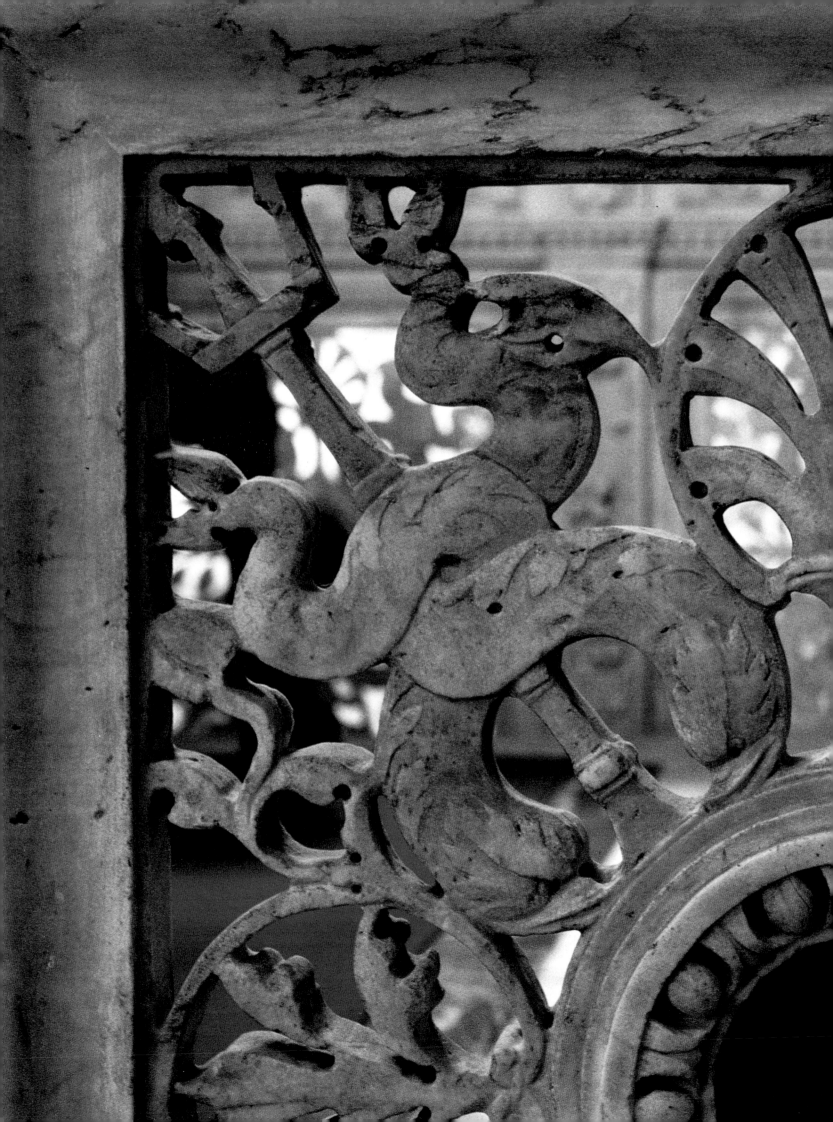

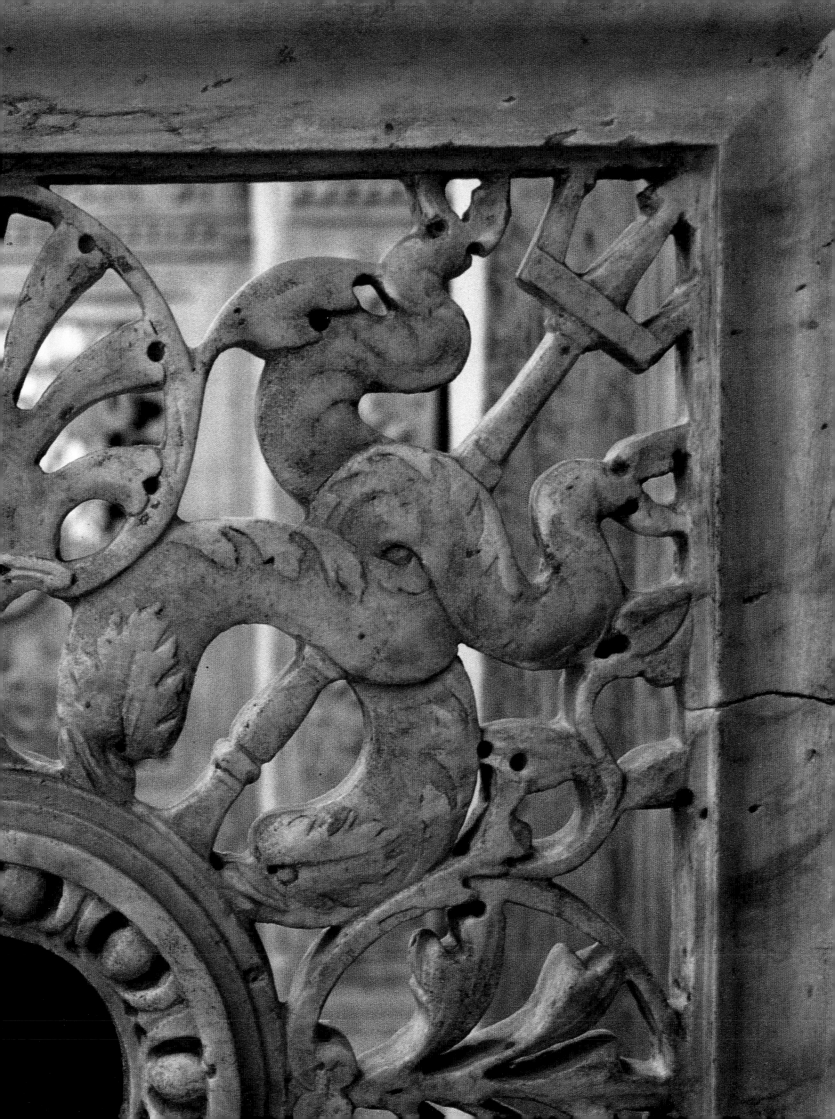

The parapets of the palaces themselves were lighter and more fantastic....

RUSKIN, *The Stones of Venice*

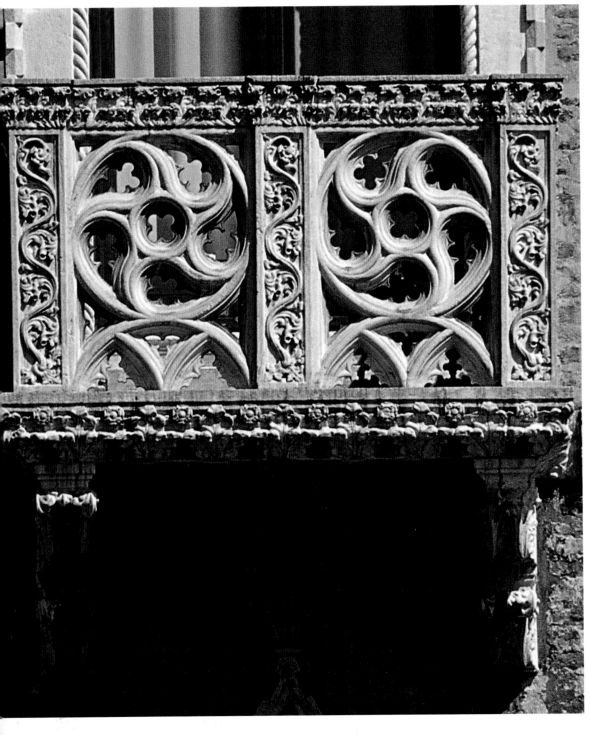

Left One of the highly ornate balconies from the Gothic Palazzo Contarini Fasan, which was allegedly Desdemona's house. The elegance of the flamboyant Gothic balconies derives from the unusual wheel shape of the openwork design, revealing Nordic influences.

Right The hand of the drunken Noah reaches for a bunch of grapes that seem miraculously to be growing at street level on the corner of the Doge's Palace near the Ponte della Paglia (Bridge of Straw).

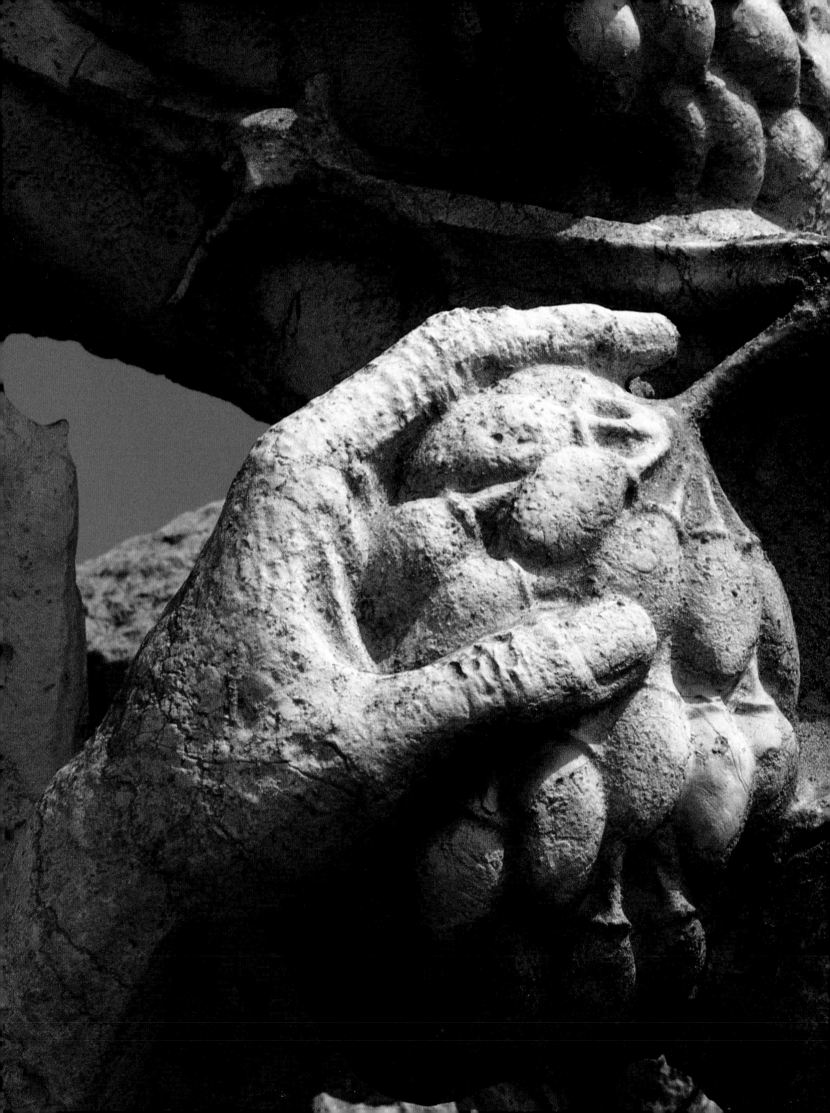

figures of powerful Moors, rings out the daily and eternal cycle of time.

From the summit of this building, a sweeping panorama of the city stretches out before us. Our gaze glides across what appears to be a craggy and mountainous landscape of rooftops; glancing over the varying inclinations of their roofs, ranging from vertiginously steep to gentle slopes, and taking in all the red and brown nuances of this disorderly and chaotic chessboard of rooftops. From here, to our great dismay, there suddenly rise tall buildings which – because of the rigid wall enclosing the Ghetto which makes it impossible to expand in any direction – grow relentlessly upwards. We look down on to concave gutters, are startled by the profusion of strange and surprising gargoyles, their faces borrowed from a fantastical bestiary, and spot the place where the rainwater runs off the roofs. Then our eyes begin to distinguish the clusters of chimneys that flourish on the borders or slopes of roofs and often surround (or attempt to rival in height) the dainty cantilevered platforms, known as *altanas*. Finally, there are the *campanili* soaring at different angles into the sky.

Chimneys are the subject of continual reinvention , and their strange and unusual designs enrich the garden of stone with their astounding novelty. After having observed the town from above, G. M. Urbani De Gheltof, an anxious and tormented historian, attempted

The luxuriant and overlapping leaves of ancient Venetian columns provide shelter for the animals who come to rest in their shade, as on the Byzantine capital found in the Muazzo courtyard in San Giovanni Evangelista in the *sestiere* of Castello; here the fixed gaze of a zoomorphic head attracts the curiosity of passers-by.

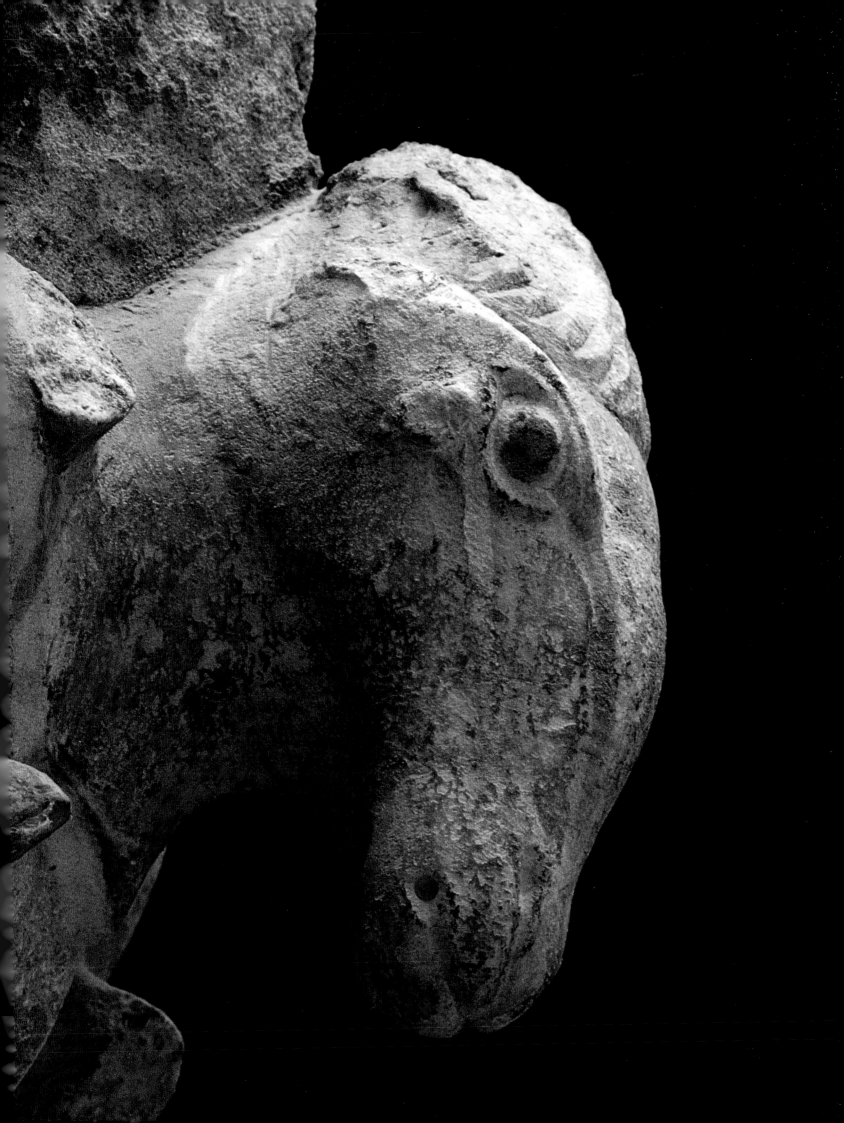

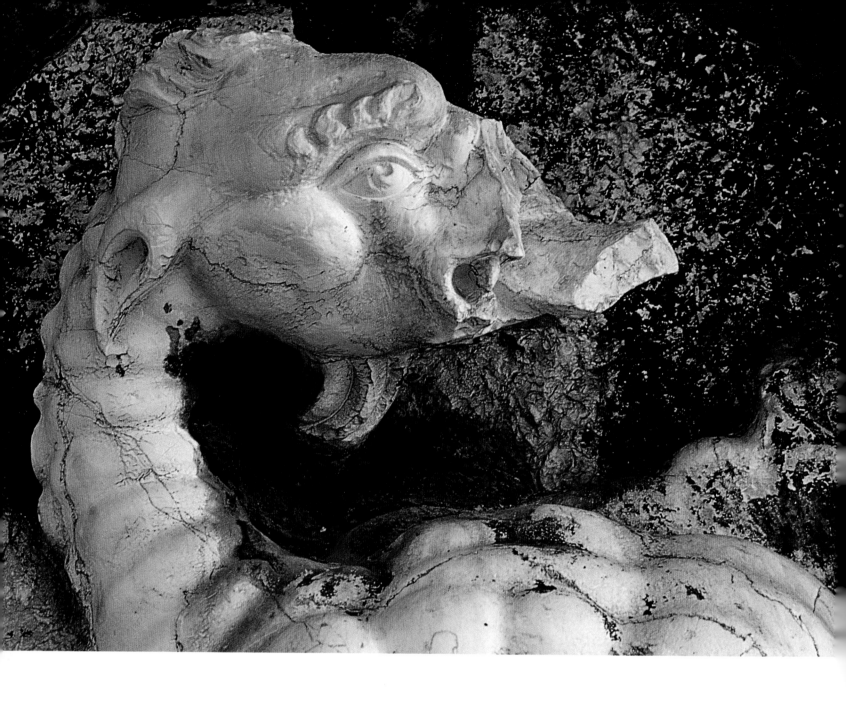

one day to develop a systematic way of classifying the most common types of chimney from amid the great profusion of styles. However, he quickly realized that his enterprise was doomed to failure and could only result in pitiful defeat. In reality, the cylindrical-shaped flues open into a succession of truncated and inverted cones resembling upside-down bells; of small arches, be they round or ogival; and of corbels where the rigid geometry of the cylinder and cone are juxtaposed or grafted together – occasionally one even comes across the trefoil shape of three overlapping bells. There are no limits to the variations and sizes of the polyhedral structures of the many stone dados supported on cylindrical flues. From here, fork- or trident-shaped pipes sometimes flow, intended for 'dealing with and defying the impertinent and annoying

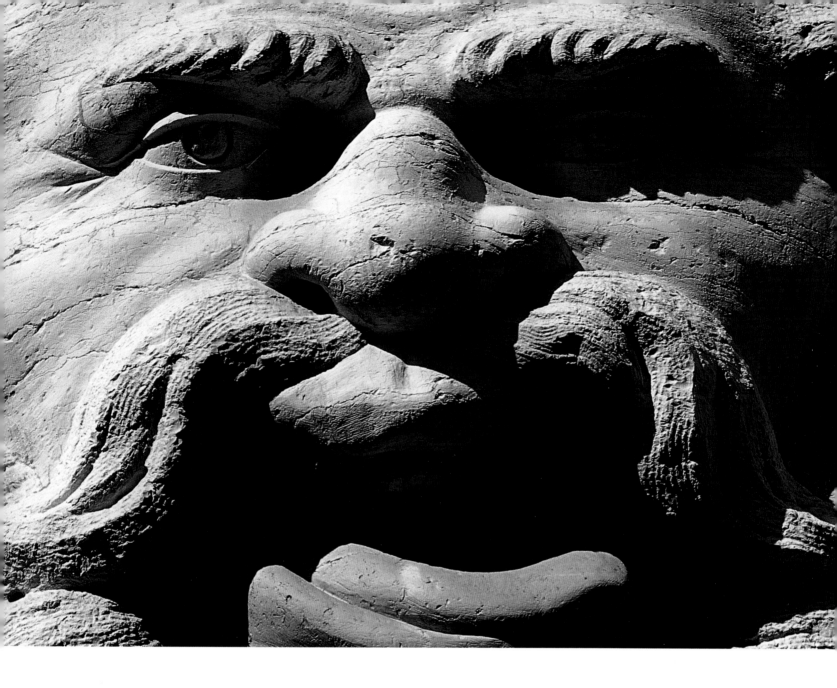

waves of smoke, just as Neptune, the powerful god of the sea, had dealt with other waves'.

Marcel Proust, engaged in the remembrance of things past, reminds us that, with the evening light accentuating its colours, an entire garden seems to flourish on the rooftops of the city; the variety of shades and nuances of flared chimney seems to suggest that this stone garden is tended by someone with a passion for the tulips of Delft and Harlem.

The bell towers are also composed of cylindrical or quadrangular forms, sometimes truncated or flattened at the top, or surrounded by a balustrade

Above Zoomorphic figures, such as the dragon at the base of the facade of the church of Santa Margherita, or anthropomorphic ones, such as the irreverent moustached face on the facade of the church of the Ospedaletto in Barbaria delle Tole, built by Baldassare Longhena in the 17th century, were probably intended to keep evil spirits away.

Overleaf A procession of monks praying in front of the Virgin of Mercy was sculpted on the side of the church of San Tomà.

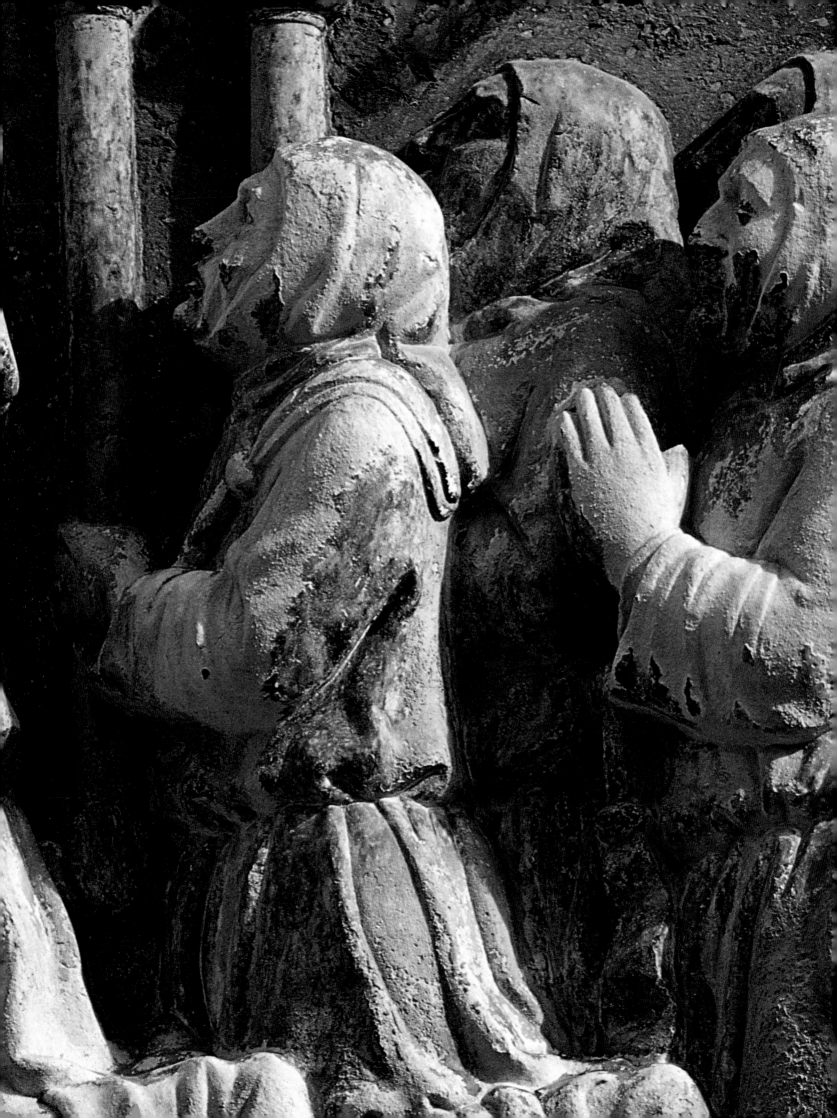

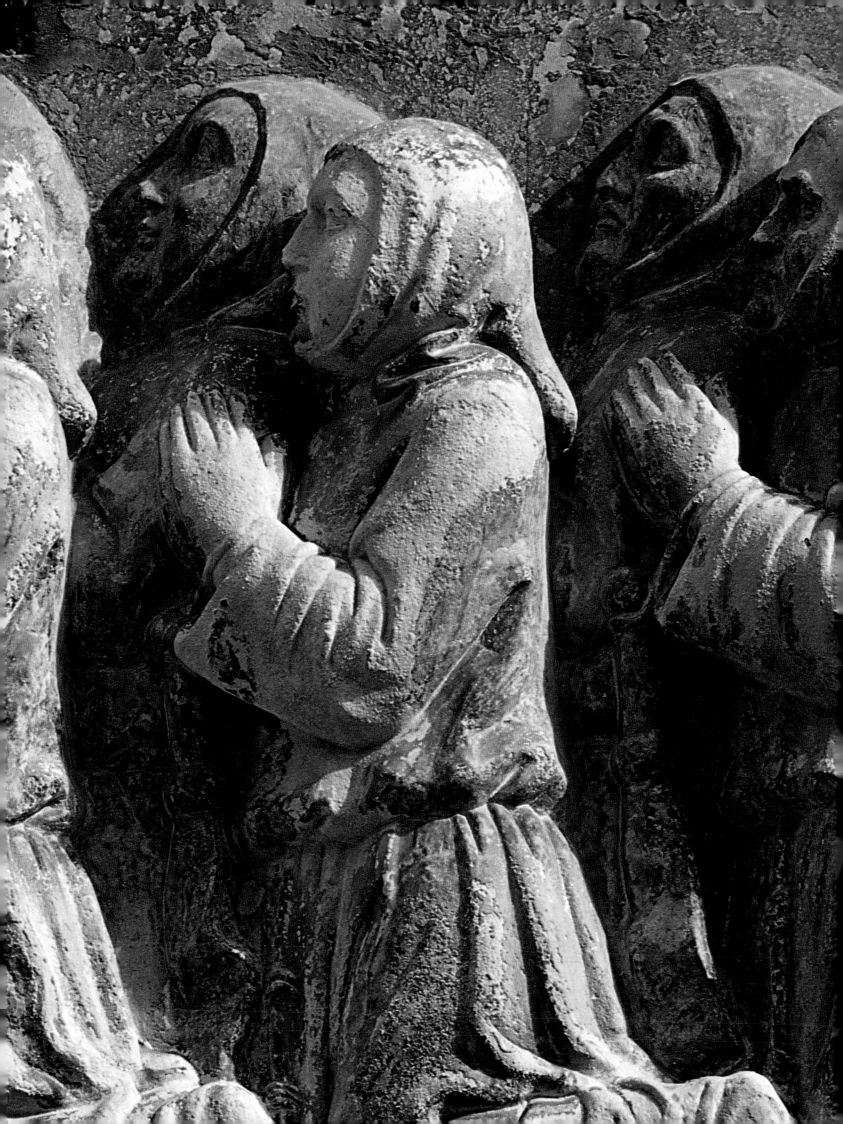

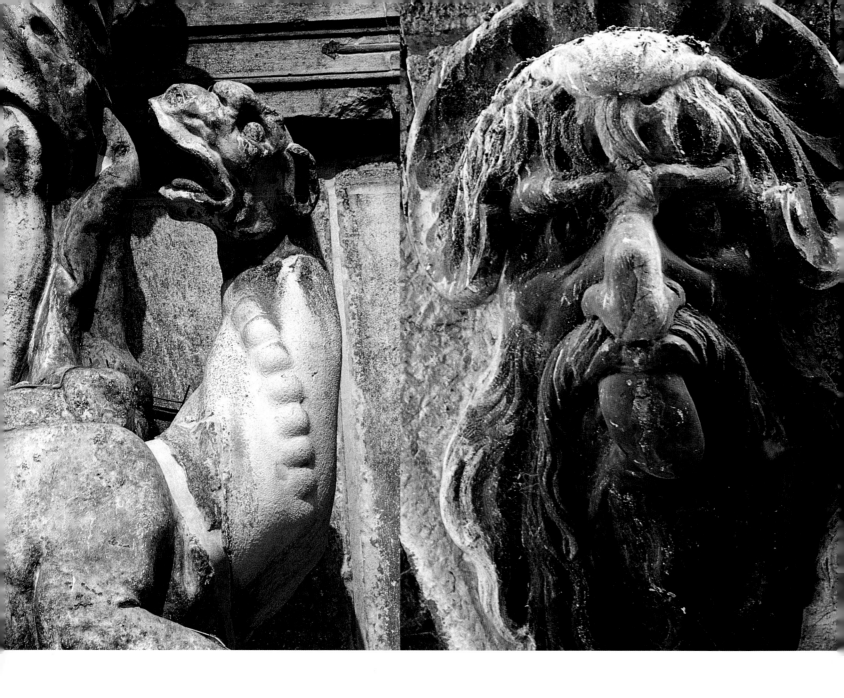

that protects the bell cage, or sometimes providing the base for a small columned temple crowned with a bulb-shaped cupola. Sometimes their compact mass, striated with sober blind arches at ground level, is gradually narrowed down to form agile and pointed, marble-lined pyramids further up, creating – against the stable and imperturbable backdrop of the sky – a jigsaw of sloped surfaces that mocks and defies all the laws of equilibrium, and seems all too likely to collapse pitifully to the ground. This constant defiance of the normal laws of construction demonstrates that it is not the possible, but the *impossible* that triumphs in Venice, confirming the unfailing strength of the bond that unites the stones to their shifting and watery foundations. To paraphrase Jean-Paul Sartre, the 'last tourist' in Venice, we could conclude that these miraculous leaning

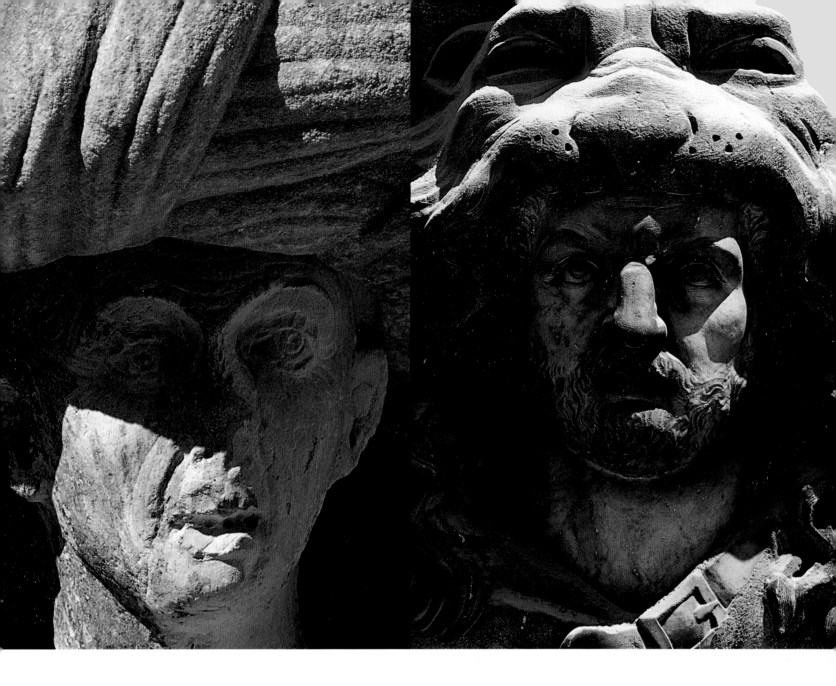

vertical shapes or 'these princely chalets rise out of the water', since 'it is impossible to believe that they would float; a house, above all a leaning one, cannot float'. Nor can we affirm that 'they rest on the lagoon', for if they did, they 'would sink under their own weight'. But we cannot consider them weightless since 'we can see quite well that they are made of brick, stone and wood, so instead we *sense* them to be rising from the waters.' Stepping back from the bell towers and looking up at them from their base, we notice, at the level of the bells, the sense of a transversal blocking the upward momentum; it as though 'their density is restored, their mass inverted.

Left to right A striking and unusual series of faces: a contorted camel with an overly long neck on the Baroque facade of the church of San Moisè; the strange bearded face, set in an inhuman grimace, that keeps watch over the door to the staircase of the San Bartolomeo bell tower; the surprised look of the face of one of the turbaned Moors who guard the Campo dei Mori in the *sestiere* of Cannaregio; and the severe expression of the head sculpted by Domenico Rossi on one of the balcony supports of the Palazzo Tiepolo, built in the 18th century in San Polo.

161

Jets of water turned to stone, it is as if they have appeared precisely at that moment and that previously there was nothing. In a word, they are always a little like apparitions.'

When we lower our eyes exhausted by the spectacle above, we rediscover the complex and uneven weft of the paths of this relentlessly labyrinthine stone garden. While exploring the narrow alleys, we catch glimpses of foreshortened facades and of shimmering *rii* that have escaped the decree to be filled in and paved over. These were orders given at a time when Venice, burnt out with exhaustion, had stopped being a 'pure' island impervious to external influences; a time when the Republic, which had once been the envy of the entire world, had abdicated its throne and its myth, and was resigned to accepting other myths from abroad, ideas that were foreign to the city's very essence. On that sad, foggy day at Campoformido, Venice witnessed the arrival of the new, temporary nobility who had come to auction off the stones of her destiny — a

Far left The cloak belonging to a member of the Barbaro family, his great 17th-century wig and the scarf wound tightly around his neck and flapping in the wind, identify this aristocrat who inhabits the facade of Santa Maria del Giglio with his brothers. In this Venetian Baroque church, the sacred definitely takes second place to the self; no crosses, saints or Christian symbols have been allowed to trespass here.

Left On the corner of the Doge's Palace, a 14th-century Noah sleeps calmly. The softness of his long beard demonstrates the stonemason's care and attention to detail.

destiny that was utterly embedded in those stones – and to sell them coldheartedly to the highest bidder. A great friend of Pushkin, Pyotr Andreevich Vyazemsky, who both experienced and wrote about 'the rule of golden Venice', remarked that there were:

> No roads, only passages
> Where people flock in single file.
> Palaces are marble mountains
> That the scalpel has engraved.
> Here the roads are transparent
> And in the blue-green colour of the ground
> The palaces are reflected
> Building a city beneath the waters.

In the beginning were the waters; then came the stones. But the water has always reflected light on to both the modest and the majestic constructions – both equally beautiful – throughout the countless adventures that took place in that unparalleled and unprecedented garden; it was a light which, in magnifying the city's beauty, foretold its eventual vulnerability.

The stones of Venice, darkened by time, disillusioned and worn, delicate crystals that shatter and crack at the slightest unusual noise or the lightest of unexpected blows, are a fragile repository for the fading past that dissolves away inside them. From within the impossible garden that they adorn, the stones beg to stop being loved, since the love that their enchantment inspires will be their ruin; it has become nothing more than a vulgar habit that deliberately ignores the warnings of the ancient columns and the tensions of brutal, temporary and thoughtless ownership. Pursued for selfish ends by obsessive passion, infatuation and loss, the 'palaces of porphyry and jasper' are reduced to nothing more than the reflection of 'black velvet' on 'the dusky grey waters'. The stones of Venice are loved but loved badly; they only ask to melt way like sand into the sea which – in a prophetic gesture that has now lost its meaning – first gathered them up and laid them down in an Eden-like garden of stone, populated by angels and miracles. All that is left now is an agonizing and unquenchable yearning for the past. A poet, recognizing the rarity of Venice and understanding the slow decay and unfathomable essence of what had gone before and what was to come, reminds us that the only paradises are lost ones. The stones of Venice, amid the suffering and bitter turmoil of so many memories, will only begin to shine again – re-covering the city's pavements, repaving the steps of staircases, rebuilding the bridges, readorning the array of facades, spires and pinnacles, and plunging once more into the liquid transparency of the canals – at the moment when they are finally lost forever.

... there is no end to the fantasy of these sculptures, and the traveller ought to observe them all carefully....

RUSKIN, *The Stones of Venice*

The acanthus leaves that ornament one of the giant capitals on the facade of San Stae, an 18th-century work by Domenico Rossi, are transformed – as if by alchemy – into a luxuriant tropical palm tree with lush leaves. Air and light seem to penetrate and ruffle the leaves.

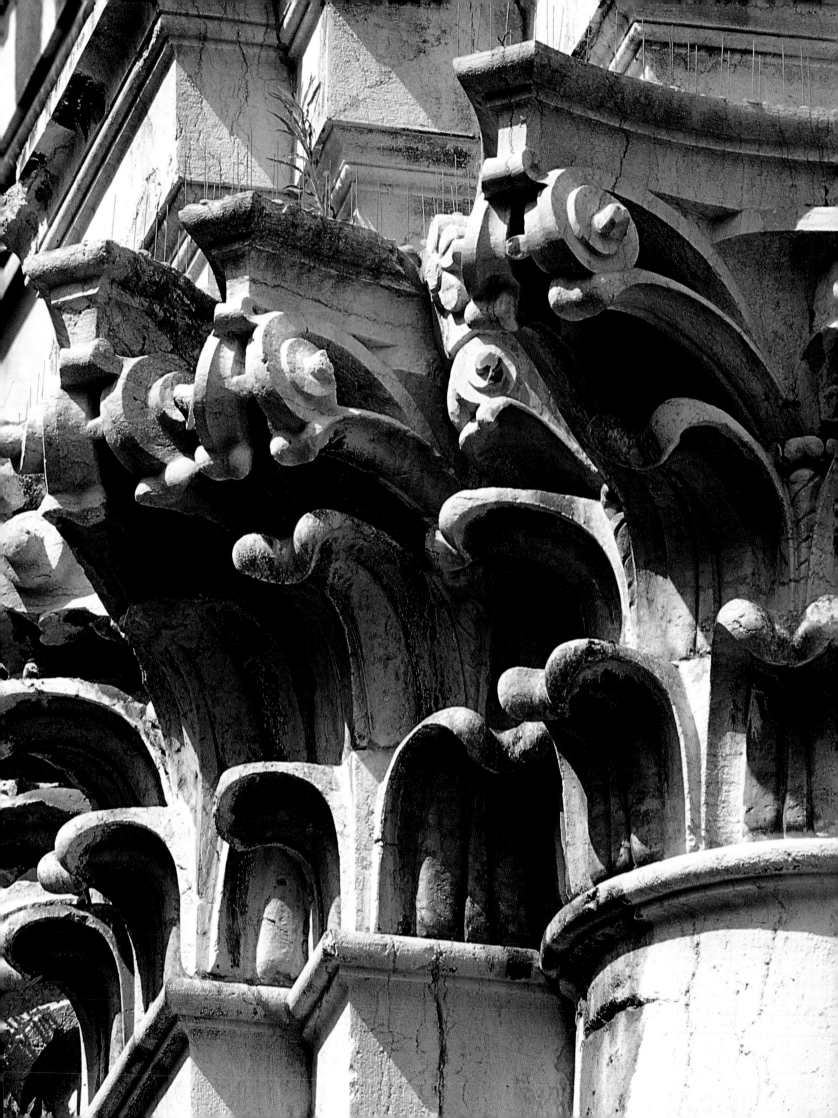

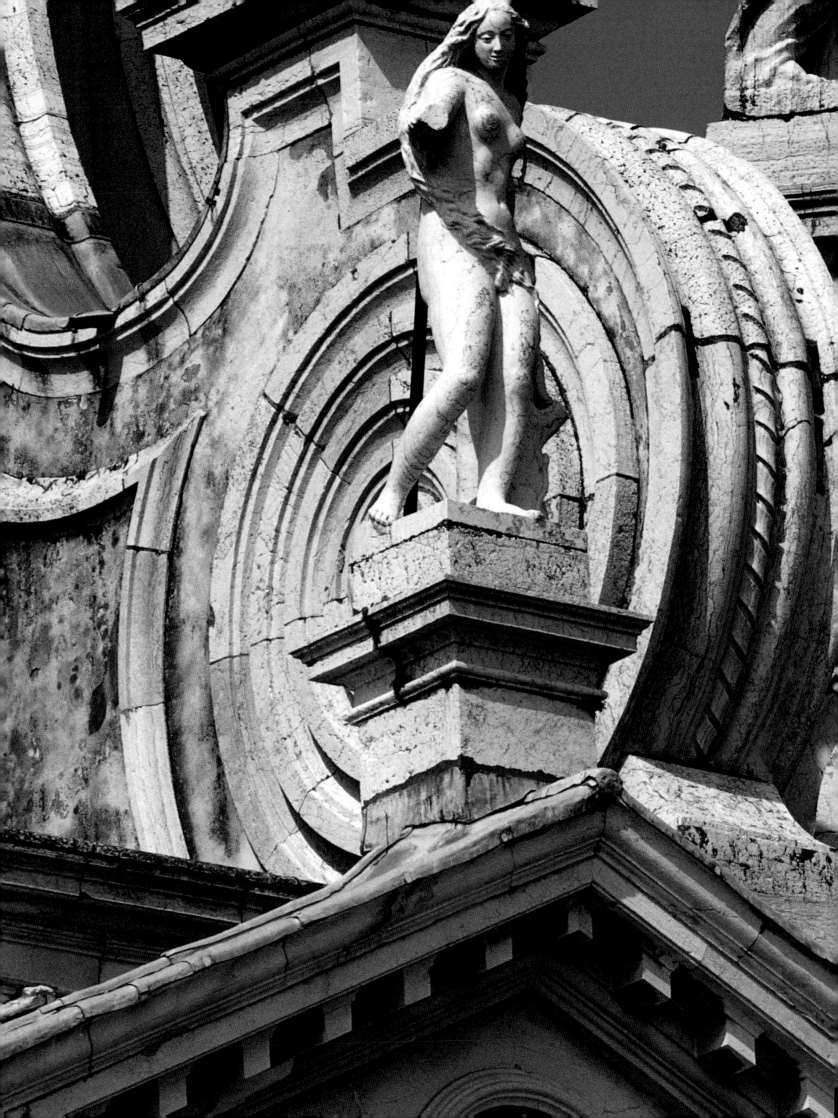

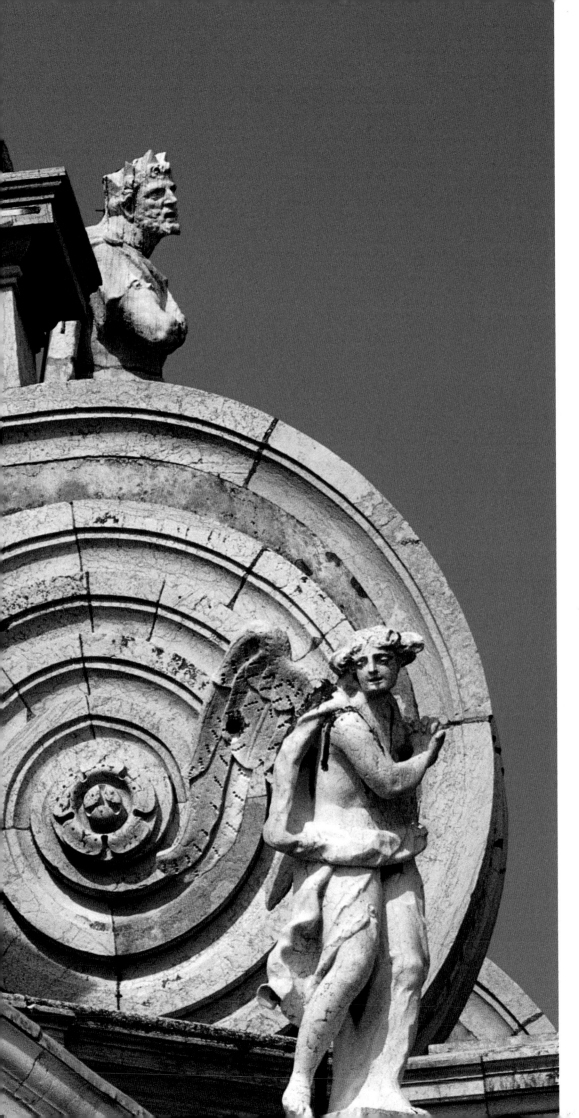

Left The imposing volutes which unfurl on the octagonal lantern tower of the church of Santa Maria della Salute look like frothy waves in a stormy sea, inhabited by celestial beings.

Overleaf The motif of a stylized wave reappears on the sumptuous baldachin of the high altar of the church of the Gesuiti. The fluffy clouds inhabited by cherubim and the golden rays of the sun, created by the dove of the Holy Ghost, merge with the flashes of refracted light that dissolve, from through the rear windows, the reflection of the water of the nearby canal.

167

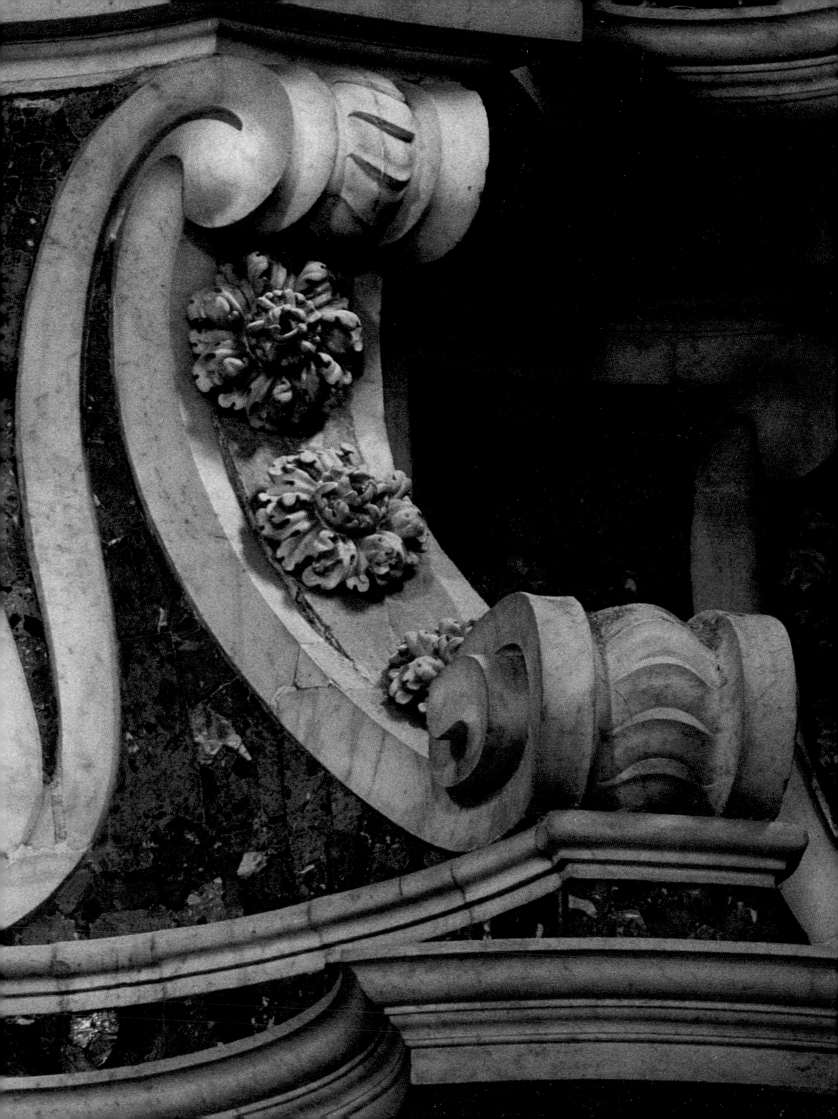

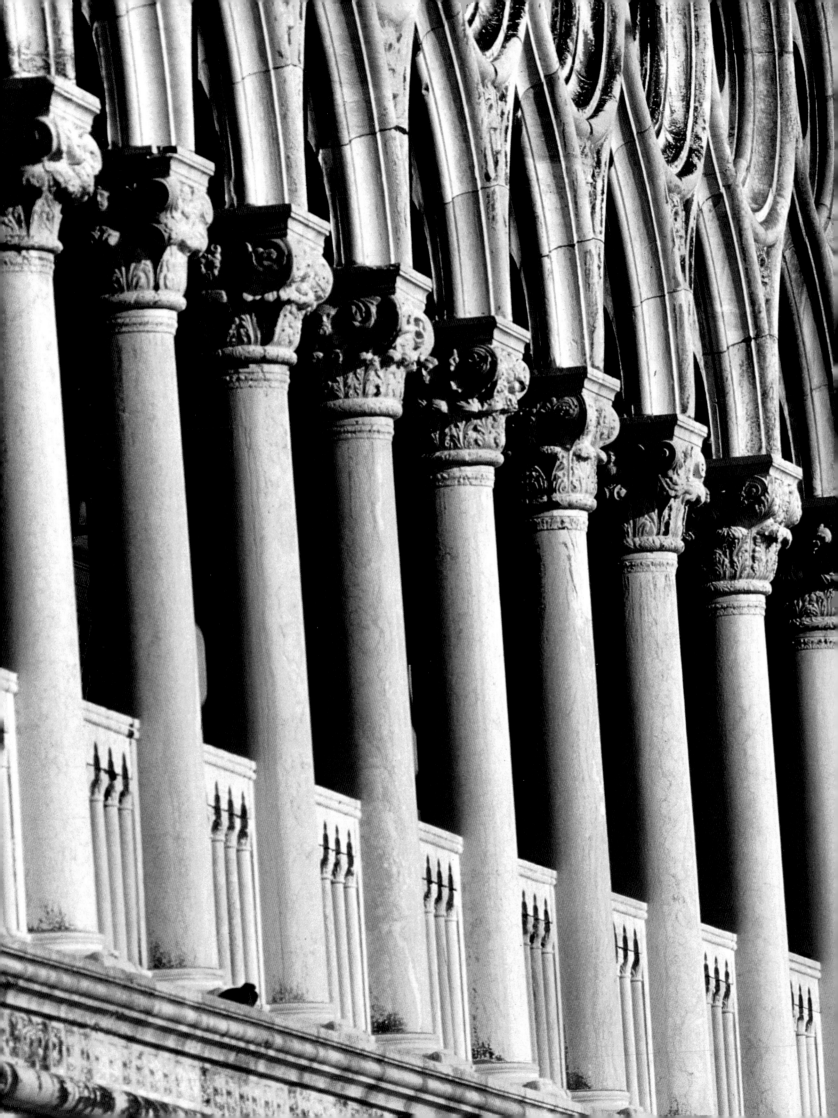

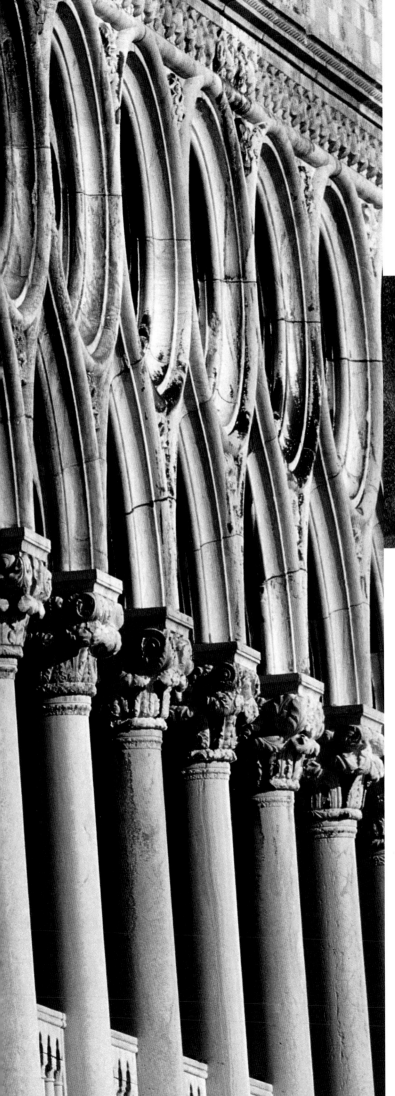

Left The dense forest of slender columns, surmounted by flowering capitals that support the open loggia of the Doge's Palace, has sheltered and protected the long line of Doges who served the government of the Republic from the middle of the 14th century.

Above Birds take advantage of Noah's drunkenness to peck at the grapes that spring from vines planted at the very base of the Palace.

171

A Venetian Glossary

Altana a type of wooden platform or terrace, built on roofs.

Ca' abbreviation of *casa*, meaning house. In Venice, it is also used to describe palaces owned by the nobility, as only palaces owned by Doges could be called *palazzi*.

Calle a small street or alley that runs between houses. A small *calle* is called a *calletta*.

Camerlenghi treasurers of the former Venetian Republic.

Campo literally, a field, since these spaces were originally covered in grass. This is the term used for town squares, since only the Piazza San Marco was worthy of the title *piazza*. The diminutive is *campiello*.

Casa a house, in this case a beautiful dwelling.

Fondaco (or **fontego**) a combination of warehouse and house, where merchants both lived and stored their goods.

Fondamenta a quay along a canal.

Lido an offshore beach.

Marano a goods boat without a deck.

Masegni trachyte paving stones.

Moleca originally, the moment when a crab is totally indefensible and soft, as it changes its shell. A lion *in moleca* is therefore shown seated or crouching.

The other traditional stance for a lion is known as either *andante*, *passante* or *gradiente*, that is to say, standing with its front paw resting on a book, which is open at the famous phrase '*Pax tibi, Marce, Evangelista meus*'.

Murazzi dykes that separate sea water from that of the lagoon.

Piovego (**Judges of**) a judicial body consisting of three members, responsible mainly for the protection of public places.

Piscina a small part of the lagoon (now filled in) surrounded with buildings where, apparently, Venetians once took their children swimming.

Provveditori sagi alle acque magistrates, originally only temporary but permanent from the end of the 15th century, who were responsible for the ecosystem of the lagoon.

Provveditori 'di comun' magistrates in charge of the art of weaving wool; at the end of the 15th century, they were also made responsible for communication routes.

Ramo a very short *calle*, often a dead end.

Rio a canal. Venice has only three true canals: the Grand Canal and those of Cannaregio and the Giudecca.

Ruga a straight *calle* lined with shops.

Salizzada an important thoroughfare; these were among the first streets to have been paved.

Scuola literally, a school, but in fact, a Venetian name for a place of charity and good works, administered by religious orders. The Scuola Grande was distinguished from the others in that it housed precious relics.

Sestiere one of the six districts of the city.

Sotoportego a covered passage, a small part of the street that passes under a building.

Squero a boatyard where gondolas are made and repaired.

Stazio a landing stage for gondolas.

Terraferma the mainland, implying the land behind Venice and, more accurately, land that had been conquered.

Traghetto a public gondola with two rowers, used as a ferry across the Grand Canal; *traghetto* may also designate points at which the Grand Canal can be crossed by ferry.

Zattere the long quay of Dorsoduro, where the *zattere*, or trading boats, unloaded.

Bibliography

Acheng, *Diario veneziano*, Rome and Naples 1994

Edoardo Arslan, *Gothic Architecture in Venice*, trans. Anne Engel, London 1971

Corrado Balistreri-Trincanato and Dario Zanverdiani, *Jacopo De Barbari. Il racconto di una città*, Venice 2000

Paolo Barbaro, *Venezia l'anno del mare felice*, Bologna 1995

Elena Bassi, *Palazzi di Venezia*, Venice 1976

Giorgio Bellavitis and Giandomenico Romanelli, *Venice*, Bari and Rome 1985

Gino Benzoni, 'A proposito di acque: accostamenti possibili', in *Da Palazzo Ducale*, Venice 1999

Sergio Bettini, *Venezia, nascita di una città*, Venice 1971

Piero Bevilacqua, *Venezia e le acque: una metafora planetaria*, Rome 1995

Fernand Braudel, *Venise*, Paris 1984

Joseph Brodsky, *Watermark*, New York 1992

Beverley Louise Brown, *Renaissance Venice and the North*, London 2000

Charles de Brosses, *Journal du voyage en Italie: lettres familières*, Grenoble 1971

Donatella Calabi, 'Canali, rive, approdi', in *Storia di Venezia, vol. XII. Il mare*, eds. Alberto Tenenti and Ugo Tucci, Rome 1991

Emanuele Antonio Cicogna, *Delle iscrizioni veneziane raccolte ed illustrate*, Bologna 1982 (1st ed. Venice 1824–53)

Charles Dickens, *Pictures from Italy*, London, Paris and Leipzig 1846

Johann Wolfgang von Goethe, *Italian Journey: 1786–1788*, trans. W. H. Auden and Elizabeth Mayer, Harmondsworth 1970

Henry James, *The Aspern Papers*, New York and London 1888

Giulio Lorenzetti, *Venice and its Lagoon*, trans. John Guthrie, Trieste 1975

Mary MacCarthy, *Venice Observed*, London 1961

Antonio Manno, *Il poema del tempo. I capitelli del Palazzo Ducale di Venezia*, Venice 1999

Michel de Montaigne, *The Diary of Montaigne's Journey to Italy in 1580 and 1581*, trans. E. J. Trechmann, London 1929

Charles Louis de Montesquieu, *Journal du voyage en Italie*, Paris 1774

Saverio Muratori, *Studi per una operante storia urbana di Venezia*, Rome 1959

Giannina Piamonte, *Venezia vista dall'acqua*, Venice 1963

Lionello Puppi, *Nel mito di Venezia:autocoscienza urbana e costruzione delle immagini*, Venice 1994

Lionello Puppi, 'Venezia tra Quattrocento e Cinquecento. Da "nuova Costantinopoli" a "Roma altera" nel sogno di Gerusalemme', in *Le città capitali*, Bari 1995

Alberto Rizzi, *Scultura esterna a Venezia*, Venice 1987

Alberto Rizzi, *Vere da pozzo a Venezia*, Venice 1992

Tiziano Rizzo, *I ponti di Venezia*, Rome 1983 (3rd ed.)

John Ruskin, *The Stones of Venice*, London 1851–53

Tudy Sammartini, *Decorative Floors of Venice*, London 2000

Francesco Sansovino, *Venetia città nobilissima et singolare*, Venice 1968 (1st ed. Venice 1581)

Jean-Paul Sartre, *La reine Albemarle ou Le dernier touriste (fragments)*, Paris 1991

Antonio Alberto Semi, *Venezia in fumo, 1797–1997*, Milan 1997

Giuseppe Sinopoli, *Parsifal a Venezia*, Venice 1991

Giuseppe Tassini, *Curiosità veneziane*, Venice 1990 (1st ed. Venice 1863)

Alberto Tenenti, 'Il senso del mare', in *Storia di Venezia, vol. XII. Il mare*, eds. Alberto Tenenti and Ugo Tucci, Rome 1991

Egle Renata Trincanato, *Venezia minore*, Milan 1948

John Unrau, *Ruskin and St.Mark's*, London 1984

Ettore Vio, *St Mark's Basilica in Venice*, London 2000

Alvise Zorzi, *Venice 697–1797. City, Republic, Empire*, trans. Nicoletta Simborowski and Simon MacKenzie, London 1983

Giampietro Zucchetta, *Venezia ponte per ponte*, Venice 1992

Index of Illustrations